CHINA

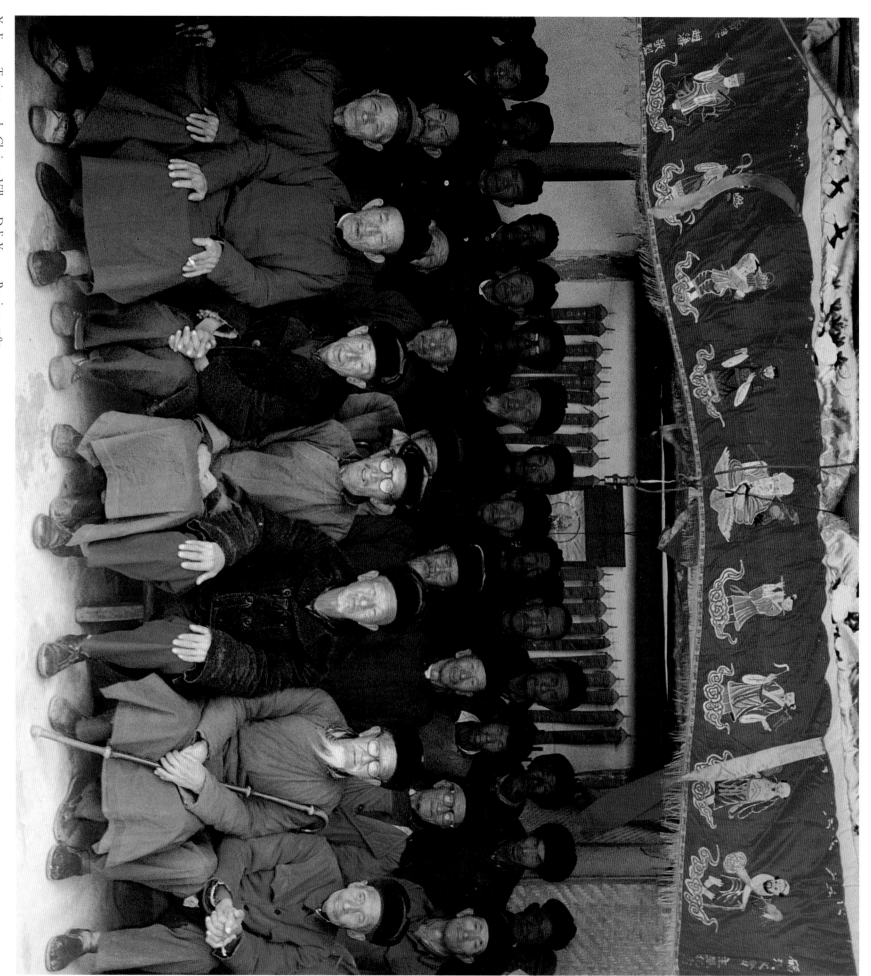

CHINA

FIFTY YEARS INSIDE
THE PEOPLE'S REPUBLIC

ESSAY BY RAE YANG

APERTURE

CHINA: *FIFTY YEARS INSIDE THE PEOPLE'S REPUBLIC*
IS MADE POSSIBLE BY THE SUPPORT OF

THE STARR FOUNDATION

THE ACCOMPANYING EXHIBITION
IS GENEROUSLY SUPPORTED BY

FORD MOTOR COMPANY

IN KEEPING WITH THEIR COMMITMENT TO
THE LIFE AND CULTURE OF CHINA AND ITS PEOPLE
AND TO EXCELLENCE IN PHOTOGRAPHY

———

THIS PUBLICATION AND THE ACCOMPANYING
EXHIBITION IS A TRIBUTE TO
MR. T. C. HSU OF THE STARR FOUNDATION
WHOSE LIFE CONTINUES TO BE DEVOTED TO
BUILDING TIES OF FRIENDSHIP
BETWEEN CHINA AND THE UNITED STATES

CONTENTS

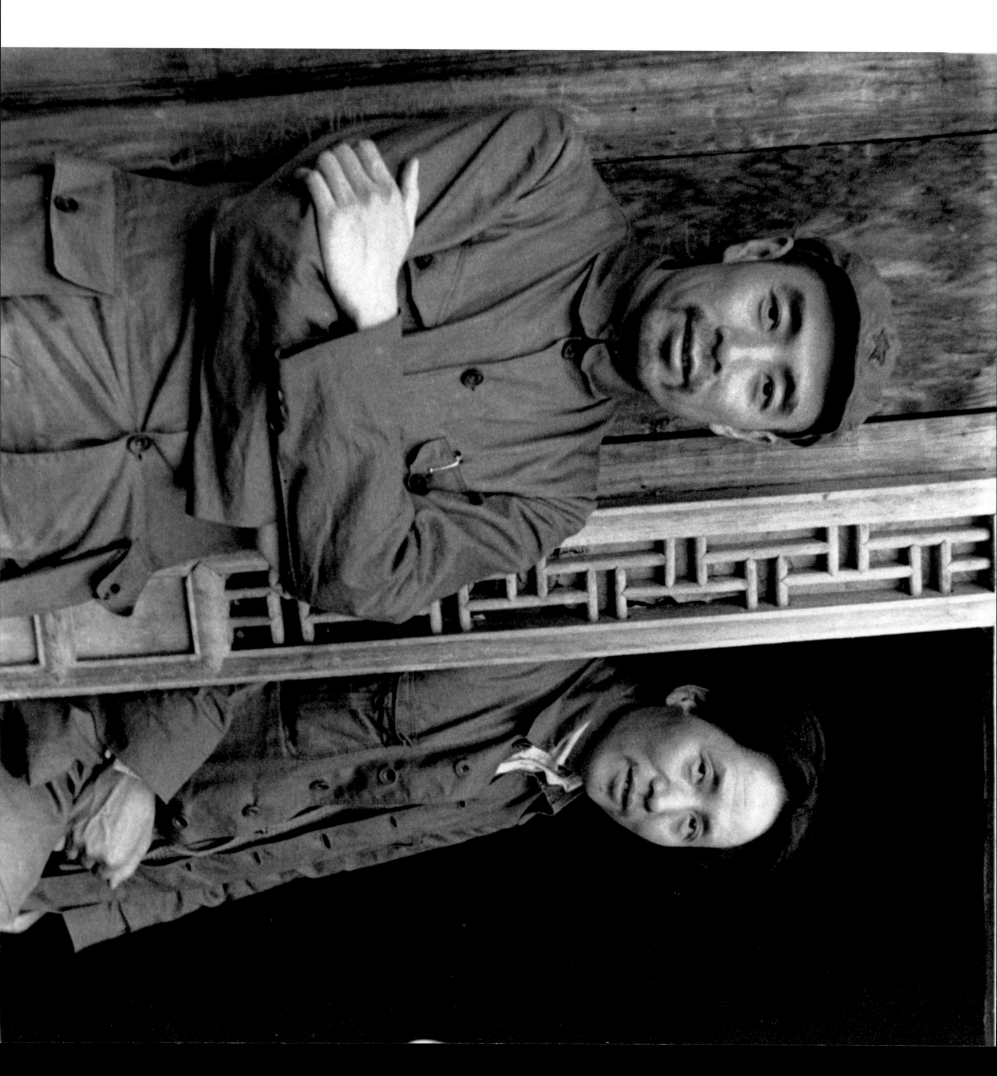

THE BIRTH OF A NEW CHINA

There are said to be some victors who take no pleasure in a victory unless their opponents are as fierce as tigers or eagles: if their adversaries are as timid as sheep or chicken they find their triumph empty. There are other victors who, having carried all before them, with the enemy slain or surrendered, covering in utter subjection, realize that now no foe, rival, or friend is left—they have only themselves, supreme, solitary, desolate, and forlorn.

—Lu Xun (1881–1936),
from "The True Story of Ah Q"

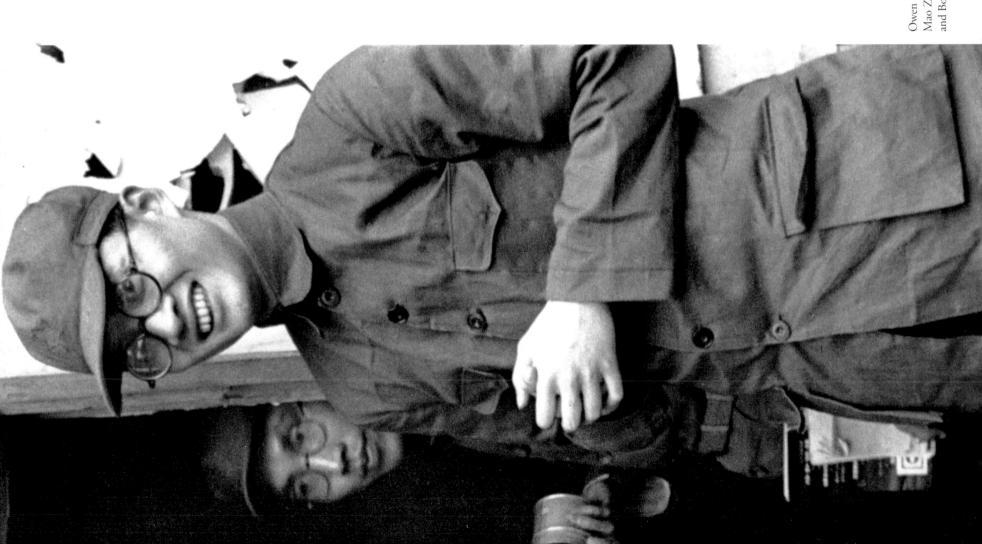

Owen Lattimore,
Mao Zedong, Zhou Enlai,
and Bo Gu, Yanan, 1937

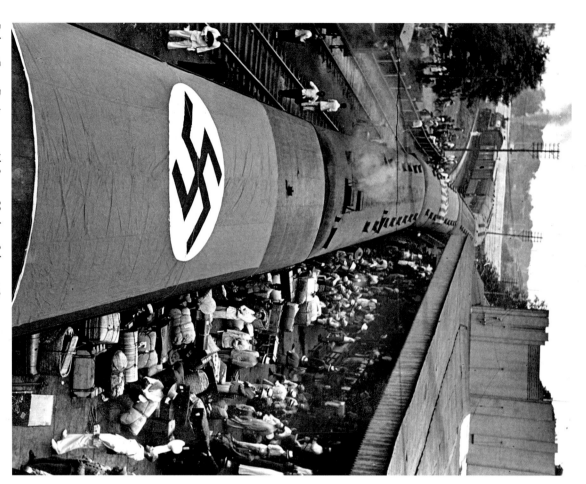

Robert Capa, During war with Japan, Hankou, July 5, 1938

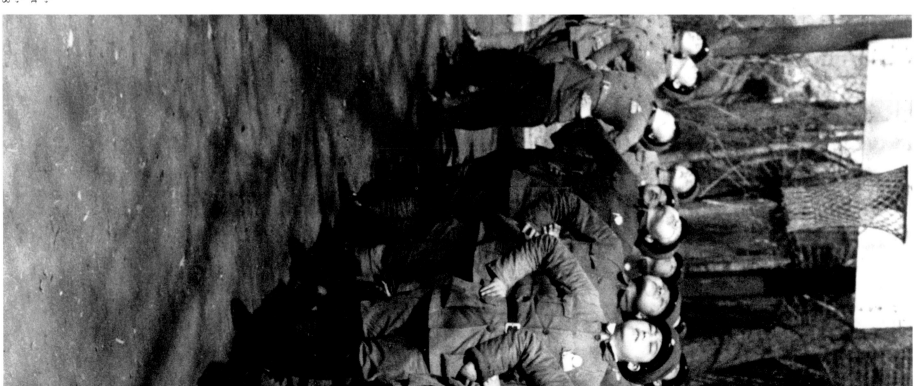

Robert Capa,
Female Nationalist
Army cadets,
Hankou, 1938

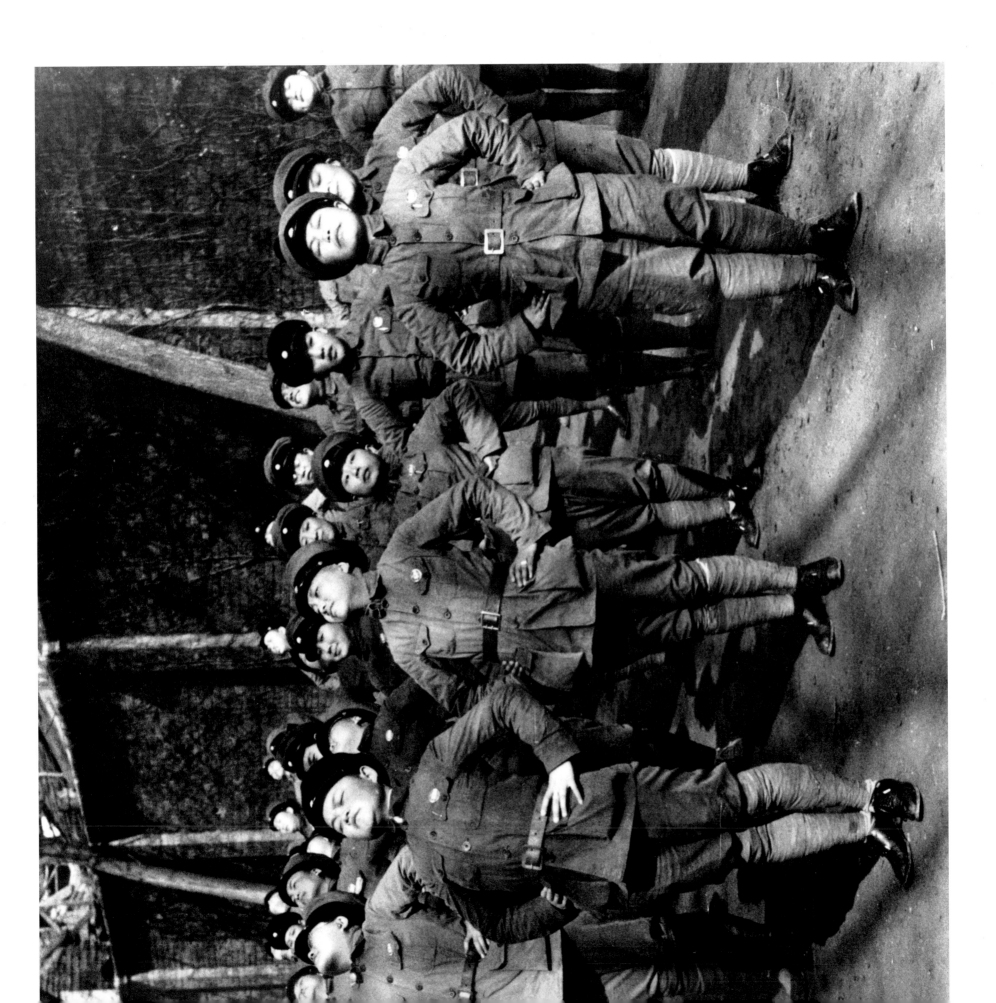

Robert Capa,
Professor Shen Jun Ru
exhorting students
to resist
Japanese invasion,
Hankou, 1938

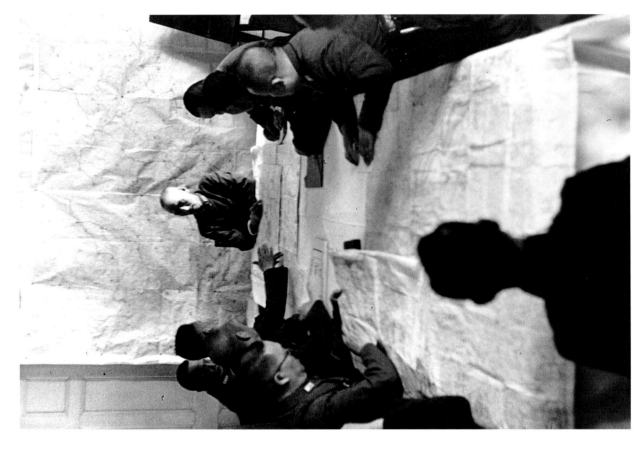

Robert Capa, Hankou, July 4, 1938

I recall the crowded years, the towering ideals,
Students together, young,
In the time of our flowering,
Spirited intellects
Quick to rant and rail,
Setting the land to rights
With stirring words

—MAO ZEDONG (1893–1976),
from "Changsha"

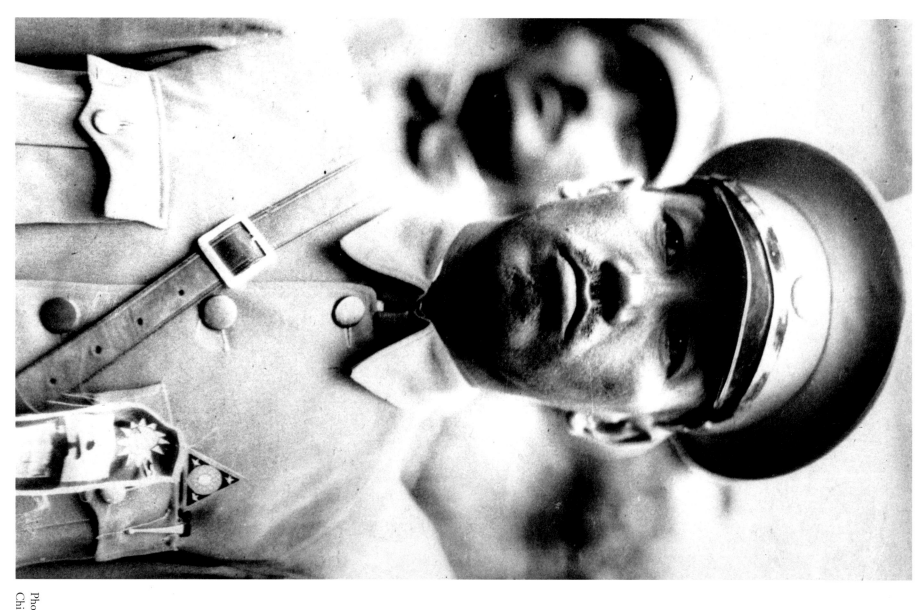

Photographer unknown,
Chiang Kai-shek, 1935

One man says, "The Future is better
than the Present."
Another says, "The Present is by far worse
than the Past."
A third one says, "What?"
Time says, "You all have insulted my Present.
You who favor the Past go back to it!
You who prefer the Future follow me
forward to it!
To the one who said, 'What?'
I have no comment."

—Lu Xun (1881–1936),
from "Man and Time"

THIS IS OUR CHINA

RAE YANG

There is an old expression in China: "Blue ocean turns into mulberry field"—transformation comes inevitably with history's movement. But that well-worn saying seems an insufficient summary of China's last fifty years—really such a small span in the country's long and eventful history—which have brought colossal changes, politically, socially, economically, and culturally.

Outwardly, the Beijing where I grew up has all but vanished. In its place stands a postmodern city ringed with beltways, studded with five-star hotels, and teeming with 1.3 million cars, making it the third most polluted city in the world. Inwardly, the beliefs of many of us who have lived through this epoch have been left shipwrecked and our values have changed. Yesterday we were all singing "socialism is good;" today, capitalism is gaining momentum and money is the central thing. The photographs in this collection are truly precious: they capture moments that became history almost instantaneously, so fast has history moved over the past five decades. During that time, we Chinese have cherished beautiful dreams, struggled hard, lost so much, and come so far, yet few can even guess at what the future holds for us. If Confucius was right when he said, "Reviewing the old, one will discover the new," these photographs may offer revelations.

Fifty years ago in China, heaven and earth were turned upside-down. The People's Republic of China was born. This historical event condensed into a single image, engraved on the memory of millions of Chinese, including those like me who were not yet born: on October 1, 1949, Mao Zedong stood at the Gate of Heavenly Peace in the center of Beijing, flanked by his comrades and friends. He declared in a high-pitched Hunan voice: "The central government of the People's Republic of China is established. The Chinese people have stood up."

These two sentences sent shock waves all over China and beyond its borders, with responses ranging from ecstasy to agony. The force of its impact would be felt around the world in the decades to come. Years later, my mother told me that Mao's announcement drew a flood of hot tears from her. She had recently graduated from Yanjing, one of China's top universities, and for my mother and most of her peers, Mao's words meant that China had finally gained its independence.

More than a hundred years of humiliating defeats, unequal treaties, and foreign occupations—from the time of the Opium Wars to the Japanese occupation—had finally come to an end. For my mother, this part of history was not merely a lesson memorized from a textbook. Her body itself was testimony: on her belly, frightful scars—they looked to us like old tree bark—were a constant reminder of how real it had all been.

In 1942, my mother had been a high-school student in Shanghai, which five years earlier had been bombed and then occupied by the Japanese. Four months later, during the Rape of Nanjing, at least two hundred thousand Chinese were massacred. These brutalities, still fresh in everyone's memory, had convinced the Chinese that they were not seen as human beings by the Japanese. One day while riding her bicycle in the street, she was hit by a car. She was refused admittance to two hospitals, where it was feared that she might die at any moment. Finally a hospital took her in, and my mother ended up spending months there slowly recovering. Her parents stayed with her day and night. But the family would not sue for liability—because the driver of the car that had hit her was Japanese. So my mother and her family swallowed their anger, paid the hospital bills with money from their own pockets, and endured the pain of that harrowing ordeal.

When my mother recovered, she decided to go to Sichuan, an area that was unoccupied by the Japanese, about eight hundred miles to the west of Shanghai. The War of Resistance against Japan was still raging, and it was a dangerous journey: the main roads were blockaded, the smaller ones infested with robbers and rapists. My mother and another young woman set off anyway; they felt they would rather die on the way and become Chinese ghosts than stay in Shanghai as stateless slaves.

The war ended on August 15, 1945. In the following year a civil war broke out in China between the Communists and the Nationalists. In three years, the Nationalists (Guomindang), led by Chiang Kai-shek, were defeated and fled to Taiwan. On the mainland, the People's Republic of China was founded and a new era began. Five thousand years of Chinese history, a torrential river, now flowed in a new direction. At

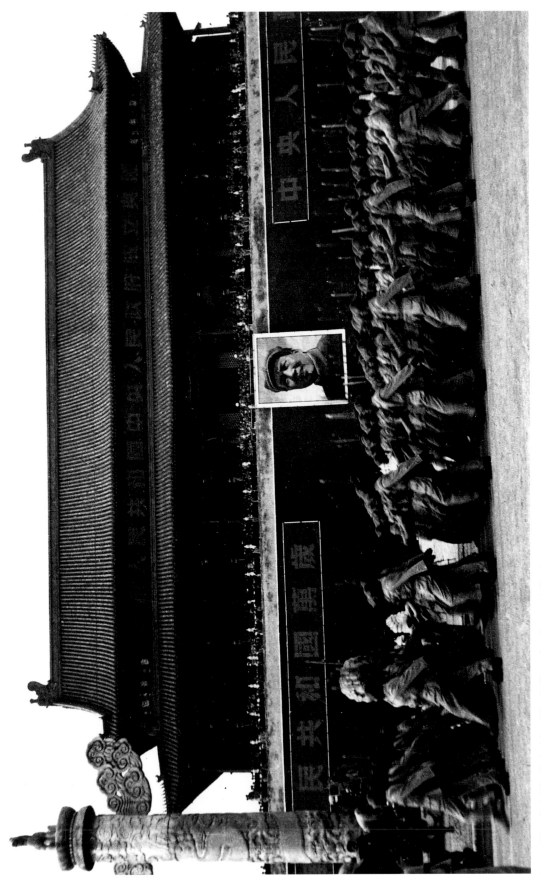

Meng Zhao Rui, The Forbidden City, Beijing, October 1, 1949

There is one sentence that can light fire,
Or, when spoken, bring dire disasters.
Don't think that for five thousand years
nobody has said it.
How can you be sure of a volcano's silence?

Perhaps one day, as if possessed by a spirit,
Suddenly out of the blue sky a thunder
Will explode:
"This is our China!"
—Wen Yiduo (1899–1946), from "One Sentence"

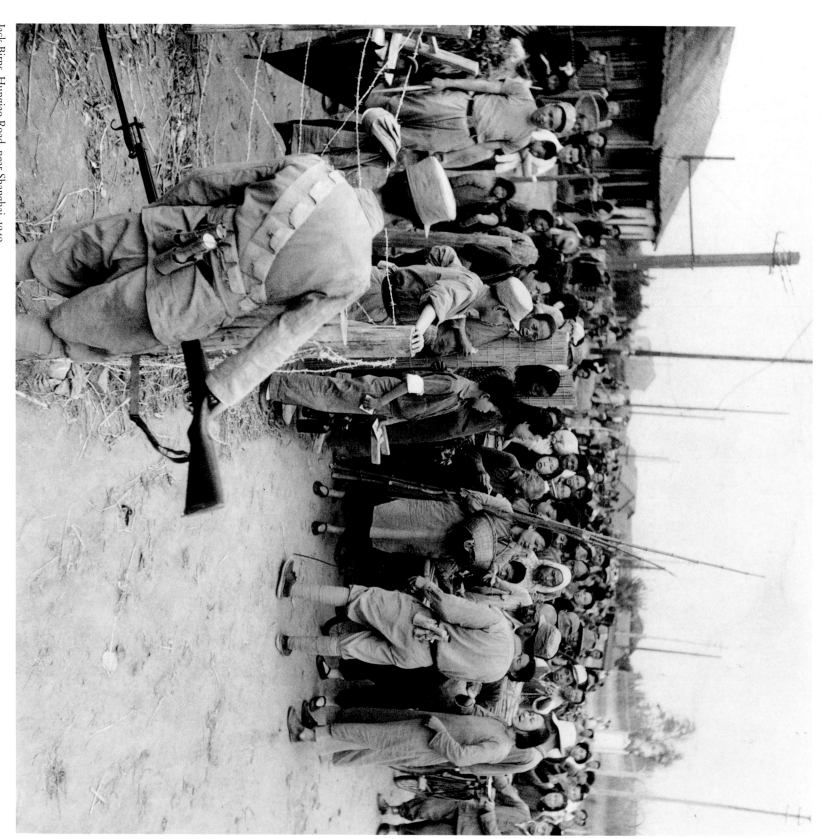

Jack Birns, Hungjao Road, near Shanghai, 1949

Sam Tata, Shanghai, summer 1949

this juncture, many Chinese felt optimistic about their future. Those who had been uprooted during the wars returned home and settled down. Many married and had children. The population, some 540 million in 1949, began to grow rapidly, and the new government did nothing to curb the growth. (In the eight years from 1949 to 1957, China added over one hundred million people to the world's population.)

My parents were among the first group to rush ahead and set up families. They were engaged in October 1949. The auspicious day they chose for their engagement ceremony was the Moon Festival. (In China, the full moon has always been a symbol of happiness and the union of loved ones.) Their wedding followed on January 1, 1950—and the following December, I came into the world, a member of the first wave of Chinese baby-boomers.

Memories of my childhood are vague, "looking at flowers in a fog," as we say. A few impressions, however, stand out vividly. One is that people around me, especially the women, liked to sing. My mother, for example, liked to sing about a sunny sky, red flowers, liberation, and socialism. Today, of course, we would see these as propaganda songs. But back then in China, *propaganda* was actually a good word—it meant something that would enlighten and mobilize the people for a good cause. The word *comrade* was the same; it carried such warmth and devotion that it was almost sacred. Who would have thought that two decades later the word had become so negative that we often used it to start a quarrel with a stranger?

My mother's voice, which I heard as a child, I can hear even today. It was cheerful and confident and it flowed from her heart. It convinced me that she, like many other people at the time, was happy about the social changes that were sweeping across China. Poor peasants took land and property from landlords and from rich peasants through the Land Reform campaign. Workers got jobs—referred to as "iron rice bowls"—which people believed were absolutely secure. The working people stood up as the masters of the country. Criminal gangs were crushed. Opium and "white powder" vanished without a trace. So did hooligans, prostitutes, and street beggars.

On May 1, 1950, a new law went into effect, banning arranged marriages and polygamy, both of which had been customary in China for centuries, making it illegal for men to take either concubines or child wives. The new law stated that men and women had equal rights, and ensured that the interests of women and children would be protected. It gave women the right to seek divorce, which was unprecedented in Chinese history.

Like a fish in water, my mother moved along with the new spirit and thinking of the times. She became the first woman in her family who dared to fall in love openly with a man of her own choice. No parental commands, no go-betweens; her marriage was her own decision. On her wedding day, she had neither dowry nor traditional bridal sedan-chair. With just a small suitcase and a proud smile, she walked with my father to her new home in my paternal grandmother's house.

Once there, she insisted that the servants call her Comrade Li Hua instead of *Da Shao Nainai* (young master's wife). This shocked and amused the old women there, lifelong servants in the household who had refused to be liberated even after 1949. They stood in front of her on their bound feet, unable to utter a word. For years afterward, the women still laughed and talked about this first encounter behind my mother's back.

Throughout the 1950s, millions of women, most of them city dwellers, began working side-by-side with men. "Equal work, equal pay," and "Women hold up half of the sky" were the new maxims. The majority of these women did not even have high-school diplomas, so they became textile workers and shop attendants. Their wages were low, but having that income was very important. Aside from the much-needed additional purchasing power, the theory of the time was that women's equality with men was based on their financial independence. This theory made sense to a lot of women in China. Before this era, women had been expected to "obey fathers before marriage, obey husbands after marriage, and obey sons after the death of the husbands," because unless they were widowed, with small children, they had no independent legal, social, and financial status.

As for my mother, she was a professional. First she worked as a translator in the Chinese consulate of Berne, Switzerland, later as a college professor in Beijing. These jobs brought her respect and a good income. She attributed all of her success to the new society. So, in my memory, she was a lot more enthusiastic about liberation than my father, who had joined the Communist Party during World War II; in the 1950s, however, he shifted his interest to photography, Western classical music, collecting antiques, and playing *Go*—none of which seemed very revolutionary.

Years later it occurred to me that my mother's good fortune in the new society was largely due to the fact that she had graduated from Yanjing University. (With her bourgeois family background, if she had tried to go to college in the early sixties, I doubt that she would have been admitted. Many high-school graduates who did well in

entrance examinations in those years were rejected because they were not from working-class families.) So shouldn't she give at least some credit for her success to the Nationalist government and Chiang Kai-shek? My mother died in 1976, during the Cultural Revolution, and I never had the opportunity to ask her that question. But I think I know what her answer would have been. Like many of her contemporaries, she was convinced that the Guomindang was corrupt to the core and Chiang Kai-shek was a ruthless dictator. Under his rule, the Chinese economy went bankrupt and many people, scholars included, were jobless. Of course, my mother did not live long enough to witness the new corruption and unemployment in the 1990s.

With my mother busy working, my two younger brothers and I were brought up by a woman we called *Erji*—Aunty—who was not a real relative but our nanny. She joined our family when she was forty-six, shortly before I was born, and stayed with us until she died in 1978. Aunty's singing, like my mother's, left a deep impression on me. When she sang, it was always in a small voice, as if she were singing just for the two of us. Aunty knew only one song, "The North Wind Blows," from a movie called *The White-Haired Girl*. The film's story was about the suffering poor peasants in the "old society." Because Aunty's life had been very hard before 1949 (her husband died when she was still in her twenties, leaving behind no money, only two small children for her to raise alone), the story moved her to tears, as it did millions in China at the time. The film's popularity fueled violence toward landlords and their families during Land Reform. Over the next three decades, these people became targets of everyone's hatred, even those who were born after 1949, were often called "small Huang Shiren" (the name of the landlord in the film) and were ostracized. The image of the evil landlord, put into my head by the film and Aunty's singing, stayed with me for many years.

But Aunty's revolutionary spirit always ran dry after this one song. Most of her singing and talking revolved around the old Peking Opera. To her, each opera was like a precious jewel which she collected in her "flower-like" years. The first three decades of the twentieth century were the golden age of the Peking Opera. Famous actors such as Mei Lanfang, whom the theater fans in old Beijing called *Juer* (Star) took the city by storm. All kinds of people, men and women, rich and poor, packed into the theaters—and most of the audience already knew the operas by heart. In the 1920s, my grandfather was the owner of the Jixiang (Auspicious) Opera House at Wangfujing (a first class resi-

dential and shopping area east of the Forbidden City) of a thriving business that brought him nine hundred silver pieces a month. In the 1950s, Aunty took me to this theater to see some of the Peking Operas. I was too young, and had no patience for the singing; I only cared for the acrobatics. Over time, however, I came to understand the stories and the morals taught by them: loyalty and righteousness for men, purity and fidelity for women, filial piety for sons and daughters, and devotion for friends. These traditional values were part of my upbringing, and they were exemplified by Aunty, who remained true to her dead husband for forty-eight years.

Another very clear memory from my childhood is that of my grandmother's house. It was a typical traditional Beijing *Siheyuanr* (square, walled compound), also located at Wangfujing. Three gray brick bungalows, with traditional rice-paper windows and rain-verandas, faced south. A fourth faced the north, with a porch leading to the street. In the 1950s, this compound housed our entire family. Three generations lived together, under the benevolent reign of Nainai, my paternal grandmother. As a child, I didn't mind at all that my family shared the last bungalow with my uncle and his family. My two male cousins, Xiao Niu (Little Oxen) and Xiao Qiang (Little Dragon), who were about my age, were my round-the-clock playmates. In the middle courtyard, Nainai and Third Aunt grew tree peonies and roses among *Tai Lake* rocks, which had round holes in them. They lived in the bungalow facing this perpetually beautiful courtyard garden. My maternal grandparents and my mother's younger brother, who had just moved to Beijing from Shanghai, were housed in the first bungalow facing south, the family guesthouse. Two of the old serving women made the bungalow facing north a comfortable home for themselves.

It was in this house that I spent the happiest days of my childhood. During the week our parents were so busy they never bothered us; we children had all the time in the world to play. The older women gave us a lot of love and attention, and we were equally attentive to them. When they thought of a story or anecdote (including the one about Comrade Li Hua), there was always someone who was willing to listen and laugh with them. And through their stories, my childhood was filled with magic. We learned that the Milky Way was a vast river in the sky, separating two lovers: the Weaving Girl (Vega) and the Ox Boy (Altair). And the moon was not the earth's satellite, but a land with a gigantic cassia tree, and a palace where there lived a beautiful lady named Chang'e, who had lived through countless adventures. The old people could never agree on the ending to Chang'e's

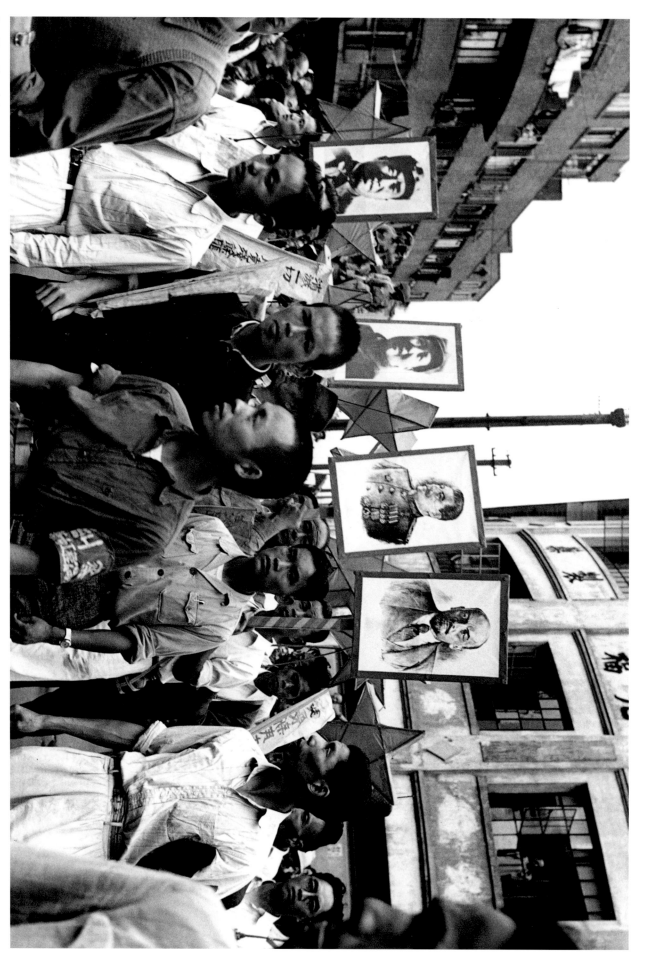

Sam Tata, Shanghai, summer 1949

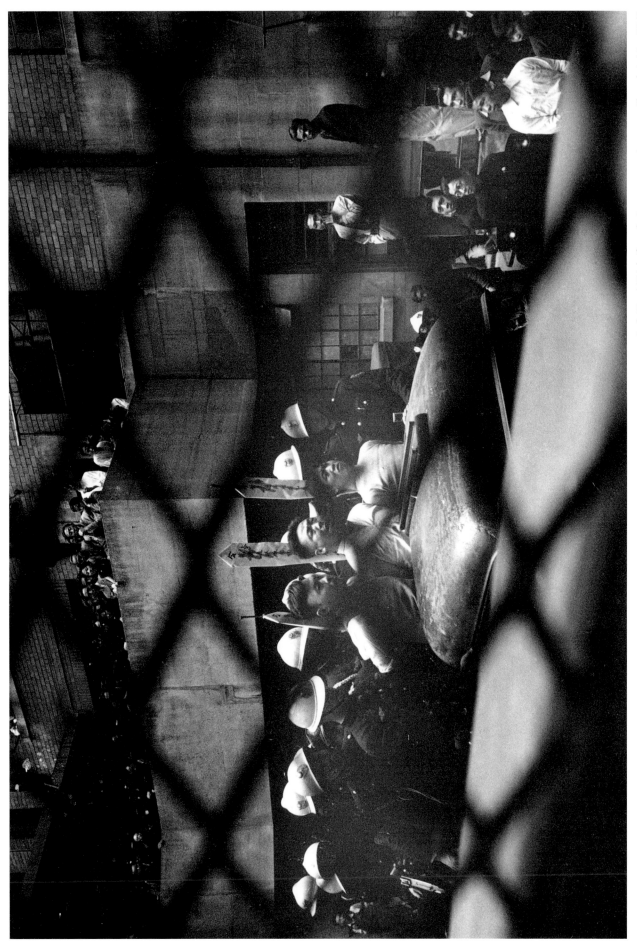

Jack Birns, Trial of revolutionary committeemen, Shanghai, May 1949

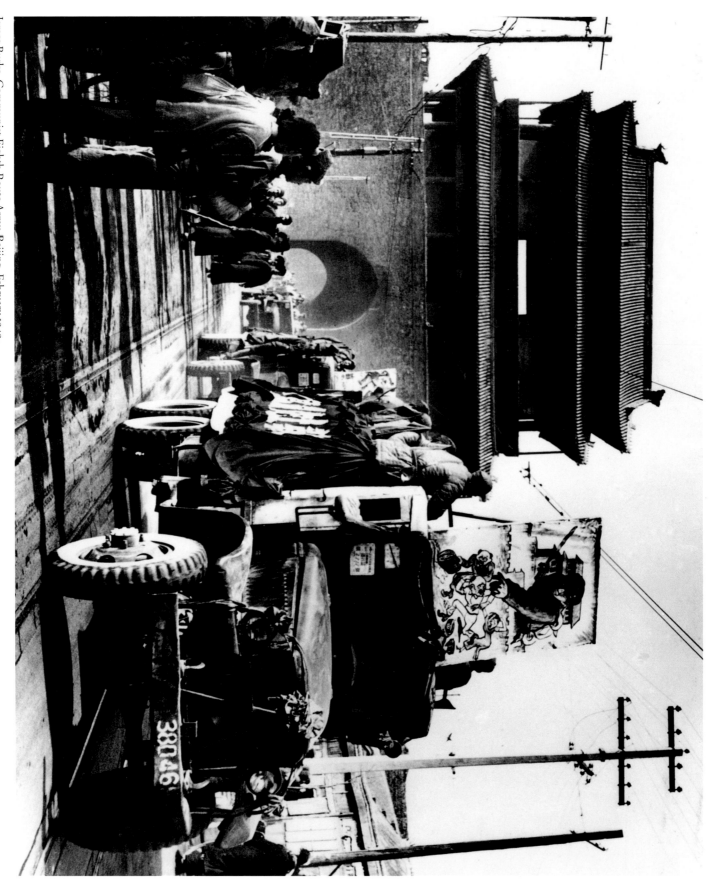

James Burke, *Communist Eighth Route Army, Beijing, February 1949*

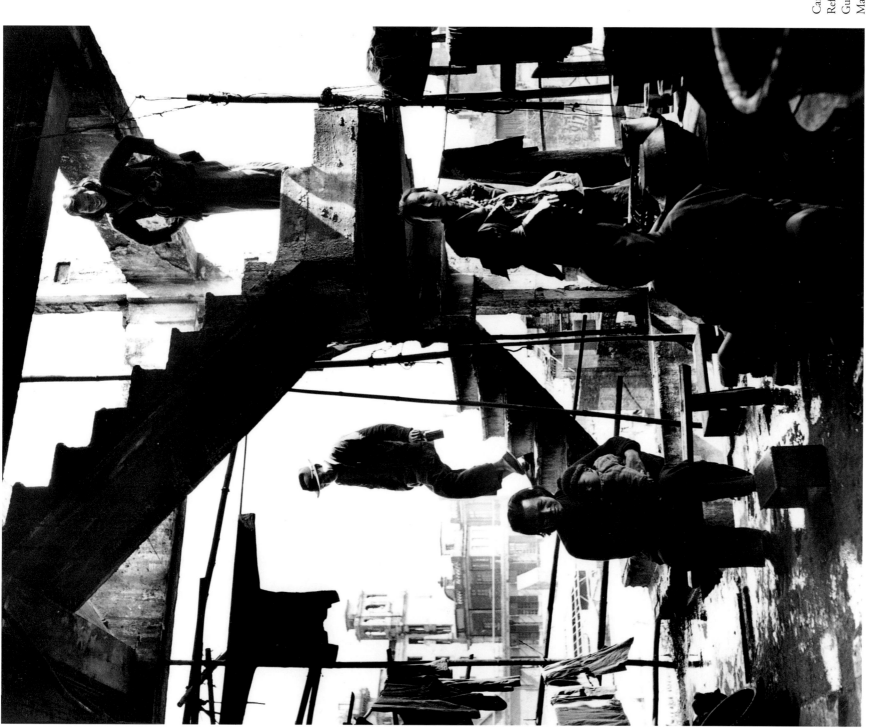

Carl Mydans,
Refugees, Guangzhou,
Guangdong Province,
March 1949

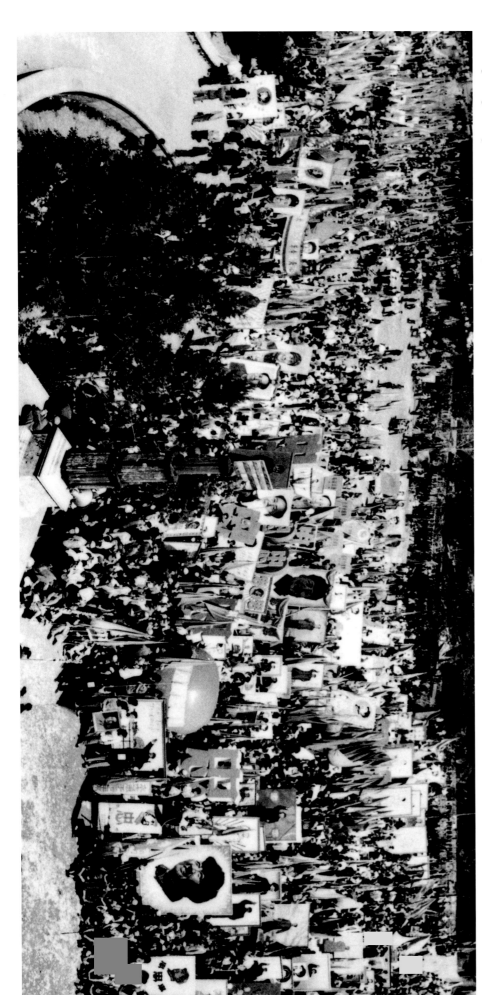

story—an old servant named Lao Nainai said that she turned into a ugly toad, while Aunty said that she remained a beautiful woman, but was very lonely in the Moon Palace. And Nainai just smiled and refused to take sides.

During Chinese New Year, we always went to Changdian, a famous marketplace downtown, where we bought colorful pinwheels and long sticks of red haws coated with crystal-clear "ice candy." Moving from one vendor to another among a huge crowd, we filled our bellies with all kinds of snacks. I remember one year, on our way home, we walked along the ancient city walls. A few snowflakes fluttered down from the sky ever so slowly, as if in a dream. I looked up. The gray city wall and a nearby tower gate stood tall and magnificent against the winter sky. To the other side there was a sea of tiled roofs and walled courtyards with leafless trees. This scene has stayed with me: the exquisite harmony of Beijing's colors, the beauty of the city as it was then.

Li Zheng Sheng, *Giving devotion to Mao Zedong*, Harbin, Heilongjiang Province, 1968

Looking back on it, I realize that the 1950s were actually not all bright sunny days and flowers like exquisite brocade. My family had its troubles, like any other family. But the feelings I had—of happiness and a sense of security—were very real. Little did I know that like so many children in China, my family was shielding me in those years. When political campaigns hit home, the adults absorbed the impact and tried their best to protect the children. So we were often unaware of what was going on. I did not know, for example, that in 1954 my family lost control of its businesses, the Jixiang Opera House and Fu He Xiang, a silk store at Wangfujing, through a nationwide campaign known as *Gongsi Heying* (Public-private Joint Operation). The following year, *Gongsi Heying* was replaced by *Dingxi* (Fixed Interest), a program under which the government took away all big businesses from private owners and turned them into state-owned enterprises. By 1955, "socialist transformation" had been accomplished in China without much resistance from the owners.

This downturn in our fortune did not worry my family, though. At that time, people assumed that in the future all enterprises in China would be "publicly owned," and that the new society would be entirely egalitarian. All adults would work to make a living; no one would be allowed to get fat by sucking the blood and the sweat of others. And a socialist system would guarantee the welfare of everyone. Even Nainai, the head of our extended family, accepted the change. Seeing that her children were well-educated professionals, she did not think that they would have difficulty supporting their families. No one could have foreseen that private ownership would return to China in three decades, and that today once again the gap between the rich and the poor would be widening.

If the loss of family businesses in 1955 did not cause people much grief, the Anti-Rightist Movement in 1957 was a different story. When that campaign roared through China, between five hundred thousand and a million intellectuals were labeled "Rightists" for crit-

icizing the Communist Party. My two uncles were among them. Although my mother's brother was allowed to stay in Beijing, my father's brother disappeared from Nainai's house. Years later I found out that he had been sent to a labor-reform farm on the bank of the Bohai Sea, where he stayed for twenty-two years, branded an enemy of the people.

The Anti-Rightist Campaign was a heavy blow that finally broke up my big family. First, my two uncles were divorced by their wives. Then my parents, under mounting political pressure to draw a clear line between themselves and their bourgeois families, moved out of Nainai's house. My childhood was over. But I was luckier than my two cousins, who had a broken family and years of discrimination to deal with. Fortunately for them their mother decided not to move out of Nainai's compound. Over the next twenty years, she never had another husband or boyfriend, and devoted all her time, energy, and love to her sons. Nainai and Third Aunt did all they could to encour-

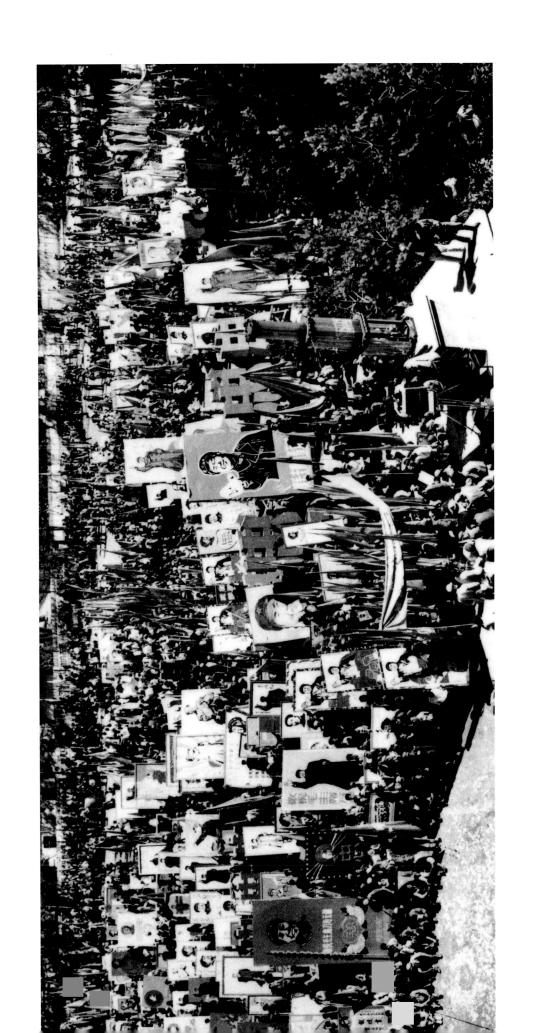

age and help her through the famine of 1959 to 1961 and ensuing political campaigns.

Though the Anti-Rightist Movement directly affected less than one percent of the population, its influence was far-reaching. There was an important lesson for the intellectuals: many who had been outspoken when Chiang Kai-shek was in power now thought that in the new, ostensibly more democratic society, they would be free to criticize the Communist Party and its poorly educated cadres. They were wrong. The old saying "Diseases go in by the mouth and disasters come out of the mouth" took on new meaning; everyone had to watch what they said.

So when the next campaign, the Great Leap Forward, gathered momentum in 1958, few dared to question it. Everybody participated actively. Working day and night, many people built backyard furnaces in an attempt to boost China's iron and steel output, while others built reservoirs to improve irrigation. Even schoolchildren got involved. For three exciting days, my schoolmates and I joined hundreds of thousands of people all over Beijing, standing on the roofs, beating pots and pans, and yelling whenever we saw a trace of any little bird. This was part of a campaign called "Get Rid of the Four Pests" (rats, sparrows, flies, and mosquitoes). On the second and third days, sparrows began to fall from the sky, exhausted or scared to death. So did all kinds of other birds. For a few months, we all ate at communal dining halls to cultivate the collective spirit. Then, in 1959, famine set in. Suddenly food was in such short supply that it was rationed according to one's *Hukou*, or registration of permanent residency. The ration was less than thirty pounds of grain and hardly anything else per person per month for those who lived in cities. Most people chose to make the best of their rations at home rather than risk sharing them at the public dining halls, where the cooks never seemed to go hungry. Everyone in the cities was soon feeling the strain. China's peasants, not covered by the rationing, fared much worse. In the wake of the Great Leap Forward, between 1959 and 1961, an estimated thirty million peasants starved to death in rural China. This was a disaster unprecedented in the entire history of the country. At the time, most people who lived in the cities had no idea of what was going on in the country. For nearly ten years, I believed the official version of the story that we had seen in the newspaper: "Despite natural calamities, not a single person has starved to death in China. This in itself is a great victory."

In 1968, I went to Manchuria and became a peasant myself. It was then that I found out what had really happened. During the Great Leap Forward, People's Communes had mushroomed, each encompassing several traditional villages and hundreds of households. Peasants lost control of their land; they also lost control of their lives. When local officials reported grossly inflated yields to please the higher-ups, a commensurate tax grain was collected accordingly. Little was left in the village for the peasants to eat. Even so, the peasants did not revolt, nor were they allowed to flee the famine and beg in city streets, as they might have done in earlier times. Instead they died like flies, and few in the cities were aware of it.

In Manchuria I realized for the first time that the government had been lying to us. I began to wonder if my parents really had not known about this. After my mother died, my father finally told me that back in 1959 she had come close to being labeled a Rightist for trying to tell the Party that the local officials were lying. That experience must have terrified her. Afterwards she never dared to tell the Party anything. If she saw something wrong, she suspected herself. This was what she told me: "You must never doubt the Party. The Party is always right. Chairman Mao never makes mistakes." And I think she was sincere when she said it.

That was the way we all believed: Mao was *always right*. My generation worshiped him. When he said: "It's right to rebel," I joined the Red Guards in 1966 and took an active part in the Cultural Revolution. First we criticized our teachers and the school principal. Then we rushed out to demolish the "Four Olds" (old ideas, old culture, old customs, and old habits) wherever we could find them. Later we tried to "pull capitalist-roaders down from their horses" —to seize power from the government officials. Subsequently, factions inevitably formed and Red Guards began to fight with one another. This went on until Mao sent all of us to the countryside to reform ourselves.

From 1968 to 1973, I worked on a pig farm. This was a turning point in my life. I was a peasant with a rural *Hukou*. The local officials treated me and the other peasants like dirt, and I began to see the history of new China in a very different light. Looking back on the Cultural Revolution, I realized what a disaster it had been: so many people had been persecuted, including Nainai, who ultimately died in a cold, windowless storage room after her house had been seized by a horde of "revolutionary masses." All over China, priceless works of art and cultural relics were destroyed—set on fire, smashed

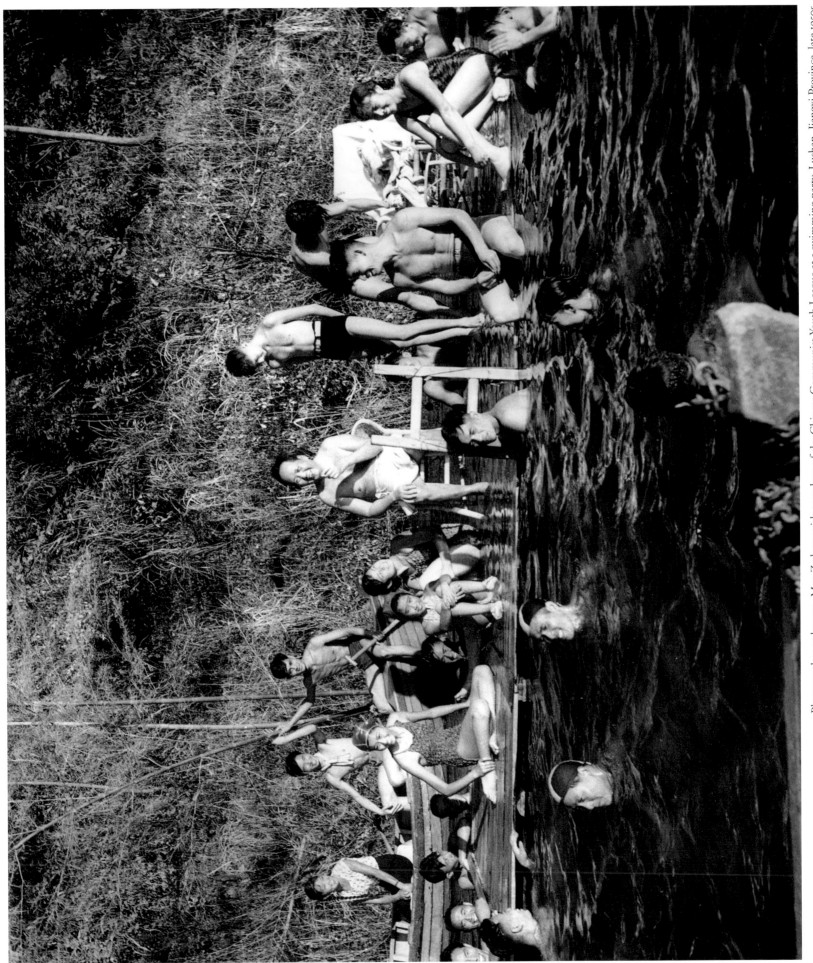

Photographer unknown, Mao Zedong with members of the Chinese Communist Youth League at a swimming party, Lushan, Jiangxi Province, late 1950s

to pieces. Famous artists and intellectuals were brutally beaten; some committed suicide. Countless families were torn apart: scholars, officials, writers, and artists were sent to "May 7th Cadre Schools" located in remote rural areas. My parents were among those sent off. To a large extent, my generation was responsible for this. Our unquestioning faith in Mao and our feverish efforts to reform China had thrown the country into chaos and caused many tragedies. Now we were stuck in the countryside, haunted by deep feelings of guilt and remorse.

The early- and mid-seventies were, for me, one long, bone-piercingly cold winter. Political power was in the hands of a group of radicals who plainly did not care about the people. Day in and day out newspapers and radios told those absurd, hated lies: "The revolutionary situation is great all over the country! The masses firmly support the Cultural Revolution! The educated youths are growing healthily in the vast world of the countryside!" Officials everywhere abused their power and opened back doors for their friends and relatives. The ordinary people lived in fear. At any moment, you could be labeled a counterrevolutionary. A slip of the tongue, or the pen, a smear in an old newspaper, even things spoken in a dream could land you behind bars.

Once, on the farm where I lived, a "counterrevolutionary incident" erupted, which implicated a great number of peasant women. These women had always stuck their needles into the wallpaper after sewing. Having no money to buy wallpaper, they used old newspapers instead. During the Cultural Revolution, Mao's pictures were all over the newspaper. So when the women's homes were raided in the middle of the night and the walls scrutinized, many were found guilty of viciously attacking the great leader by sticking needles into his face, body, and even his eyes. These women were then detained in a makeshift, lice-infested prison in the village, to learn their lesson.

Such incidents terrified everyone, and the fear lingered on even after the Cultural Revolution officially ended in 1976. The photographs by Antonín Kratochvíl in this collection, taken in 1978, capture the feeling of isolation so widespread at that time: tense, mirthless faces in the street, even the children are somber. The images are powerful reminders of the loneliness and despair that people felt back in the 1970s. Every day I asked myself why I continued to live and labor for a cause I no longer believed in.

By the mid 1970s, the Cultural Revolution was taking a toll on many families. My mother suddenly died in 1976. No one knew the

Rolf Gillhausen, Steel furnaces, Fashun, Manchuria, early 1960s

cause of her death: the small town of Jixian in Hebei Province, where she had been forced to stay, did not have a hospital. Two years later, old Aunty collapsed and died. Before that, she had been looking after my two younger brothers in Beijing. She had offered to do so when my parents were ordered to go to May 7th Cadre School in 1969. If my brothers stayed with her, they could keep their Beijing *Hukou* and get a much better education. But taking care of two teenage boys in those chaotic years, without any amenities at all, was too much work for the seventy-year-old woman, and she died just as things were beginning to change for the better.

Even with these great losses to our family, 1978 seemed to me like a new season. Deng Xiaoping emerged as a symbol of hope that the

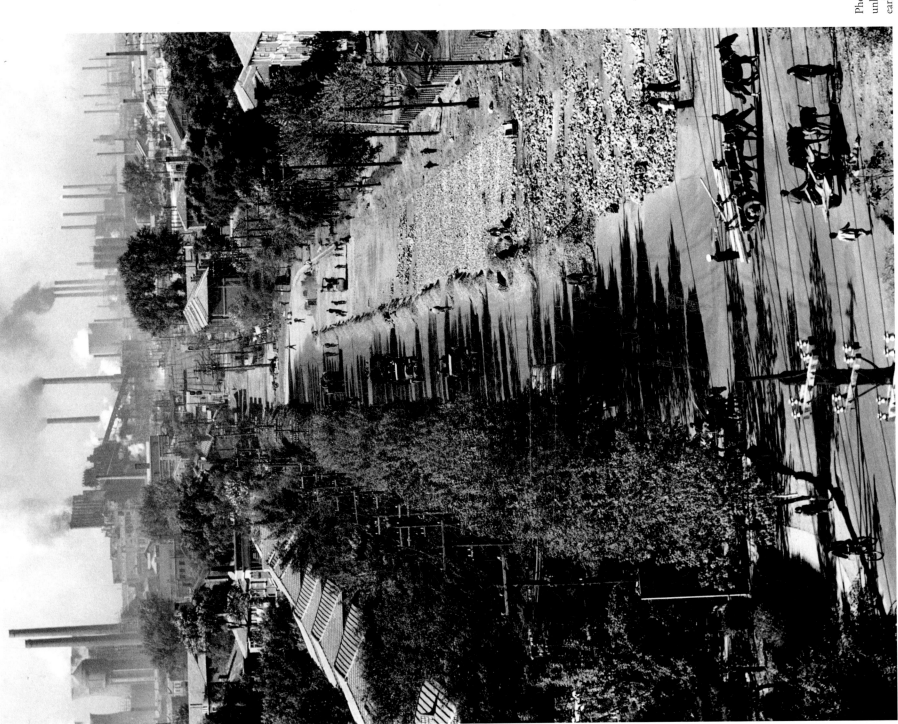

Photographer
unknown,
early 1960s

radical policies that had been in place for ten years might be reversed, and everybody's life would return to normal. Hua Guofeng, on the other hand, Mao's official successor, insisted that everything Mao said and wrote was correct. A power struggle was going on at the top, and side-street news traveled fast. As for the official newspapers, by now we had all learned to read between the lines.

For people of my generation, our strongest desire at the time was to go back to school. In the twelve years since 1966, our hands had not touched a textbook. We worried that it was too late. For a few years, I had a recurring dream: I am standing at a bus stop. I wait and wait, but somehow the bus does not come. Nobody else is in sight. Then the sun sets; shadows are spreading. Suddenly it dawns on me that I have missed the last bus. Recently, I told this dream to Han Shaogong, now a well-known writer in China; he told me that for a few years he too had dreamed of missing the last bus, and that he had stopped dreaming it in the mid eighties—as I had, too. I wonder how many others were having similar nightmares in that period.

In February 1978, universities and colleges in China welcomed the first wave of students since 1966 to be chosen through competitive entrance examinations. This practice had been suspended, and most high-school graduates in China had gone to the countryside. Now we were back. Some of the students were as young as eighteen, others were over thirty. Everyone was highly motivated—we treasured the opportunity to study. Sharing a small dormitory room with seven others and eating boiled cabbage at the student dining-hall did not bother anyone. We absorbed knowledge like starving people devouring food. Liu Heung Shing's 1981 photograph of young people studying in Tiananmen Square at night evokes the excitement of those years.

Many of the professors had just come back from the countryside themselves, and they immediately fell in love with this unusual group of students. My father was one of those professors; I know that he and others spent huge amounts of time preparing each lesson. The relationship between teachers and students had never been so close. One Peking University professor described it this way: "I love to teach you. When I stand at the podium, I feel like I am the conductor of a symphony orchestra: at all the places where I feel you should have a response, you give me a knowing smile. This feeling is marvelous."

Along with the change in college admissions, other radical policies were reversed. In the late seventies, more than ten million educated youths returned to the cities. At the same time, the Rightists were rehabilitated. After twenty-two years at the labor-reform farm, my uncle finally came back to Beijing and remarried his ex-wife.

I came back to Beijing in May 1978. By the fall of that year, I was an English teacher in the graduate school of the Chinese Academy of Social Sciences, and most of my students were older than I. The next year, I became a graduate student myself, studying in the journalism department of the same school. My teacher was an American woman (this would have been unimaginable just a year before) who was younger than I. In class, she and other American teachers talked constantly about investigative reporting and coverage of the Watergate scandal. In the department reading room, we read every issue of *Time*, *Newsweek*, and *U.S. News & World Report* from cover to cover. Even more popular than these magazines was the "Wound Literature," by writers who broke the taboo of describing the suffering of someone during the Cultural Revolution or the Anti-Rightist Movement. We students fought over magazines that carried such stories; after a hundred or more of us had read the same issue, it would become dog-eared and fall apart—but it would continue to move people to tears, and spark lengthy, heated discussions.

When winter arrived, my friends and I started to spend a lot of time at Democracy Wall. In the past, this gray brick wall in downtown Beijing had never attracted anybody's attention. In November 1978, posters appeared on it, which drew a crowd. Then more posters arrived, voicing people's grievances and discussing reforms. Occasionally there was poetry, which used the language so differently from the official literature that it stunned and stirred all of us. There were also requests and demands, such as those made by one hundred thousand young people in the Yunnan Production and Construction Corps on the southwest border: after ten years, they wanted to return home, but the government was reluctant to let them go. We were all sympathetic to their plight; when they finally won, we were exuberant. We felt such freedom at the Wall that we called it "China's Hyde Park." That winter the weather was unusually cold and snowy. But in everybody's chest, a bowl of fire was burning.

Soon, like-minded people—such as the "vague poets" (so called by the literary establishment, who deemed their work incomprehensible) and the "star painters" of Beijing's avant garde art world—began to form small associations. Unofficial magazines were published, with texts mimeographed on poor-quality paper. But these were *Min-ban* (privately operated) magazines, and that made all the difference; in the previous three decades, all media in China had been run by

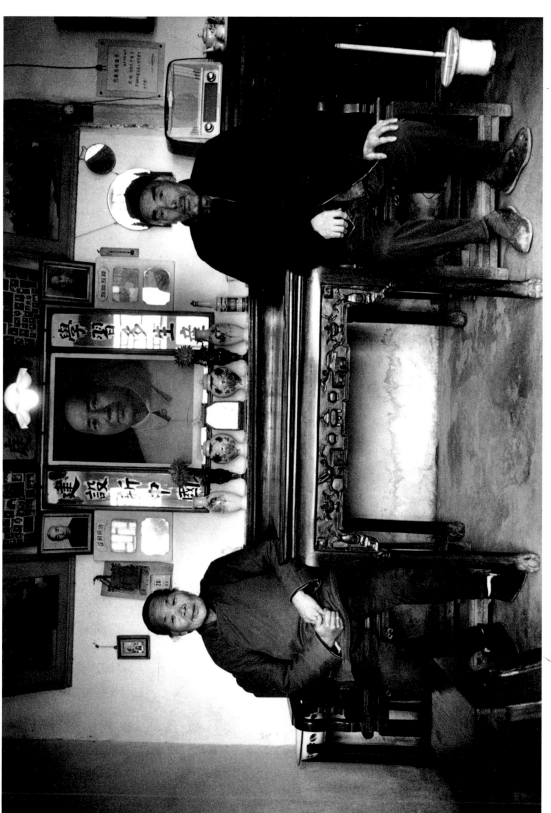

René Burri, Traditional Chinese family in their living room, Beijing, 1964

the government. *Today* was put together by the young poets (my brother Yang Lian among them). A better-known magazine was *Explorations*, in which Wei Jingsheng wrote that China needed a fifth modernization—democracy—in addition to the four modernizations already advocated by Deng Xiaoping (industry, agriculture, defense, and science/technology). For this, Wei Jingsheng was framed, accused of selling military secrets to foreigners, and sentenced to fifteen years in prison.

Deng Xiaoping took advantage of the surge in the democracy movement in 1978 to seize power from Hua Guofeng. As soon as he was in charge, however, he began to crack down on democracy. First the

Wall was moved to Yuetan Park, where few would see it. By the end of 1979, Deng banned it altogether. *Minban* magazines stopped publication one by one. Young poets and artists were harassed by the police, and so were other Wall activists.

What had seemed like the beginning of a new spring for China slipped away. Deng Xiaoping appeared to be yet another dictator. But times had changed and my generation had grown up. Because of our disillusionment and remorse in the Cultural Revolution, we could no longer put blind faith in leaders. Instead, we had learned to see things with our own eyes and think with our own heads. If Deng Xiaoping thought that by starting a war in Vietnam he could

René Buri,
Three generations live
together in Beijing, 1964

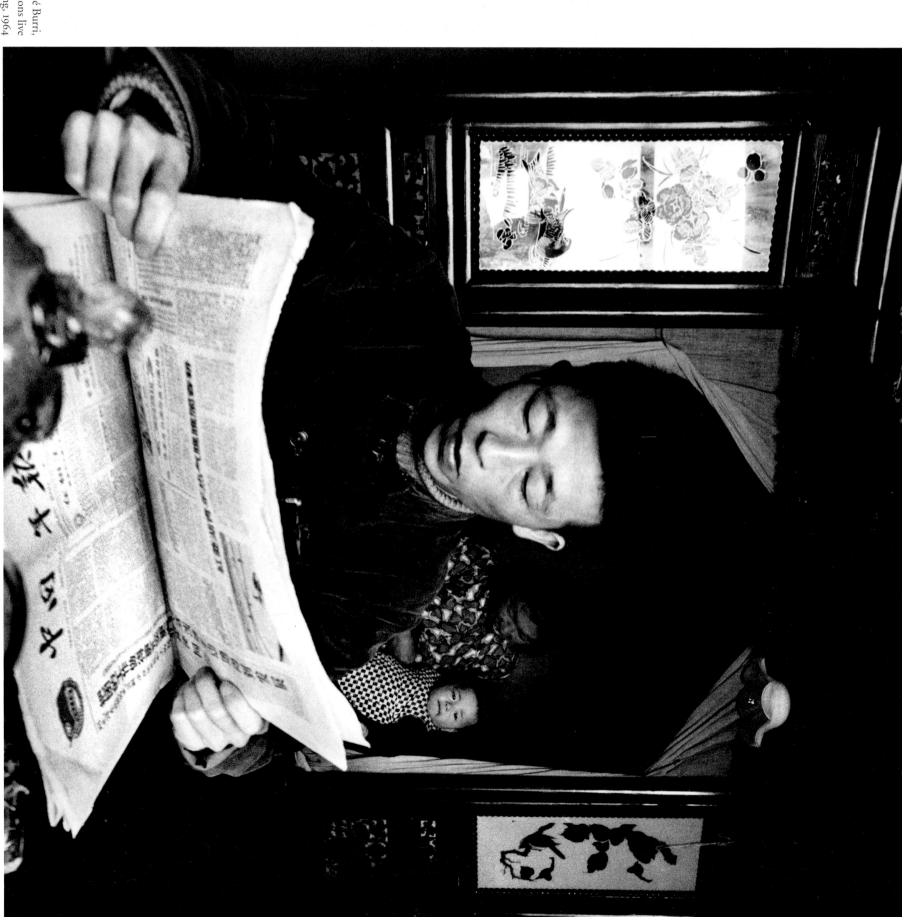

re-create the same blind patriotism that Mao had stirred up with the Korean War, so that we would forget our pursuit of democracy, he was wrong.

I took no action at the time, however; I was not as courageous as Wei Jingsheng. Fifteen years in a Chinese prison under "proletarian dictatorship" was no joke—yet "fifteen years" could not convince me that Deng Xiaoping had the right to do what he had done to Wei Jingsheng, the *Minban* magazines, and Democracy Wall. I was deeply resentful. At the same time, I began to worry about my own future. In this changed political atmosphere, journalists again became mouth-pieces of the government. After I graduated, would I be willing to tell lies for the government? If not, what would be the consequences? Fortunately, by 1980 there was a new option: Deng Xiaoping's "Reform and Opening Up" policy allowed Chinese students who had schol-arships to study abroad. So I went to the United States to study for a PhD in comparative literature.

Throughout the 1980s, Deng Xiaoping cracked down on writers, artists and students through the "Anti-Spiritual Pollution" campaign of 1983; then came, in 1985, the "Anti-Bourgeois Liberalism" cam-paign. Yet during that time, writers and artists had broken one taboo after another. Whoever did so became an instant hero. In early 1987, after thousands of students demonstrated in Anhui province and Bei-jing, Hu Yaobang, an enthusiastic reformer, was forced to resign as the general secretary of the Chinese Communist Party. In the mean-time, famous dissidents such as physicist Fang Lizhi and *People's Daily* reporter Liu Binyan were expelled from the Party. Then in April 1989, Hu Yaobang's sudden death triggered large-scale student protests in Tiananmen Square. On June 4, the army moved in on the demon-strators, spilling the blood of innocent people.

While cracking down on democracy movements, Deng Xiaoping did initiate some political reforms during his time in power. By the mid eighties, he had urged nearly all the poorly educated cadres from the old days into retirement, while promoting younger and better-educated people to leadership positions. The economic reforms Deng Xiaoping carried out were very bold and soon became irreversible. The first changes occurred in the rural areas. As early as 1978, Wan Li (in Anhui Province) and Zhao Ziyang (in Sichuan) allowed peas-ants to divide up the land and take charge. Over the next few years, the whole country followed suit. People's Communes collapsed every-where. The "Responsibility System" was established, which allowed peasants to decide which crops to grow, but prohibited them from

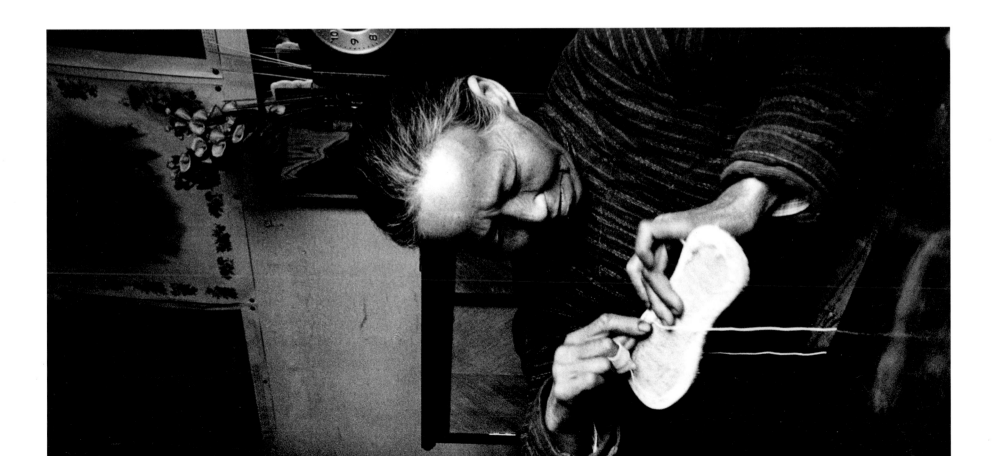

selling their land. After paying a reasonable tax grain, they were free to keep or sell the rest of their harvest and its by-products. This reform unleashed tremendous amounts of energy and ingenuity in the countryside. People worked in the fields from daybreak until sundown. Every inch of farmland was utilized to its fullest extent; even the roads were borrowed for the harvest.

In many ways, China was moving forward under Deng Xiaoping. As free markets sprang up all over the country, many peasants shook off poverty and made money by raising ducks and chickens. These used to be called "capitalist tails," which were "cut" (confiscated) during the Cultural Revolution. Other people grew vegetables or bred fish. The economy of the country came to life. In the cities, workers saw their income levels, which now included substantial bonuses and awards, rise faster than those of scholars. In the 1980s, a secure job in a state-owned enterprise was the dream of most young people.

Although from 1980 to 1990, China's Gross Domestic Product (GDP) grew an average of 10.2 percent each year (according to the World Bank), still not enough jobs were created to accommodate everyone—China's population was growing even faster than its economy. By the early 1980s, despite the fact the government had been trying to control the population since 1972, there were more than a billion people in China. By 1990, the population had grown to 1.14 billion, and experts predict that by the year 2000 China's population will exceed 1.25 billion. To cope with unemployment in the 1980s, the government encouraged people to "jump into the sea" (become self-employed). Soon restaurants and hair salons opened up in back alleys. "Shanghai tailors" (rarely with Shanghai accents) made clothes for people in shacks and basements in every neighborhood. All kinds of vendors appeared on the street selling books, flowers, antiques, toys, clothes, cigarettes, and newspapers. Many made a fortune, by Chinese standards, in just a few months.

With the money made in factories and at the marketplace, people were able to purchase luxury items, such as the color television seen in Eve Arnold's 1979 photograph. It was on televisions like that one that millions of Chinese watched live coverage of Deng Xiaoping's historic visit to the United States early the same year. By that time a relative of mine had just purchased a color TV, so I went there and watched it with a group of friends. Suddenly a night scene of Manhattan jumped into view: Skyscrapers stood like a forest; a myriad of bright lights; helicopters flew through the sky; cars flowed through the streets like a torrential river. Headlights were white. Taillights were

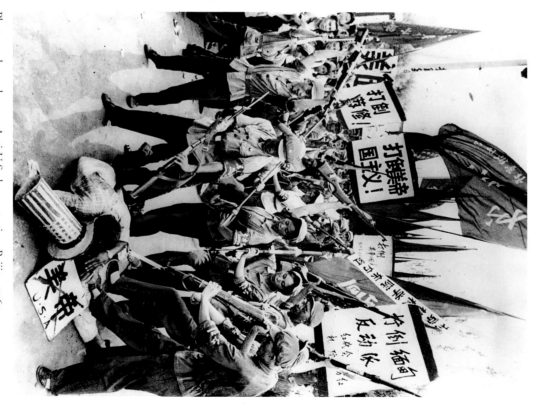

Photographer unknown, Anti-U.S. demonstration, Beijing, 1967

red. Neon signs flashed as in a wild dream. . . . Everybody in the room was breathless. "Is that what capitalism is like?" we wondered. "Wow, it doesn't seem so bad."

The image of New York stayed on the television for less than a minute, but it toppled thirty years of education that had taught me that capitalism was a cruel and exploitative system leading inexorably to periodic economic crises, depressions, and wars. In the West, I'd learned, the gap between rich and poor was as wide as that between heaven and earth; society was plagued by violent crimes, drugs, broken families, and racial discrimination. This bleak picture did not

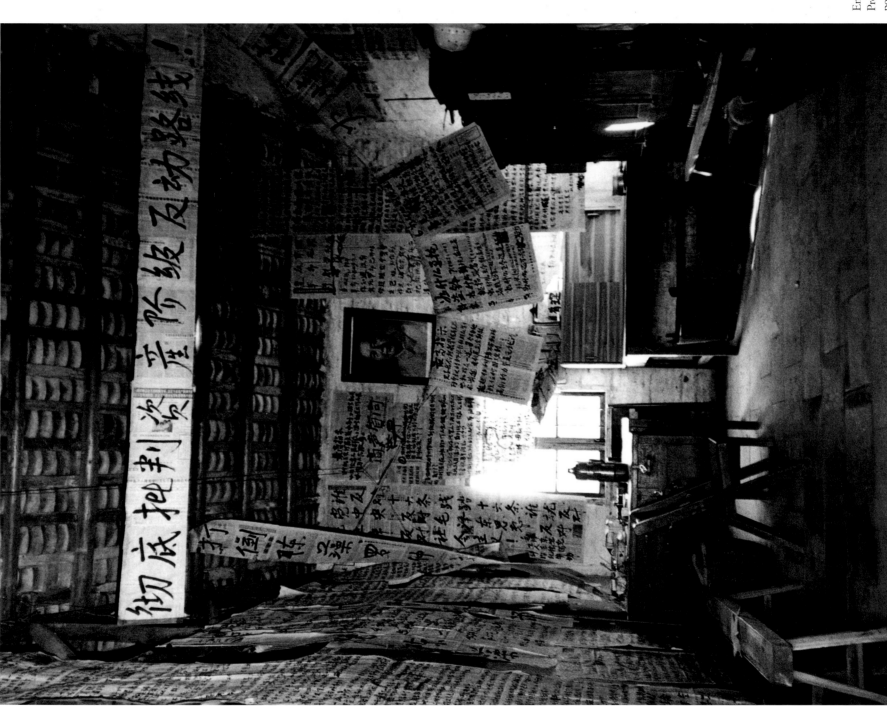

match what I had just seen on the screen—and seeing is believing. The live coverage of Deng Xiaoping's visit to America, however, created a new myth for many Chinese. It gave people the impression that if we were to switch to capitalism, everybody here would live like Americans: each family would have a house of their own, two cars, and three color TVs.

The reality in the nineties, however, was not so rosy. After Deng Xiaoping first reaffirmed the "Reform and Opening Up" policy in 1992, the Chinese economy grew some 13 percent a year for a few years, due mainly to foreign investment and growth in the private sector. But meanwhile, most state-owned enterprises were losing money. Burdened by pension payments and other benefits for the workers, they could not compete in a market economy with the private and joint-venture enterprises, which used cheap rural labor. In July 1997, the Asian economic crisis began. During the crisis China did not devalue its currency and this helped to stabilize the situation in Asia. But the Chinese economy slowed down and exports decreased. One direct result of the slowdown was massive unemployment. By the end of 1998, more than seventeen million workers had been laid off, a figure that does not account for the eighty million surplus laborers from the rural areas. A very large number of retired workers have also been affected. After decades of hard work at low wages, they are now losing their free medical care, and pension payments are sometimes delayed because many factories are on the verge of bankruptcy. The promises made to them by the government years ago have been forgotten.

Family, fortunately, remains largely intact as an institution, and plays a crucial role in this very difficult transitional period for China. As a safety net, it provides welfare for those who are in dire need of help but have no social security to fall back on. Today in China, children are still obliged both legally and morally to support their aging parents. In fact, most old people depend on their children financially, while they in turn provide child-care for the next generation. And it is also quite common for brothers and sisters to help one another out. People of my generation, born in the fifties, usually have two or three siblings; the "one family-one child" policy was not instituted until 1979.

Today, in China's market economy, some people—generally young people and men, especially those with a college degree—have more opportunities than others. Women, middle-aged people, and migrant workers with rural *Hukou* are discriminated against. Whenever a factory lays off workers, women of my age are the first to go (female pro-

fessionals, however, do not need to worry.) By the mid 1990s, scholars began to do well once again; many now have the opportunity to study or work abroad, while others travel the lecture circuit or give consultations. The pay is usually very good, so their income becomes much higher than that of workers and most shop owners, who are finding that, with a saturated market and intense competition, doing business is not as easy as it once was. There was a popular saying in the 1980s: "as poor as a professor and as stupid as a PhD"—today that kind of thinking is outdated.

All this makes people in China value education once again. Now almost everyone wants his or her child to go to college. As for the scholars, after closely observing the social and economic turmoil that came after the collapse of Communism in Russia in 1990, many have become quite conservative. They feel that economic reform has reached a critical stage, and the situation in China is so delicate that chaos could easily erupt. Democracy can wait. Maybe it will simply arrive in the wake of economic development—an idea insinuated by various government officials.

When I first returned to Beijing in 1992, after being away from China for ten years, I was dumbfounded by the changes. Riding in a taxi on one of the ring roads, I had no idea where I was. Old neighborhoods, which I had been so familiar with, had disappeared. Skyscrapers shot up everywhere. So many new roads were built, including the Second Ring Road, built on the site of the ancient city walls, which were demolished in the 1960s. The taxi drivers who liked to chat with their customers never suspected that I was lost, thanks to my appearance and local accent. I did not tell them that I was no longer a resident.

Since 1992, I have visited China once or twice a year, sometimes staying for as long as six months. Although it saddens me to see old Beijing disappear in front of my eyes, many changes are probably for the better. In the past everybody in China was an expert on politics. Now people are pragmatic, and mind their own business. Their interests have broadened, which can be seen in many photographs in this collection. Some love flowers and birds. Others like to play chess and *Go*. People of my mother's generation still love to sing. So they organize choruses and sing along with their old friends. As for the amateur dancers, depending on how much money they want to spend, they can go to fancy nightclubs that cost a thousand *yuan* a night or a free neighborhood park, as shown by Sebastião Salgado's photograph, and have a good time just the same.

Qigong, Chinese-style meditation based on Taoist philosophy, is a very intriguing phenomenon. In the early 1990s—shortly after the Tiananmen Square incident—it became very popular all over the country: tens of millions of people started to meditate, and soon all kinds of related miracles were reported. Great *Qigong* masters were worshipped as if they were deities. Even though the government has suppressed it, many continue to practice it either alone or in small groups. Then in April 1999, ten thousand believers of *Falungong*, a type of *Qigong* that teaches "truth, kindness, and tolerance," staged a demonstration in Beijing. It caught the media's attention, as it was the largest demonstration there since 1989.

It's possible that the massive attraction to *Qigong* after 1989 might have been an indication of a general confusion, even a crisis, in the Chinese people's belief systems. For centuries the Chinese believed in the power of ancestors, in heaven, in Buddha, and in Taoist deities. In 1949, all of these were condemned as superstitions. For the next two decades, we worshiped Mao, put our faith in Socialism, and tried hard to build a perfectly egalitarian society— ultimately, this revolution failed. Then the winds changed again: when Deng Xiaoping came into power, he encouraged people to get rich. Socialism became "socialism with Chinese characteristics" —which looks more like capitalism in its primary stages.

When the cultural and spiritual topography shifts so quickly, so radically, it is impossible not to feel lost. Many pictures in this collection, such as Brian Palmer's *Subway* (Beijing, 1997), capture this feeling of people's confusion and frustration: the train is about to leave; everybody is in a hurry, no one seems to know where they are going. Religion is on the rise in China: according to the latest survey conducted by the Bureau of Religious Affairs, over one hundred million Chinese believe in some form of religion. While the figure is hard to verify, huge crowds can be seen at both Buddhist and Taoist temples all over China. Party and government officials, CEOs of big companies, overseas Chinese, and local peasants mix together, burning incense and kowtowing to the gods.

People's tastes are changing, as are their values. In the cities, children are falling in love with McDonald's, and at least ten Hollywood blockbusters sweep through China each year. Few people still go to the Peking Opera. In the mid 1990s, the one-hundred-year-old Jixiang Opera House was pulled down to make room for a shopping center, a joint venture between the Beijing municipality and a Hong Kong billionaire.

Speaking of the Peking Opera, the cover photograph of this volume by Hiroji Kubota is fascinating for a number of reasons. It shows reflected images of an actor and an actress, putting on make-up before a show. But do we know that behind the female face it is an actress not an actor, like the famous actor Mei Lanfang? We don't. For me, this photograph itself is like a mirror, which reflects the faces of the Chinese. For decades, we all put on make-up and participated in one grandiose show after another. Certain roles we played voluntarily: Chairman Mao's good children, Red Guards, Rebels, Educated Youths. For a few years, I was quite convinced that I was indeed the character I was playing. In one campaign after another, we all tried to outperform others so as to show the crowd that we were the most revolutionary. At the same time, others were forced to play the roles they could not afford to play: Landlords, Rightists, Counterrevolutionaries, and Capitalist-Roaders. When this happened, sometimes we forgot that there were human beings behind the make-up. Then blood was spilled on the stage. Memory was stained. Our conscience could never be washed clean.

In the new era, of course, we have a different show going on. New characters are stepping into the spotlight: Big Wrists (those in power), Big Moneys, Little Honeys. With the rapid growth of the Chinese economy, prostitutes are reappearing in the streets, violent crimes are on the rise, drugs are back. One day the good news is that that millions of families in China have purchased computers for their children; the following day, everybody is talking about the suicide of an unemployed man who could not afford to buy a small piece of meat for his child. The nightmares of the Mao years are receding, but occasionally one wonders if we have backtracked to the 1940s.

Because China is a poor country (ranked 81 among 133 countries in terms of per-capita GDP), according to the World Bank, with limited natural resources, worsening environmental problems, and more than a billion people, the difficulties it faces now are tremendous. China's future in the next millennium is quite uncertain.

We are a resilient people to have come as far as we have, though. And wherever we go, we will take history with us. As writer Lu Xun put it in 1921: "Hope cannot be said to exist, nor can it be said not to exist. It is just like roads across the earth. For actually the earth had no roads to begin with, but when many people pass one way, a road is made."

BRIEF LYRIC

As into a dream
I enter the world
like a girl. I run through it
barefoot, my shadow
flowing across
the creaking cobbles.
Fresh drops of blood
mingle with the dew,
bright red agates
on a heaving breast.
A warm green heart
is about to blossom.
I offer my barely
tasted youth
in protest. My arms
reach out for the sun
like frail white arches.
I fear no longer
the trembling stars
in the water. Searching
for night through a forest
of books, I've become
a star myself,
trembling no longer.

—JIANG HE (b. 1949),
from "Unfinished Poem"

High school
students study under
the lights in
Tiananmen Square,
Beijing, 1981

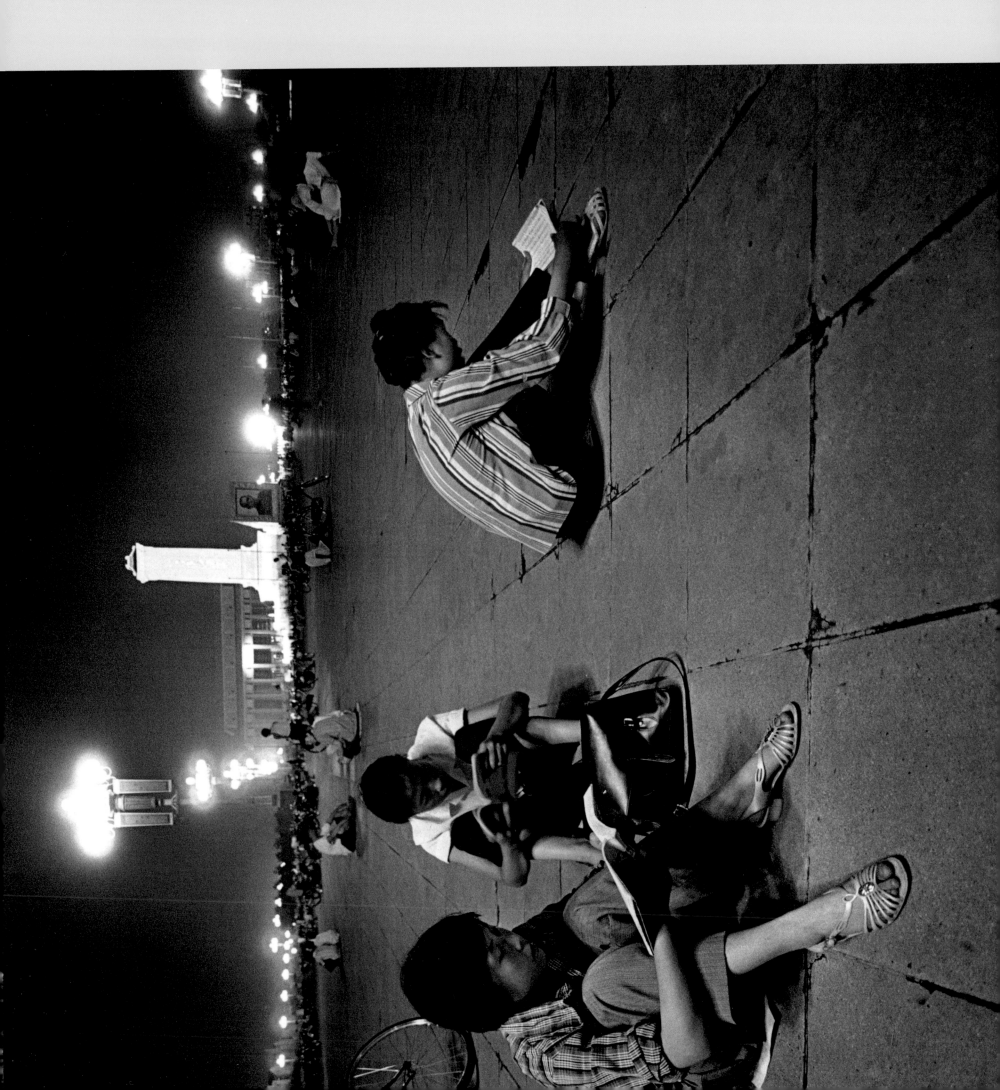

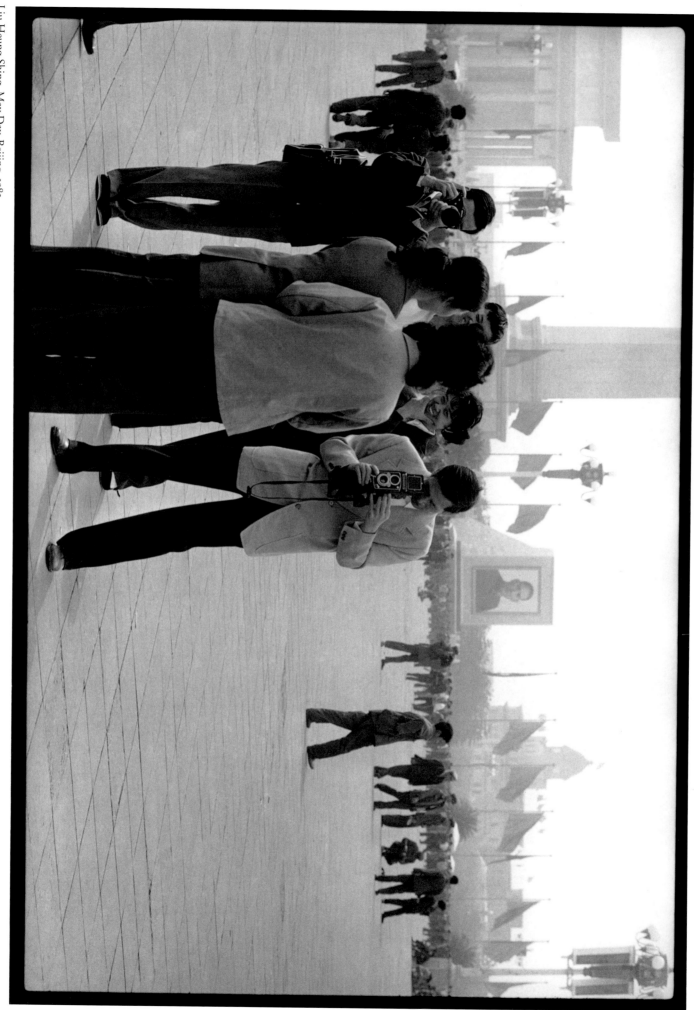

Liu Heung Shing, May Day, Beijing, 1982

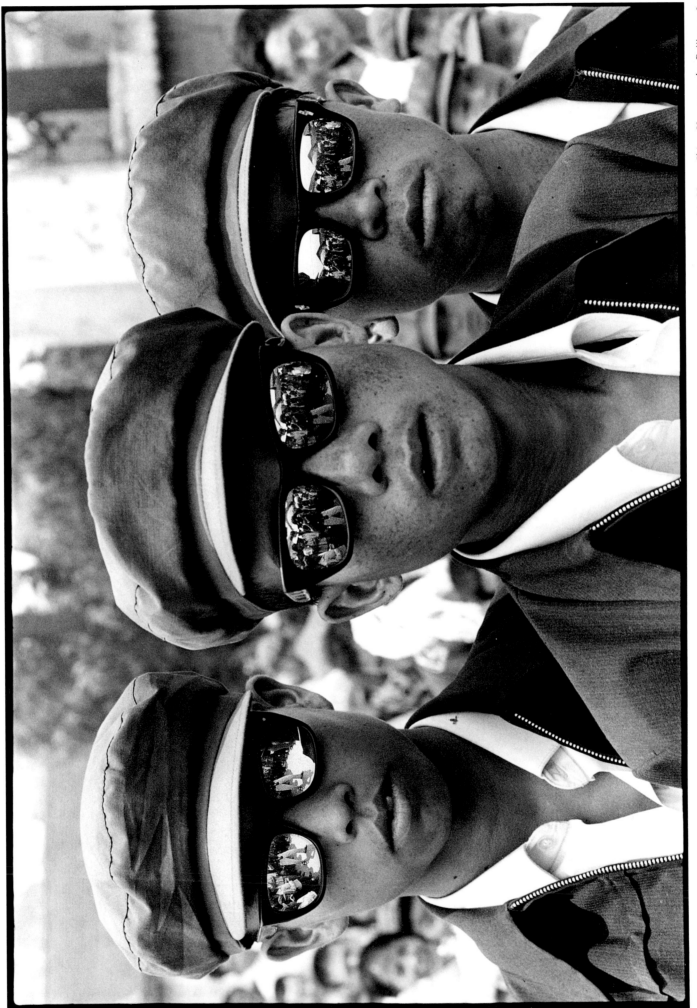

Liu Heung Shing, Young toughs, Beijing, 1981

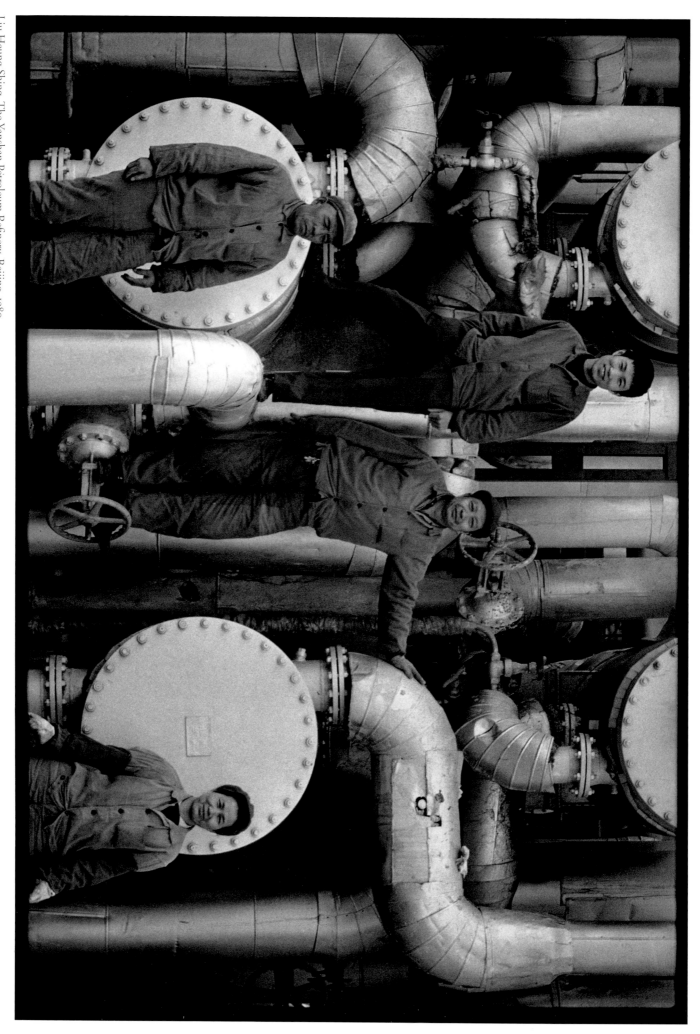

Liu Heung Shing, The Yanshan Petroleum Refinery, Beijing, 1980

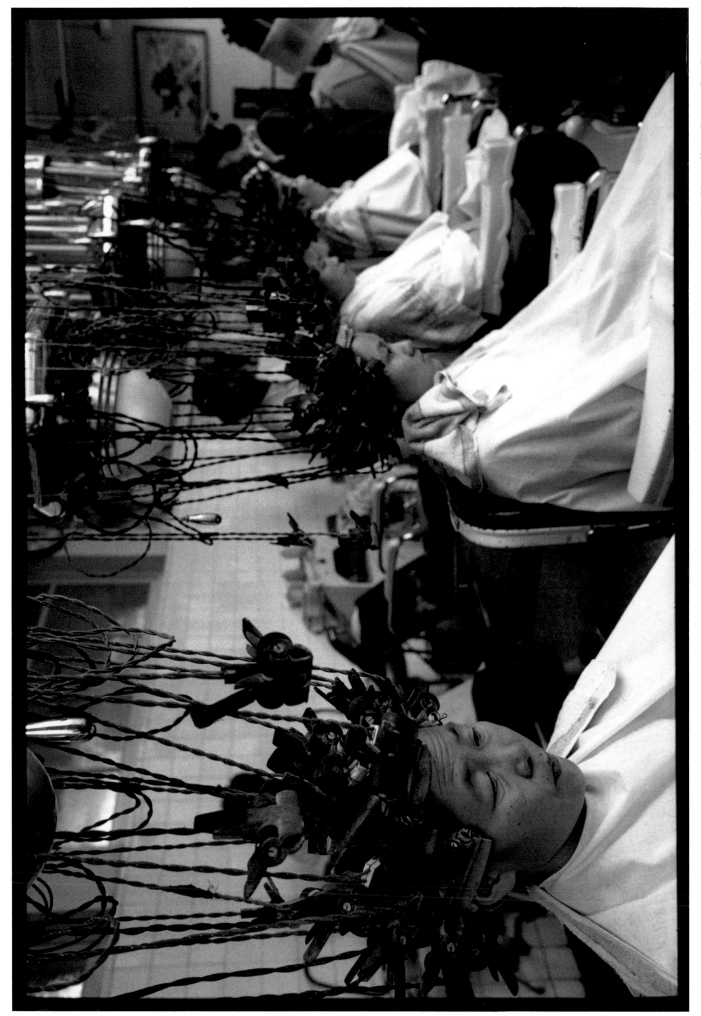

Liu Heung Shing, Beauty salon, Beijing, 1981

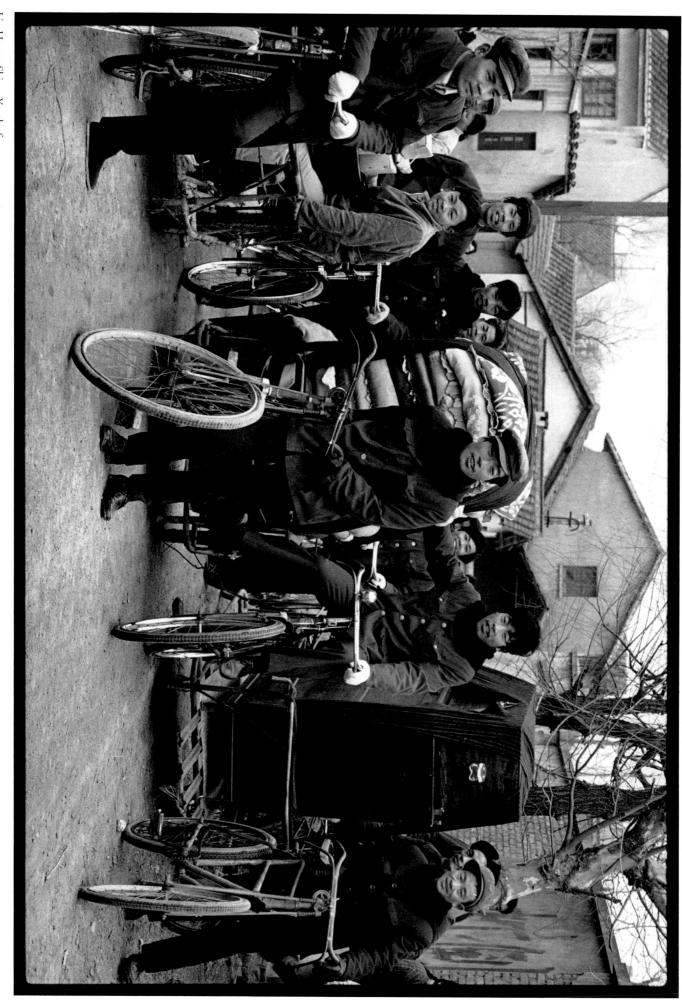

Liu Heung Shing. Youths form a caravan to carry a bridegroom's gifts to the home of his bride, Shanghai, 1980

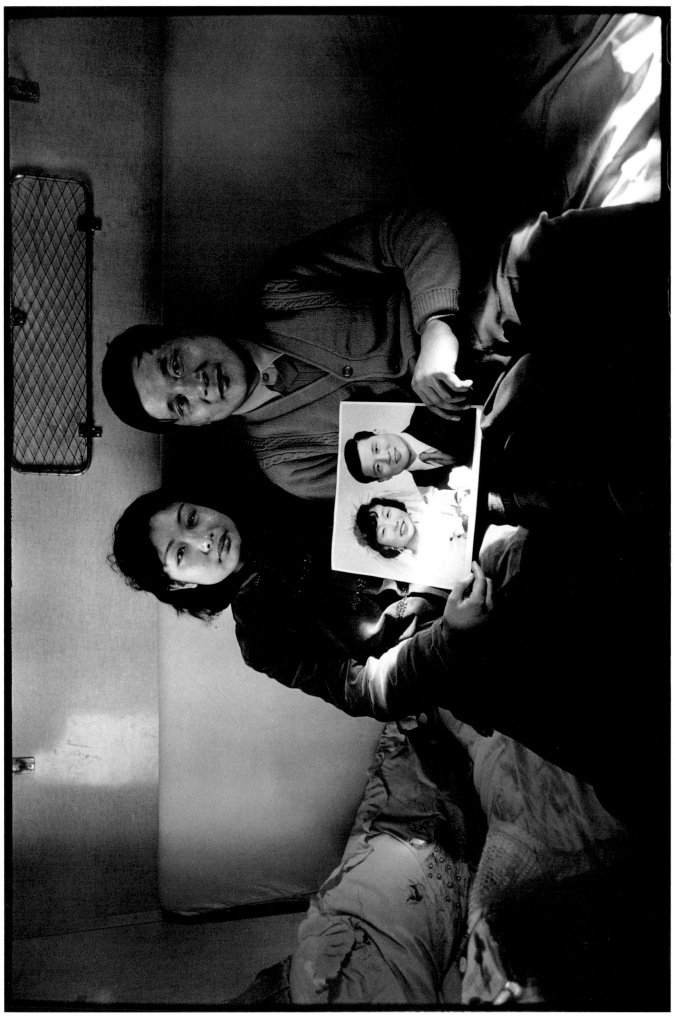

Liu Heung Shing, *Honeymooners show their wedding portrait on the train between Beijing and Harbin*, 1982

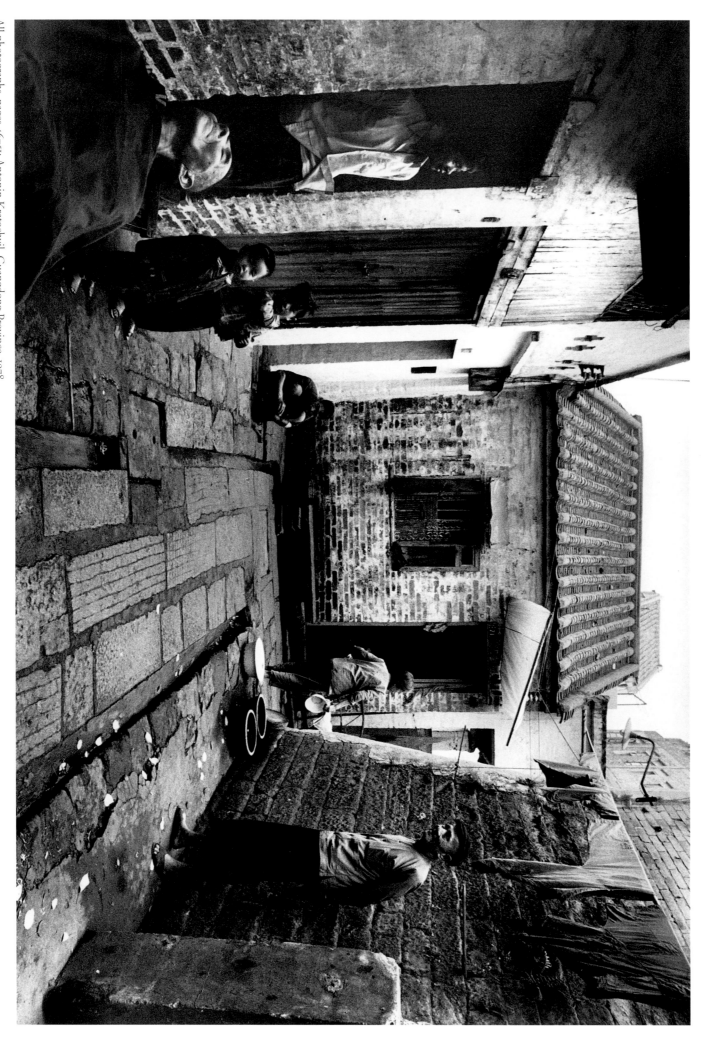

All photographs, pages 46–51: Antonin Kratochvil, Guangdong Province, 1978

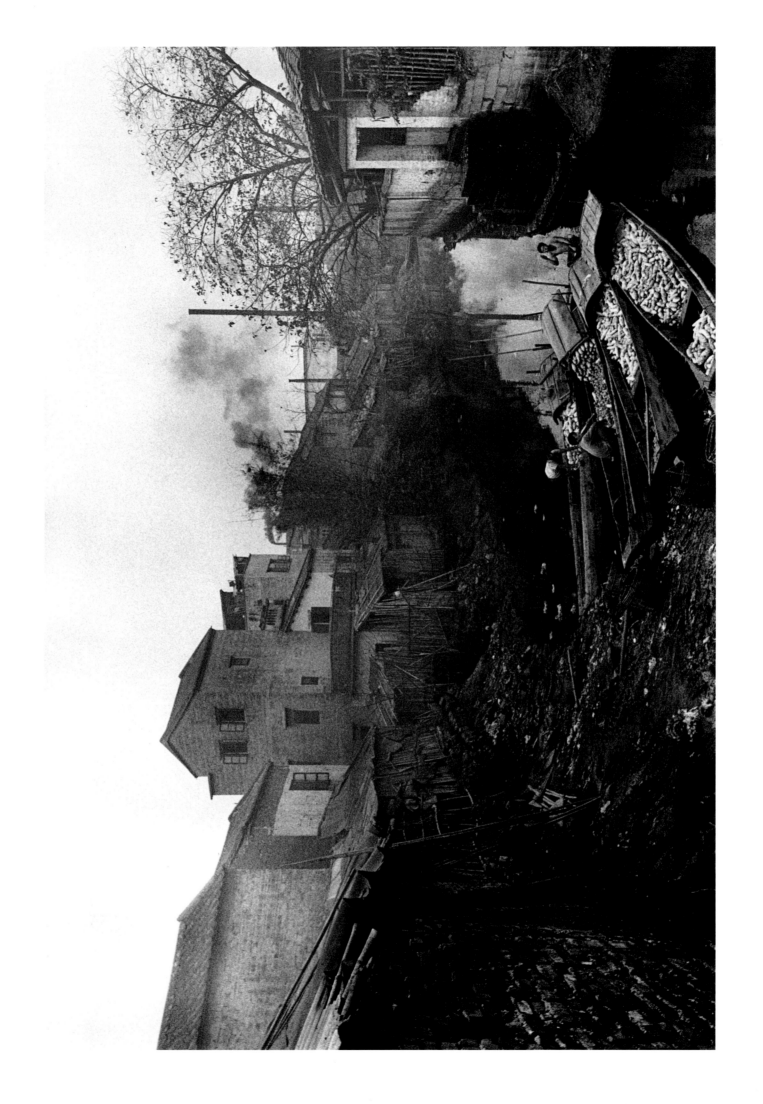

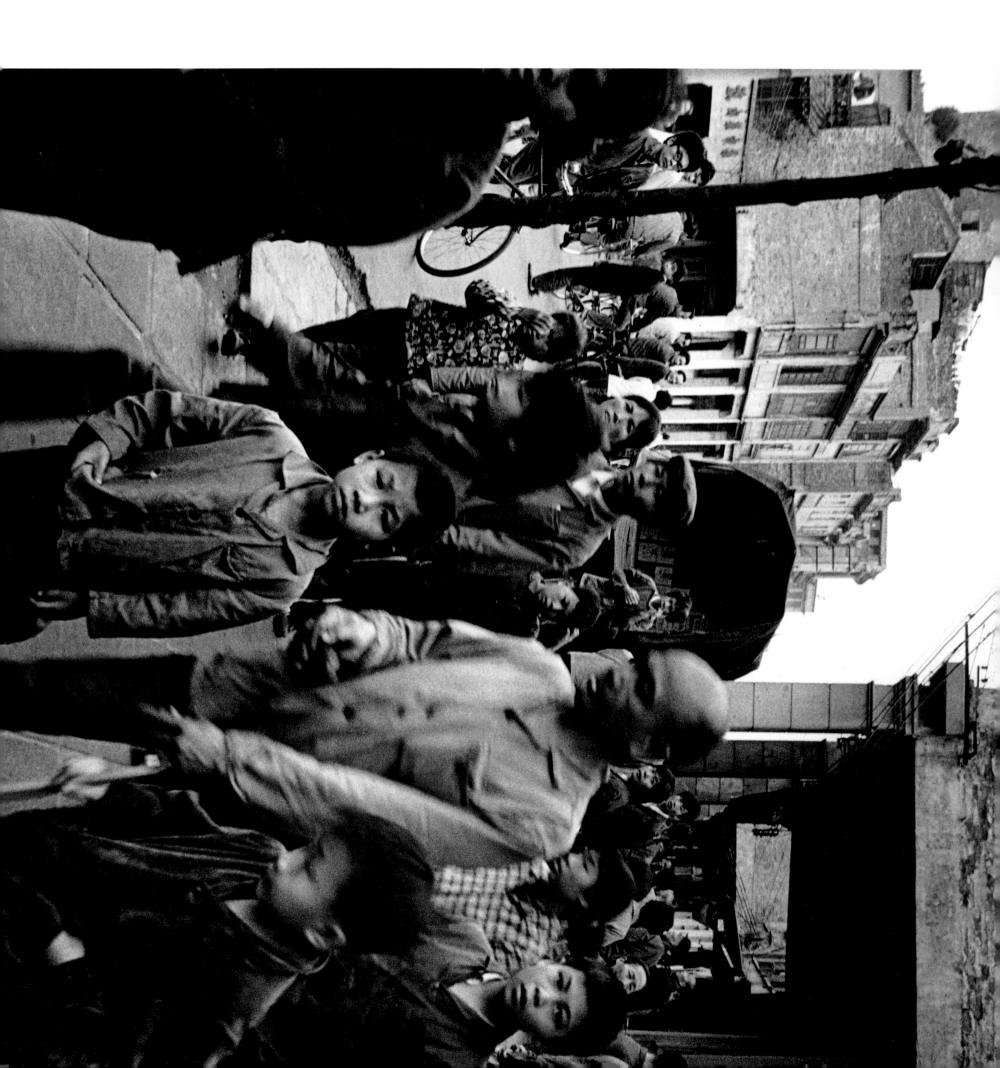

Day and night
Revolve,
While my face wrinkles
And my spirit wanes,
But the sight of injustice still pains me.
One change induces another
That cannot be dealt with by tact or wit.
The cycle goes on forever.
I only fear that in a moment
Life will disperse in the wind.
I have always trodden on thin ice.
Yet no one knows!

—RUAN JI (A.D. 210–263),
from *Poems of My Heart*

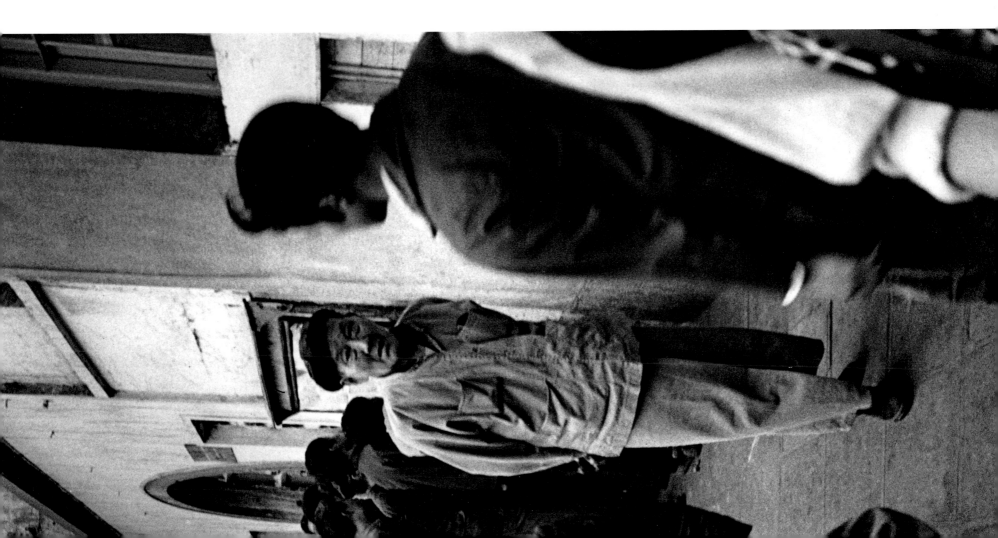

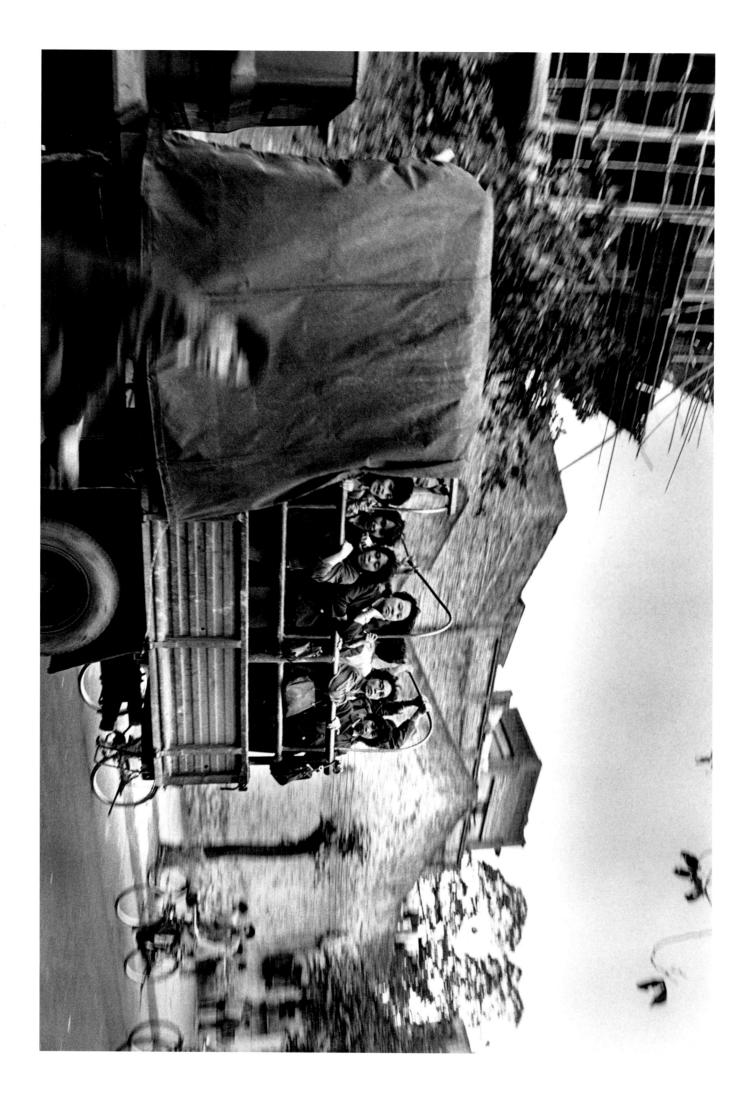

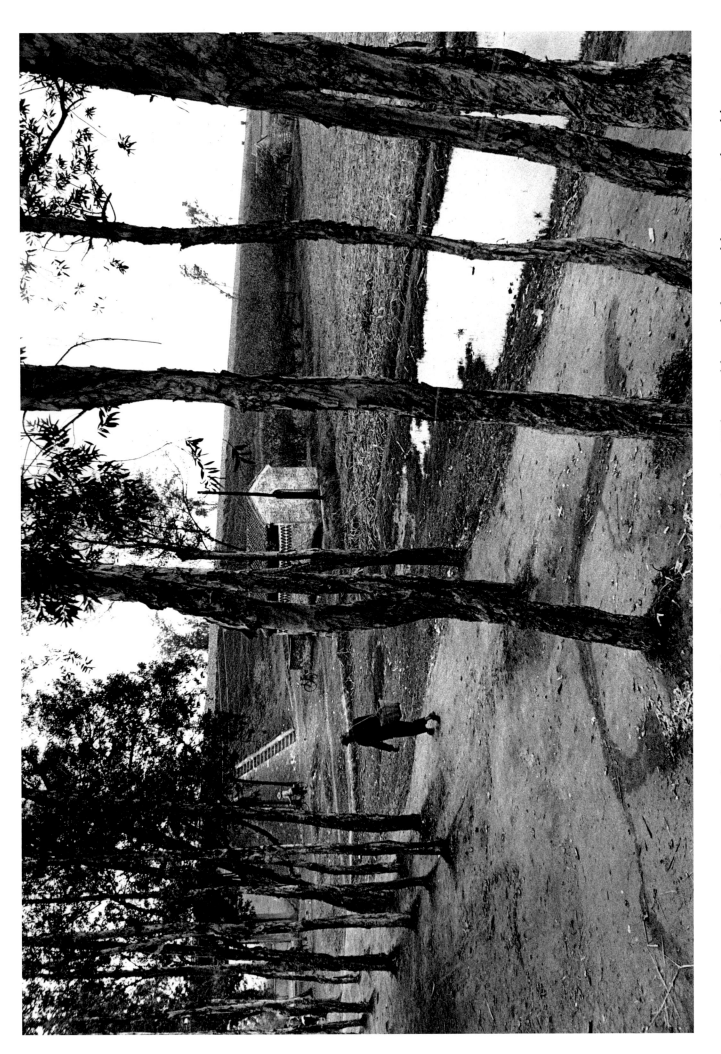

If every corner of the earth were sun-drenched, Who would stand alone and burn up in the coldness,
Who would be in need of stars? Searching for a twinkle of hope?
 —Jiang He (b. 1949), from
 "Musical Variations on the Stars"

IN CHINA, 1979 marked a period of easing toward the West. For the first time after almost a generation of secrecy, the Chinese government was taking its own people (and the outside world) into its confidence. The official organ, the Xinhua News Agency, was reporting basic information and statistics on employment, the national income, the budget, the harvest, industrial quotas, consumer goods, and much else that had been a mystery before. To get people moving, economic incentives were to replace ideology. The Chinese were taking a heavy gamble that they could become a world power by the year 2000. It was a time of openness that made my work a joy.

It seemed to me that in China there was none of the monotonous gray conformity I had seen in Russia. Instead, there was uniformity, yet within it a startling diversity. I had expected every commune to be like every other commune, and every factory to be set up according to directives from a central plan. This was not so. Each unit solved its own problems in its own way and according to its own needs—although, granted, within the framework set up by the Communist Party. What constantly impressed me was the spirit of the people. China had just emerged from ten

years of Cultural Revolution, of purge and counterpurge, of destruction of her past and violence to her future—and possessed a whole generation of young who had been the victims of upheaval. I was surprised on two scores: how far the Chinese had come in thirty years, and how far they still had to go to leave behind the backbreaking physical labor in which millions remain engaged. China considers herself both a Third World country (Mao Zedong's phrase) and a developing country. In Xishuang Banna a group of peasants said to me, Yes, ours is still the ancient way of toil: peasants still ride water buffalo to level the land, and plant the rice shoots by hand. But there have been enormous changes for us since Liberation. The rice paddies have been cleaned up; there are medical care, retirement pensions, old-age benefits, and education for our children. We are involved in building a better world for our children. Yes, said an old man:

For our sons,

For our sons' sons, and

For ten thousand generations to come.

—E. A.

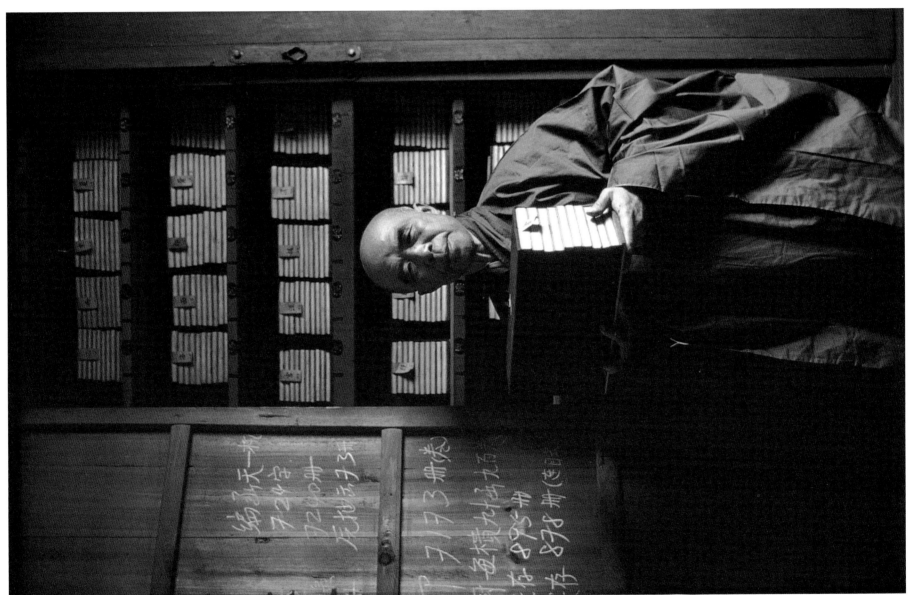

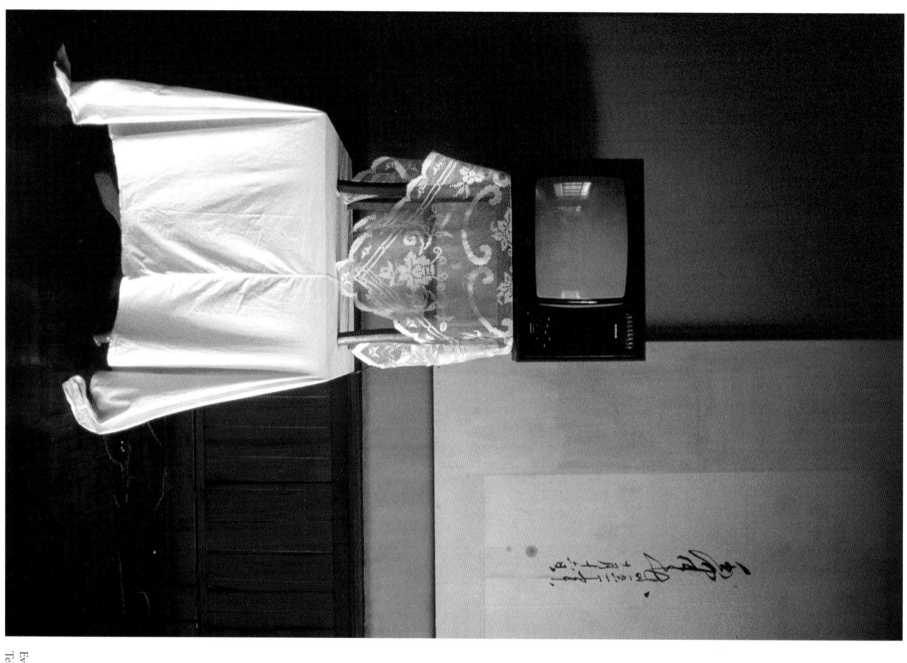

Eve Arnold,
Television, 1979

A word has abolished another word
a book has issued orders
to burn another book
a morning established by the violence
of language
has changed the morning
of people's coughing

—BEI DAO (b. 1949),
from "The Morning's Story"

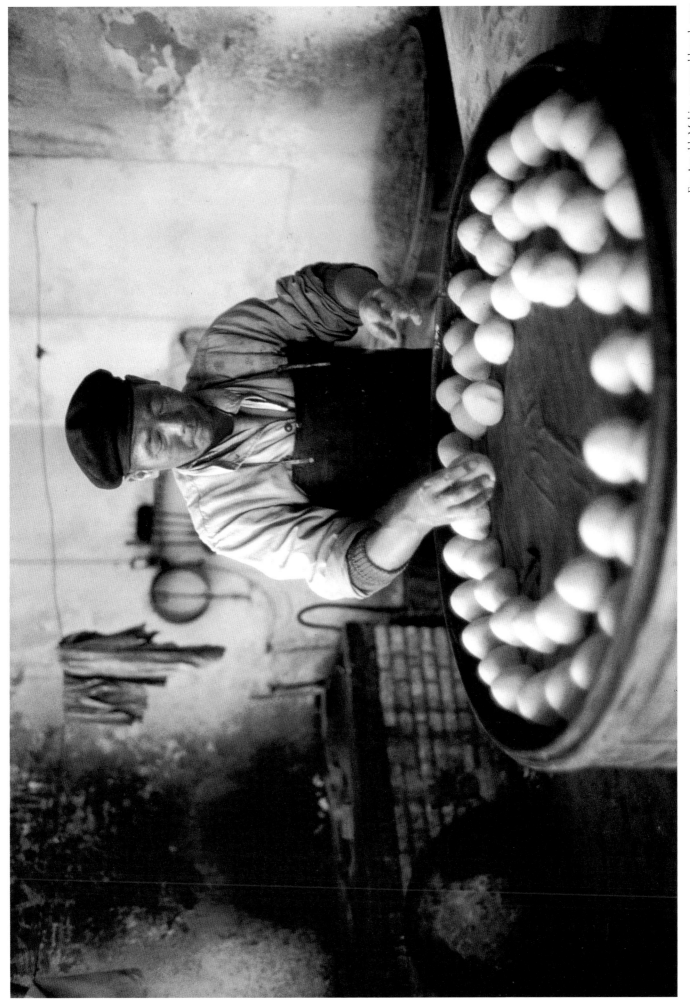

Eve Arnold. Making steamed bread, 1979

Eve Arnold, Traditional orchestra, 1979

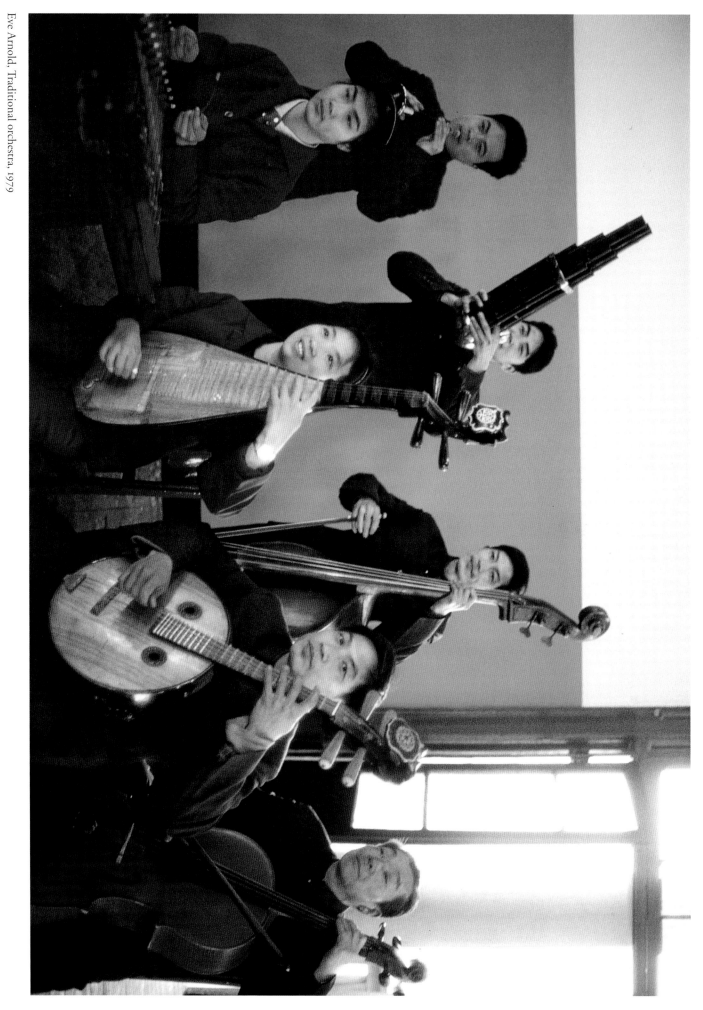

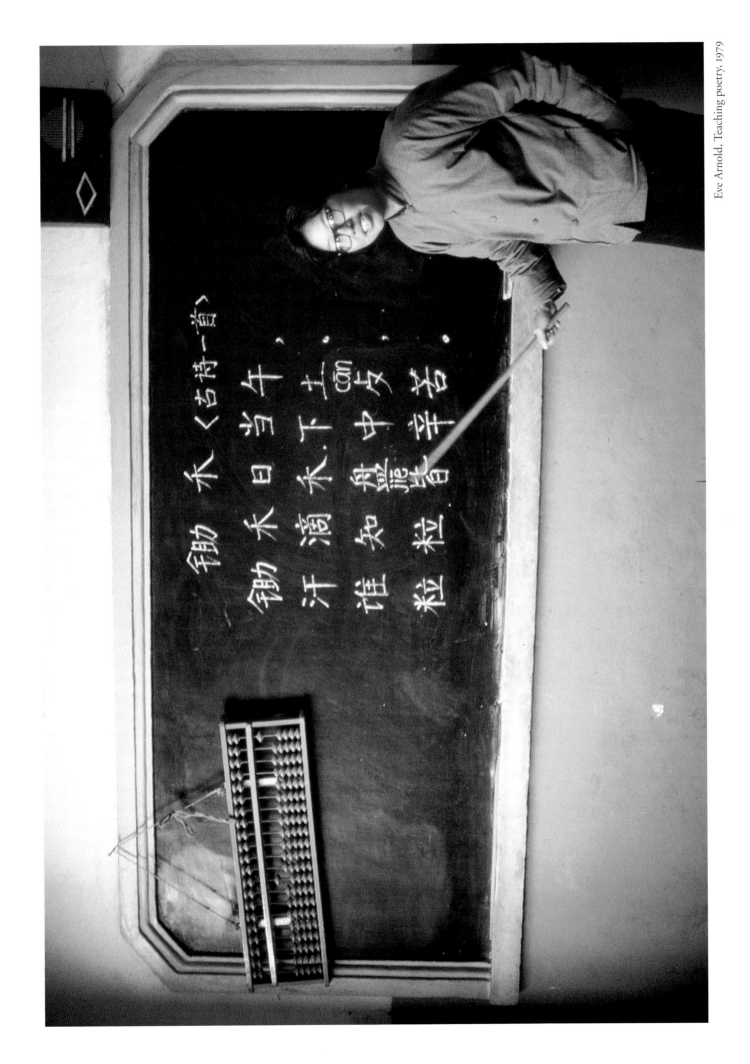

Eve Arnold. Teaching poetry, 1979

The Image is what brings out concept; language is what clarifies the Image. Nothing can equal
Image in giving the fullness of concept; nothing can equal language in giving the fullness of Image.

—WANG BI (A.D. 226–249), from "Elucidation of the Images"

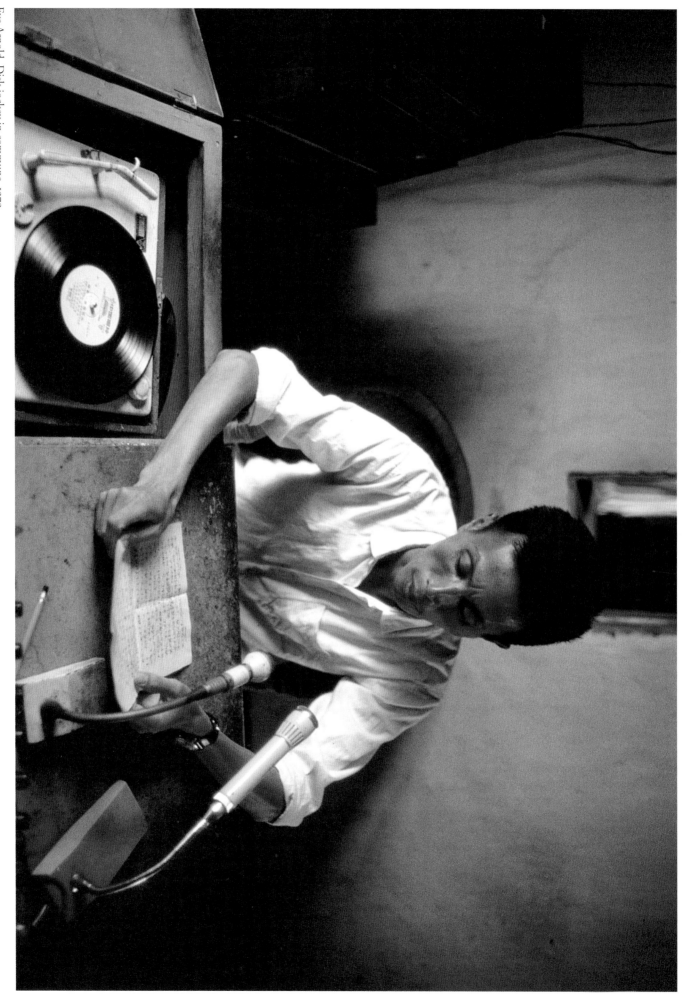

Eve Arnold, Disk jockey in commune, 1979

Eve Arnold,
Vice Chairman Liao
at home, 1979

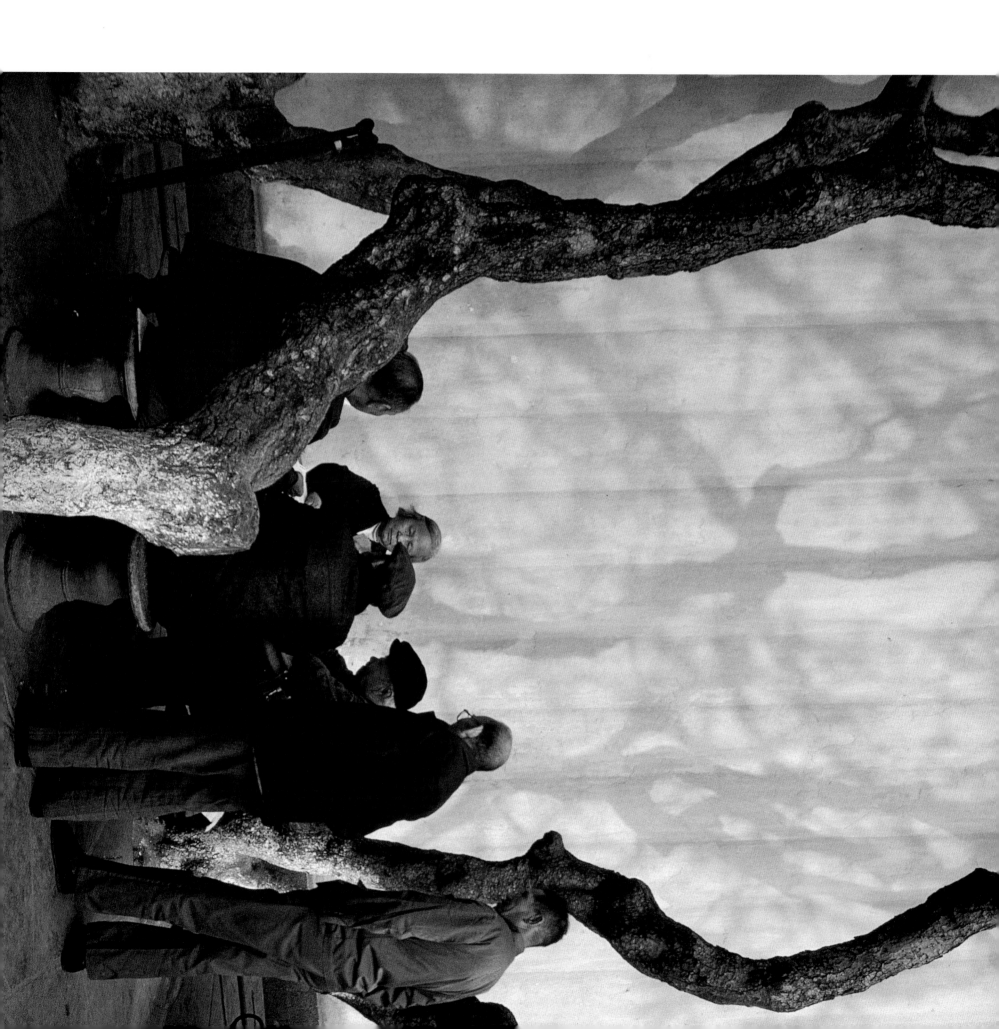

I think, therefore I am a butterfly,
Ten millennia from now, a tiny flower's gentle call —
Through clouds of no dreams and no awakenings —
Shall flutter my colorful wings.

—DAI WANGSHU (1905–1950)

HIROJI KUBOTA CHINA, EAST AND WEST

Guangzhou, n.d.

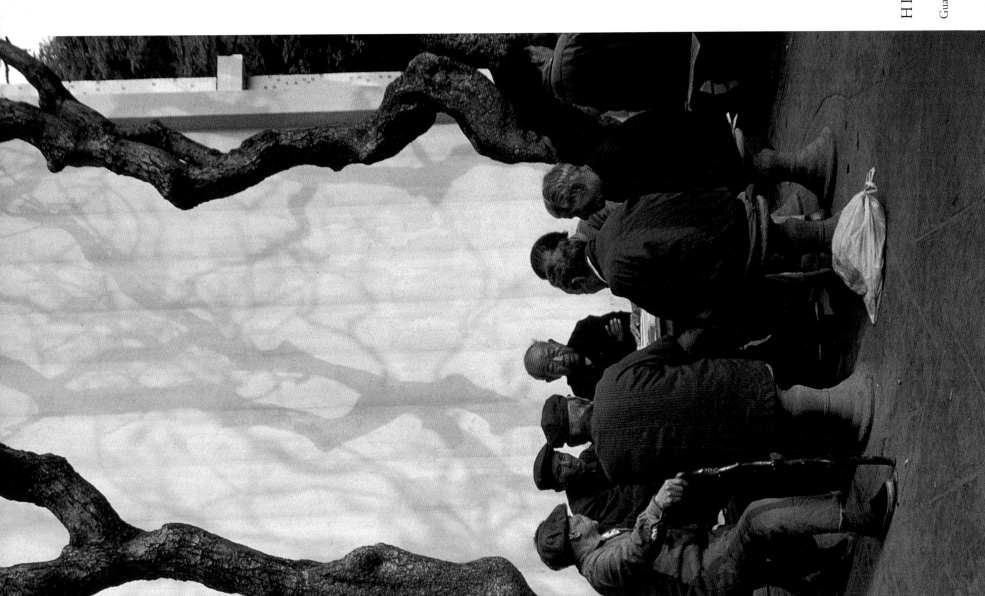

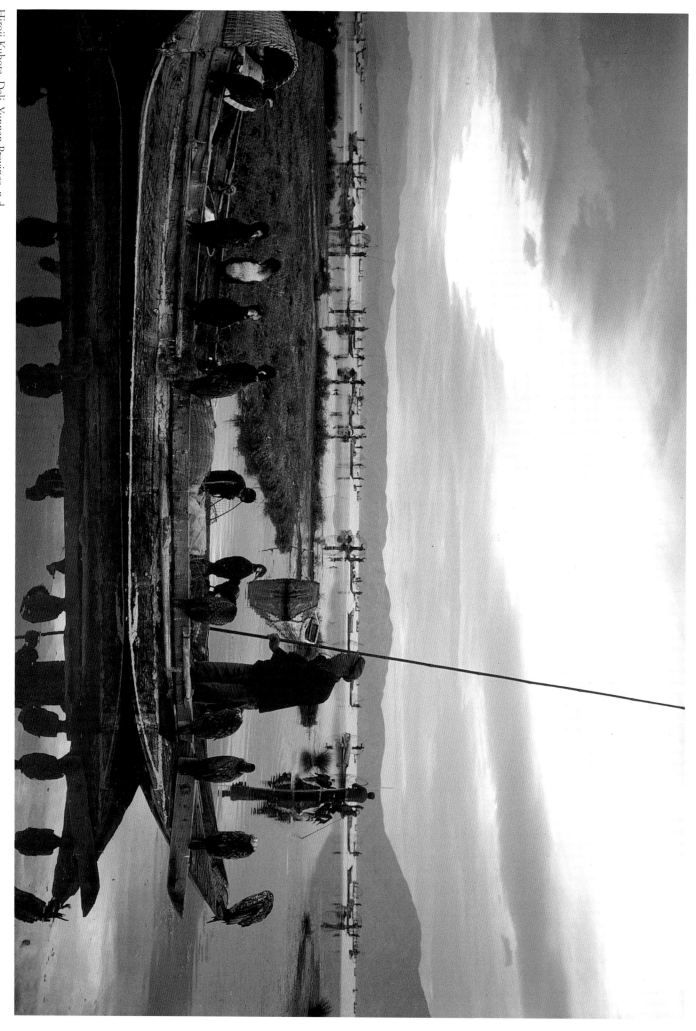

Hiroji Kubota, Dali, Yunnan Province, n.d.

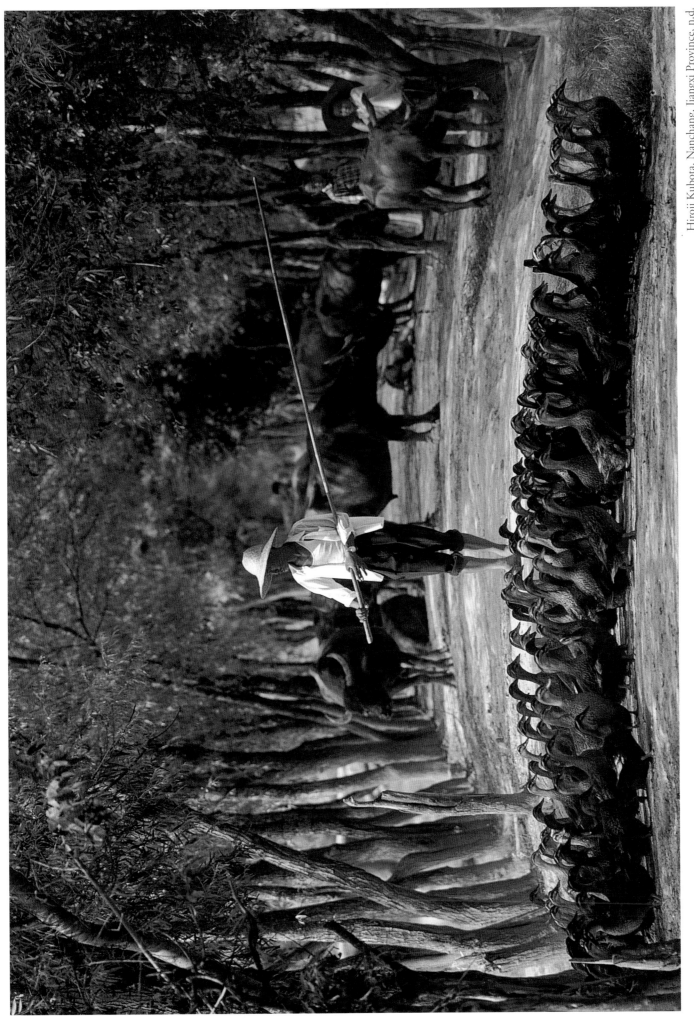

Hiroji Kubota, Nanchang, Jiangxi Province, n.d.

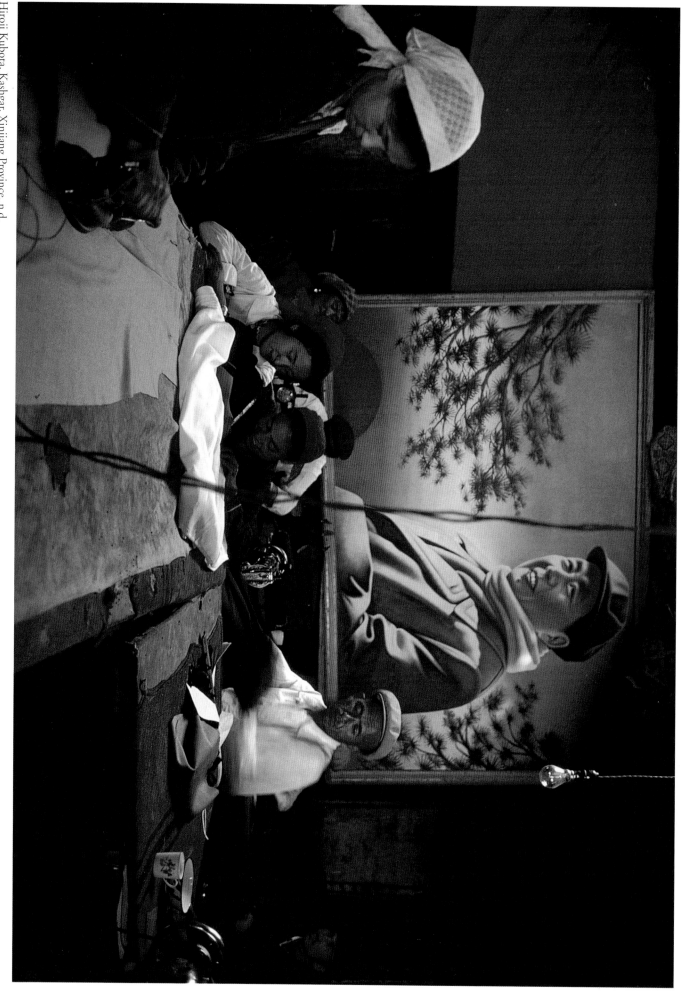

Hiroji Kubota, Kashgar, Xinjiang Province, n.d.

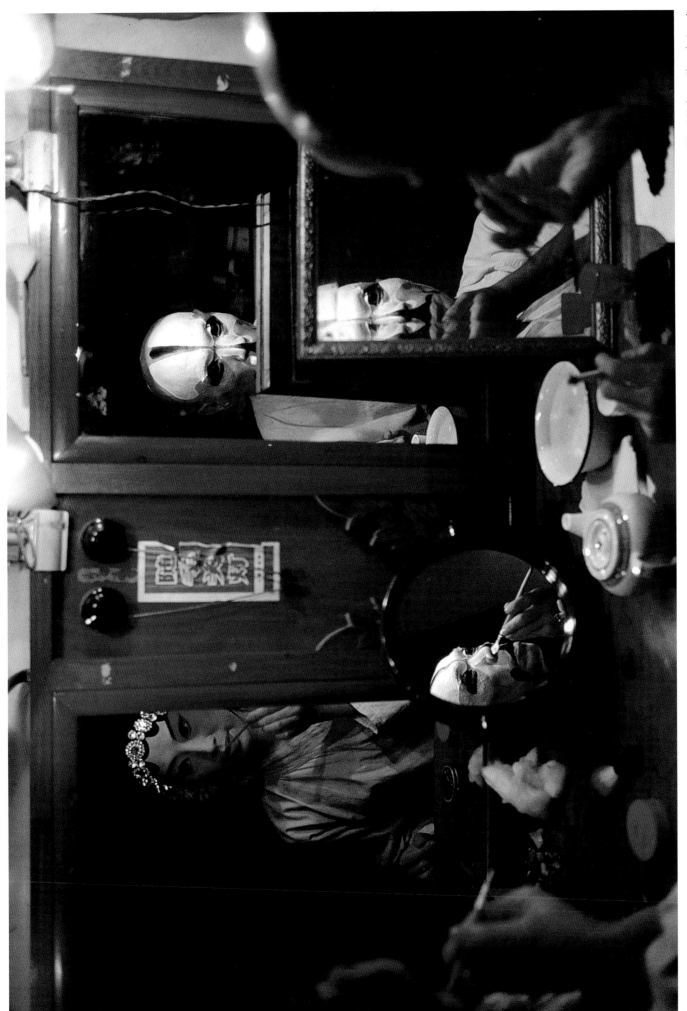

Hiroji Kubota, Shanghai, n.d.

The god then gave word to Yang the Shaman, saying,
"There is a man down below. I want to help him.
His several souls are dispersing. Go cast the lots for him."
Yang the Shaman answered, "Holder of Dreams . . .
high god . . . hard to follow the traces.
But if I must cast the lots, I fear that it is too late,
for he is decaying and it will no longer be of any use."
Then Yang the Shaman went down and called:
"Soul! Turn back!"

—Anonymous
(Fourth century B.C.–third century B.C.),
from *Lyrics of Chu: Calling Back the Soul*

Hiroji Kubota,
Hangzhou,
Zhejiang Province, n.d.

66

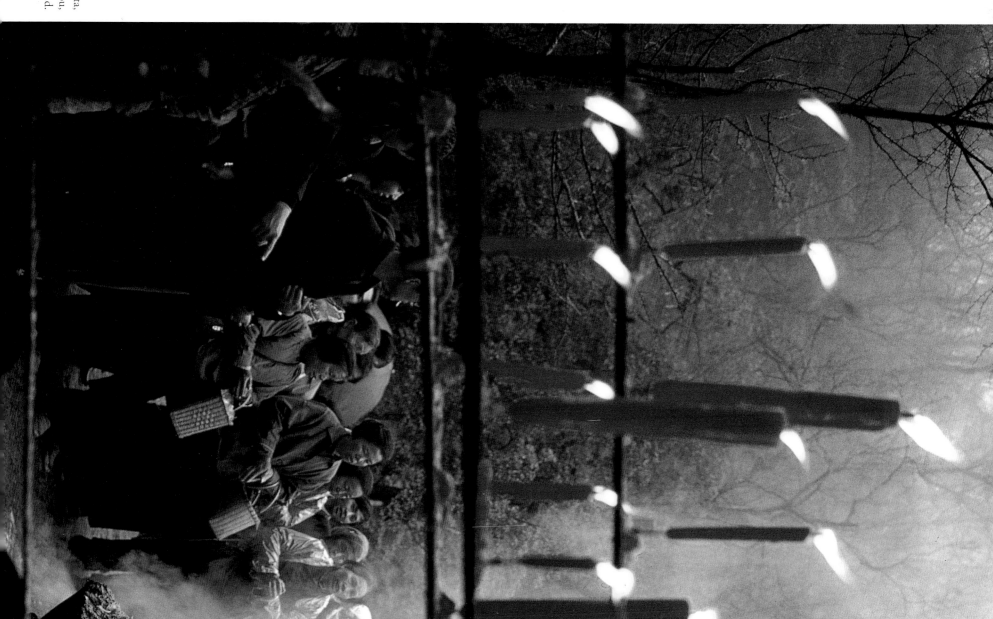

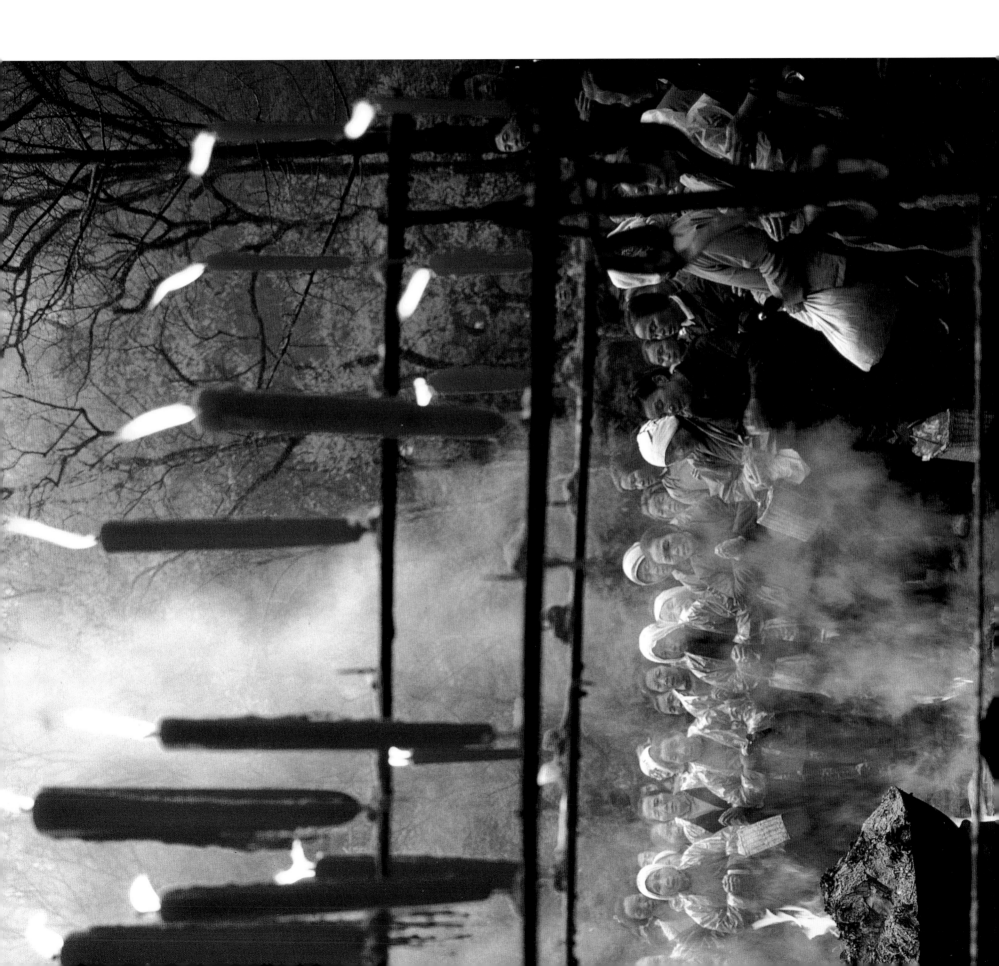

A single shape keeps changing,
a million things go on and on.

—Li Bai (A.D. 701–762),
from *The Old Airs, IX*

Hiroji Kubota, Zhongshan,
Guangdong Province, n.d.

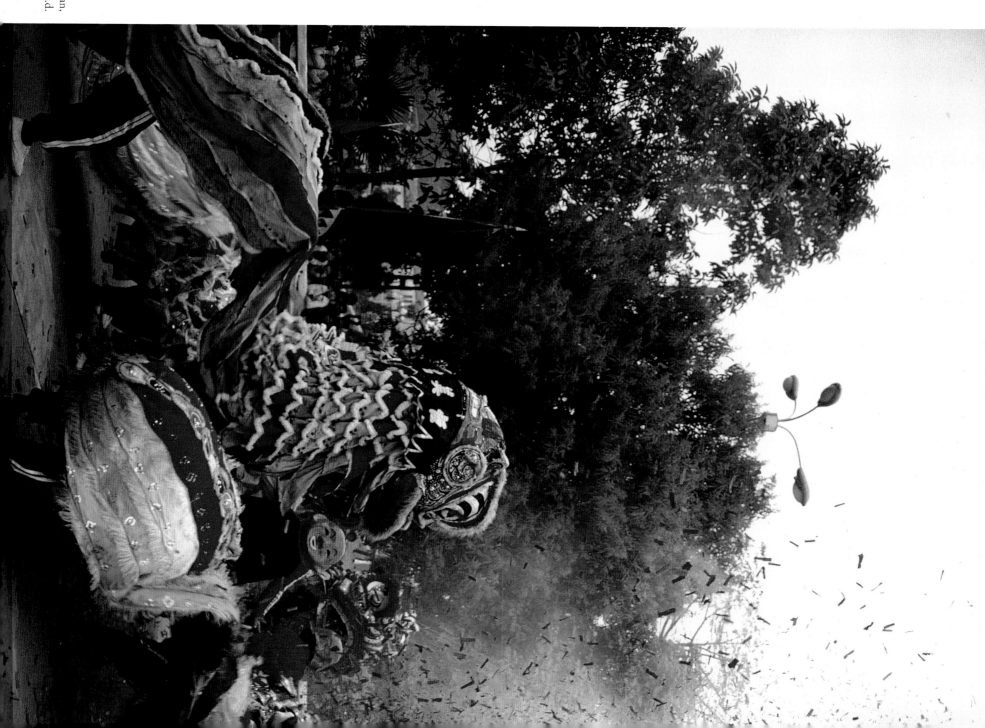

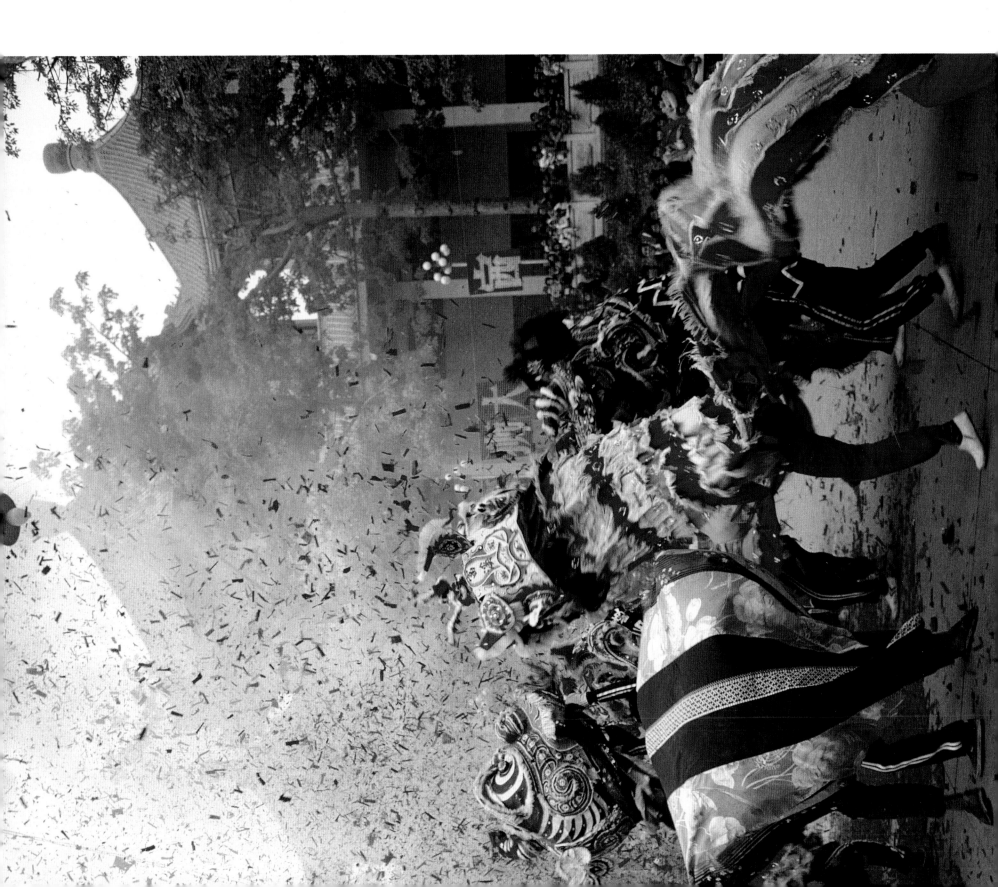

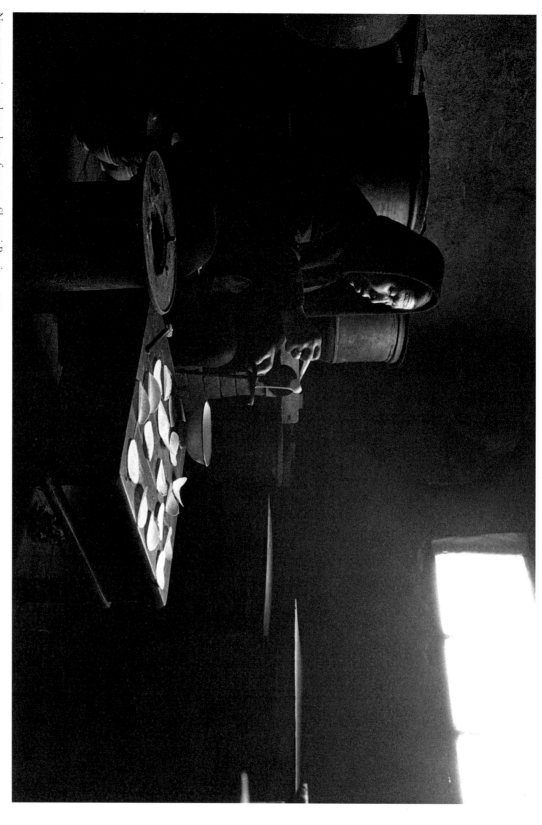

Nun prepares rice cakes as hosts for mass, Shaanxi Province, 1995

I built a cottage right in the realm of men,
yet there was no noise from wagon and horse.
I ask you, how can that be so—
when mind is far, its place becomes remote.

—TAO QUIAN (A.D. 365–427),
from "Drinking Wine, V"

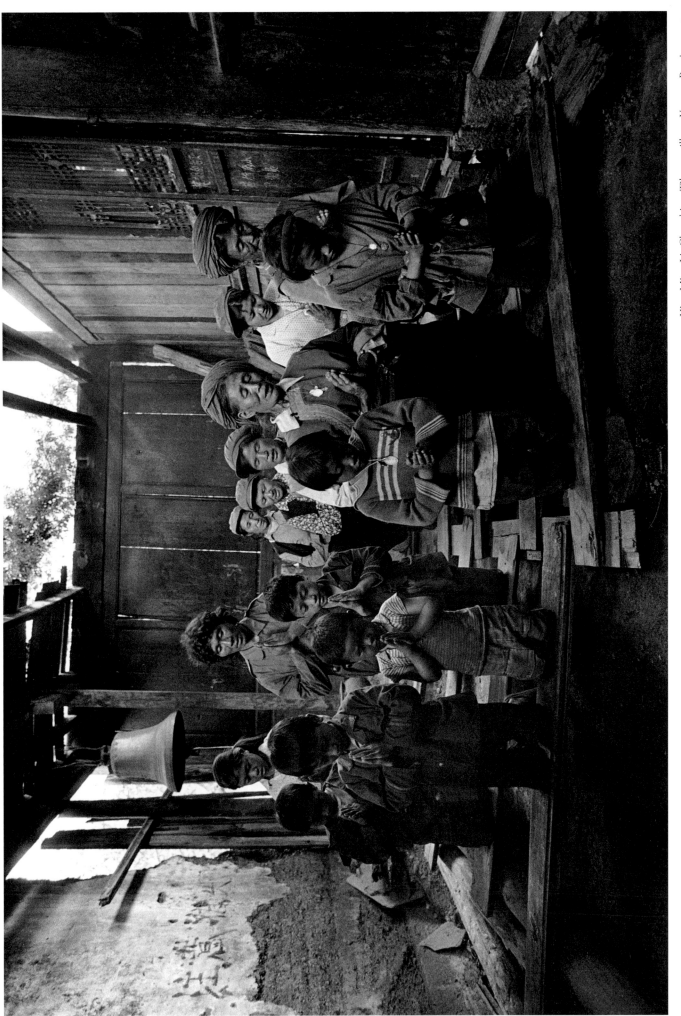

Xiao-Ming Li, Chapel in a Tibetan village, Yunnan Province, 1994

Top: Xiao-Ming Li,
Fan Yu Fei, a bishop of the
unofficial church, prays for a sick
person, Shaanxi Province, 1994
Bottom: Xiao-Ming Li,
Villagers pray for a
person who has died,
Shandong Province, 1993

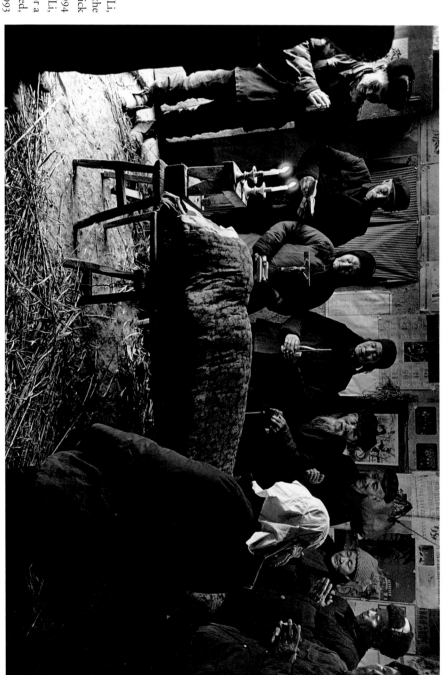

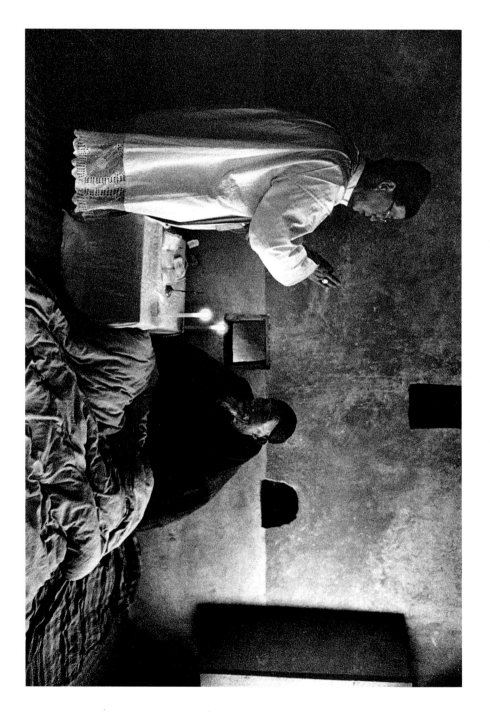

Therefore all things are one.
What we love is the mystery of life.
What we hate is corruption in death.
But the corruptible in its turn
becomes mysterious life,
and this mysterious life
once more becomes corruptible.

—LIN YUTANG (1895–1986),
from "The Northern Travels
of Knowledge"

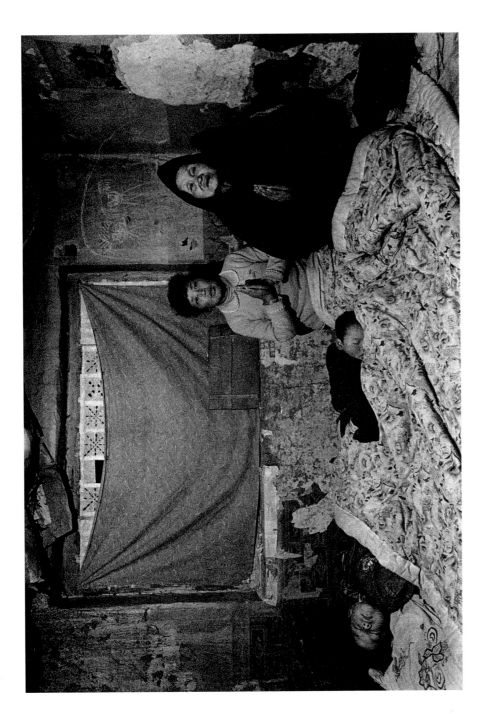

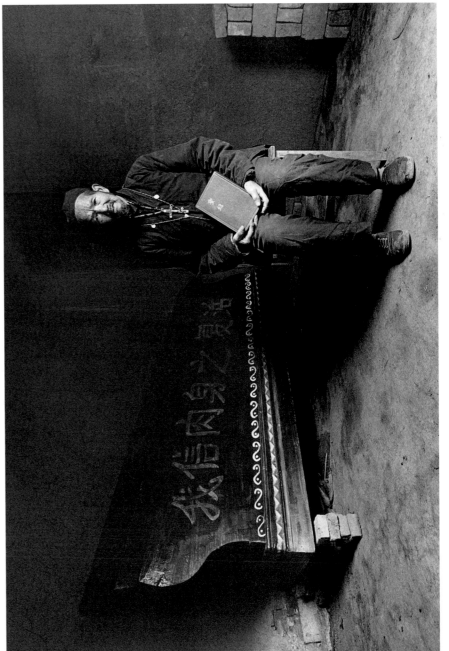

Top: Xiao-Ming Li,
Catholic family chants
before retiring,
Shaanxi Province, 1995
Bottom: Xiao-Ming Li,
Man with a coffin
he made for himself,
Shaanxi Province, 1995

Xiao-Ming Li, Yunnan Province, 1993

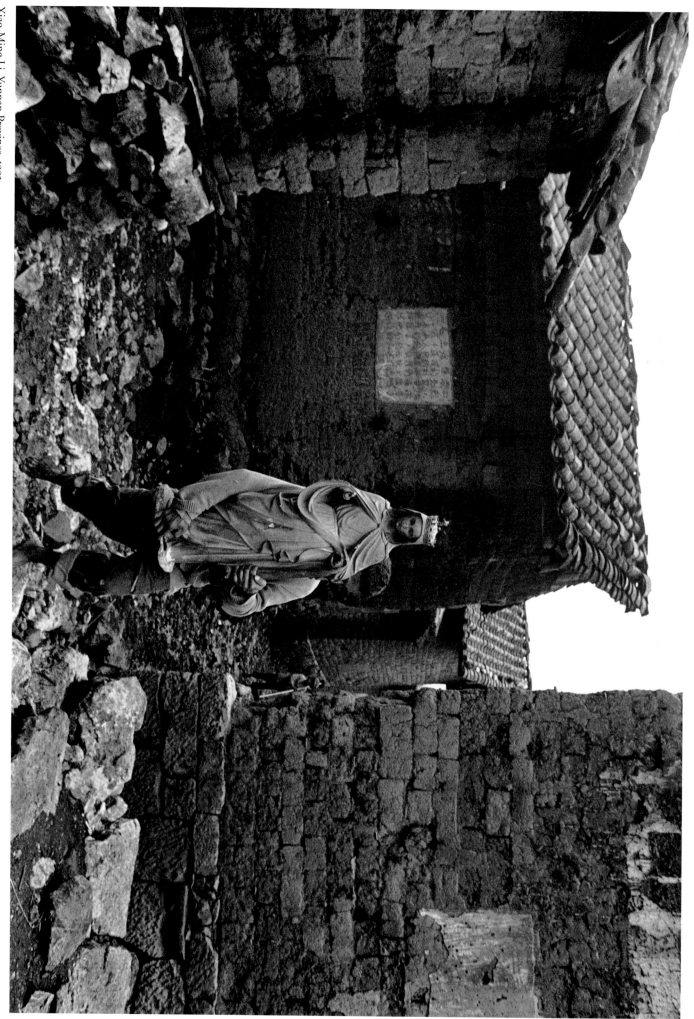

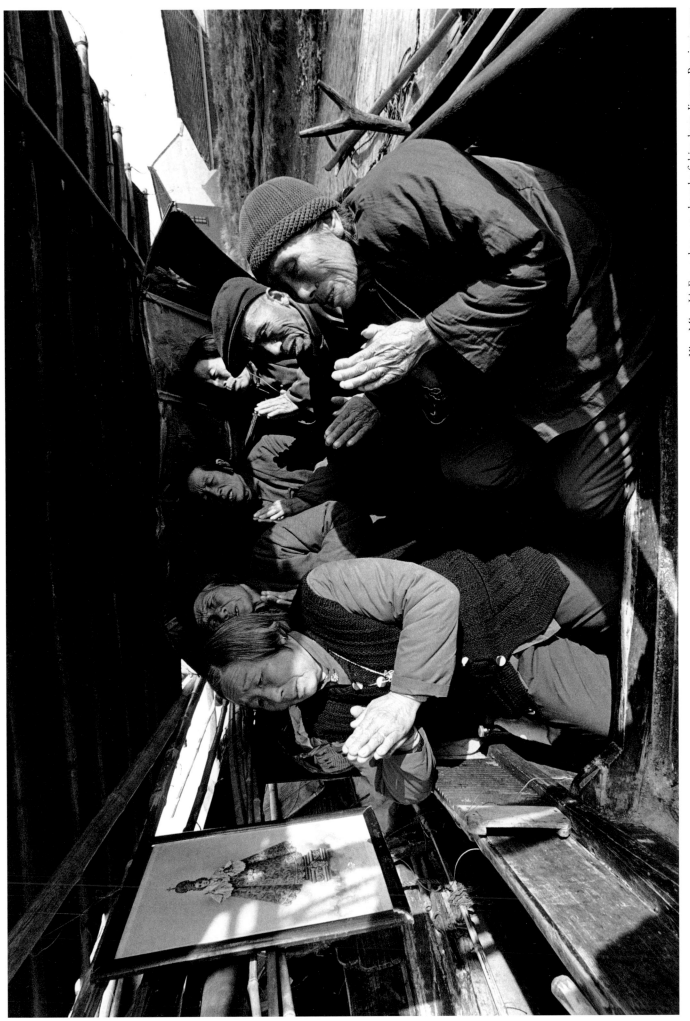

Xiao-Ming Li, Funeral prayers aboard a fishing boat, Jiangsu Province, 1993

All photographs, pages 76–83: Richard Yee, from the series "Yun Yang," Yunnan Province, 1997

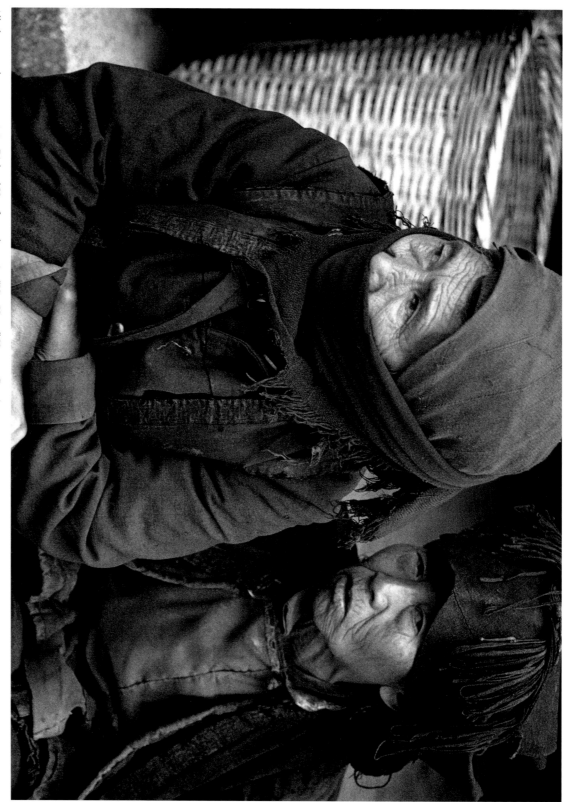

Although recalling the past may make you happy, it may sometimes also
make you lonely, and there is no point in clinging in spirit to lonely bygone
days. However, my trouble is that I cannot forget completely, and these stories
have resulted from what I have been unable to erase from my memory.

—Lu Xun (1881–1936), from Call to Arms

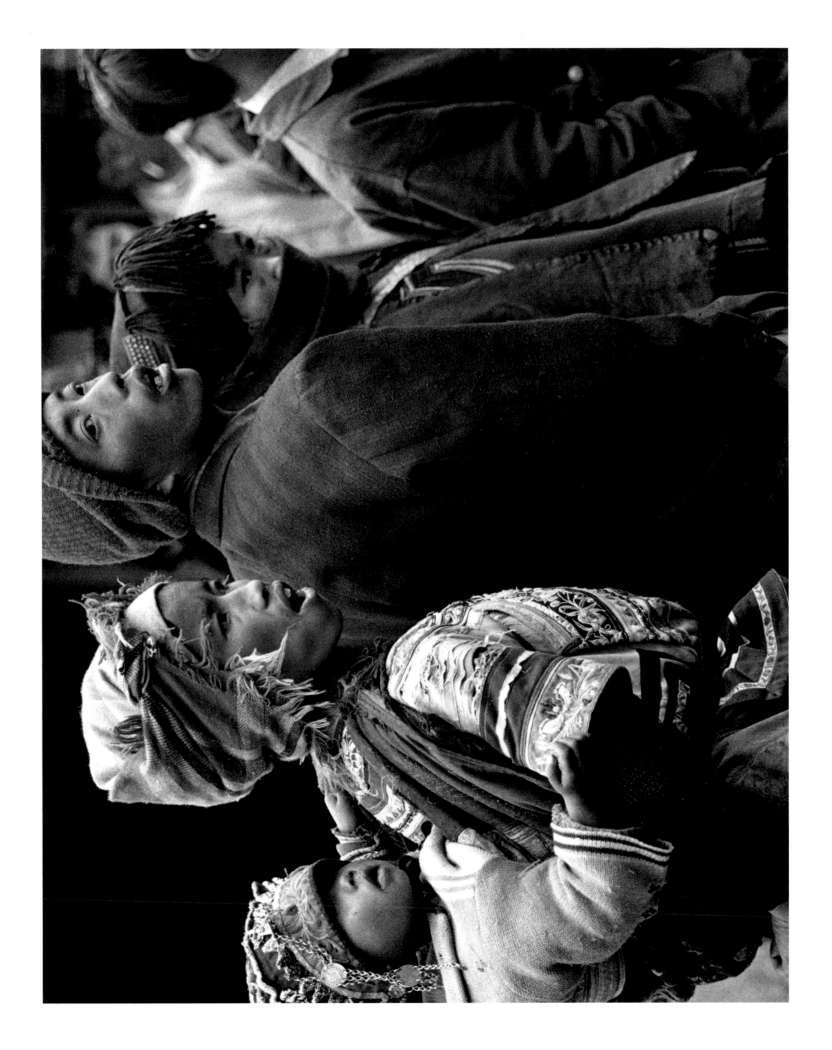

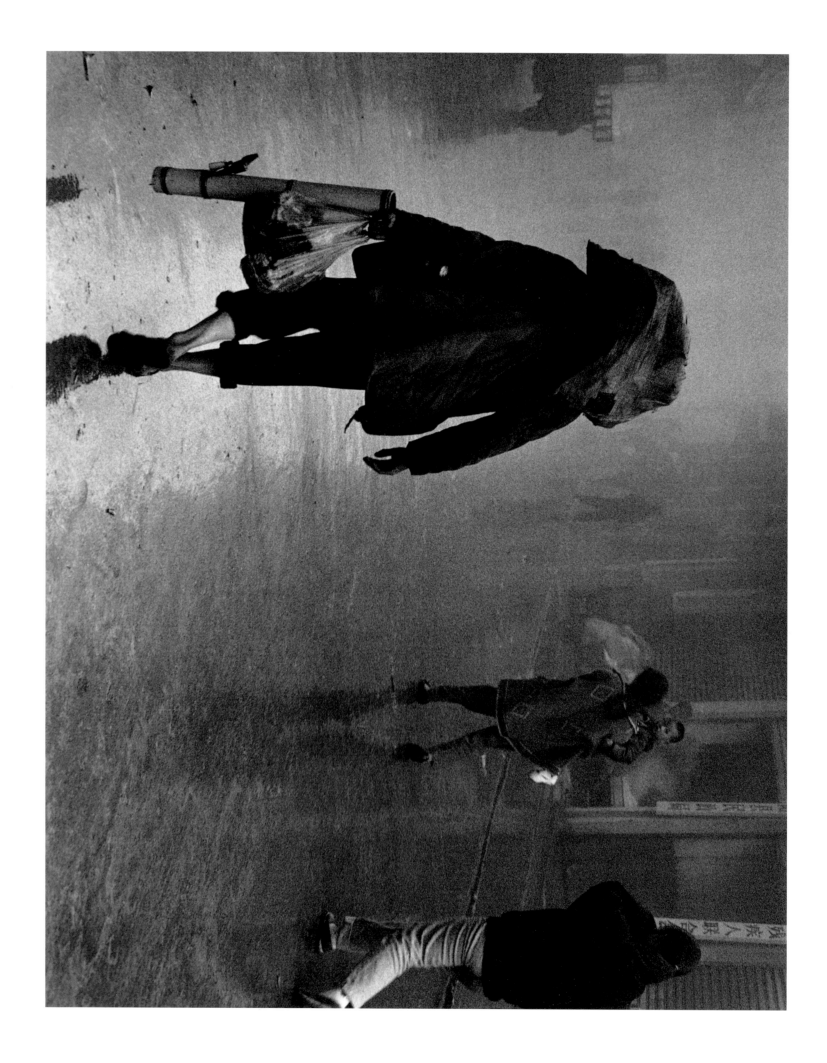

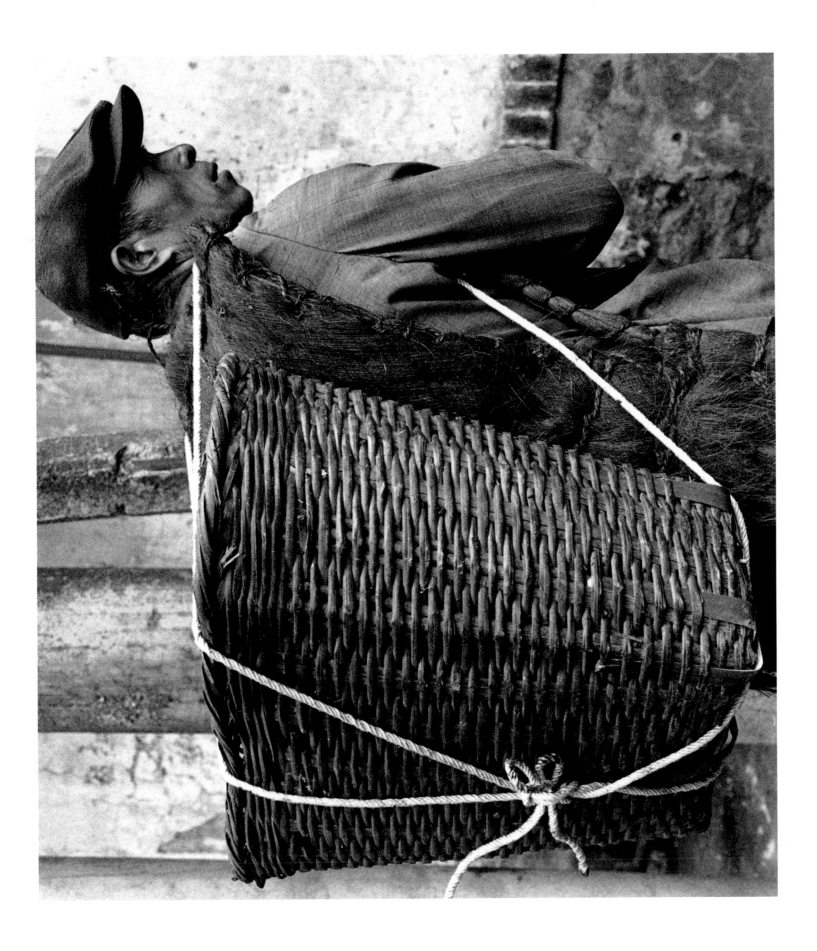

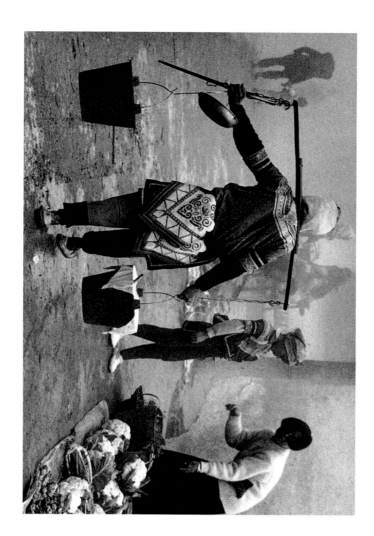

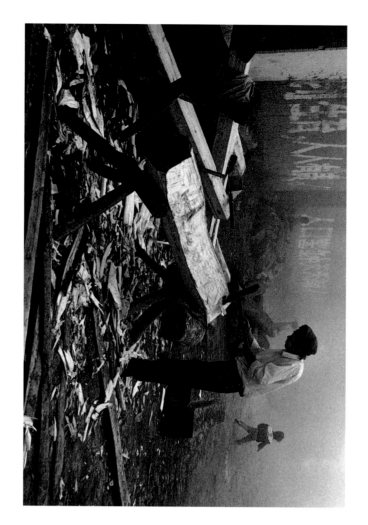

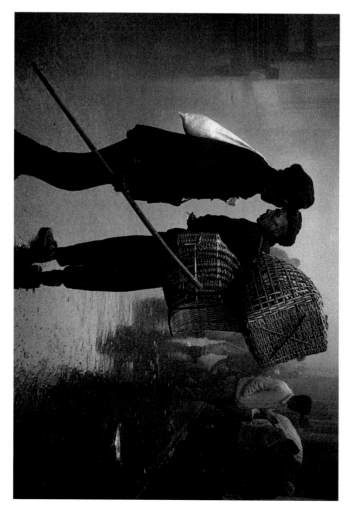

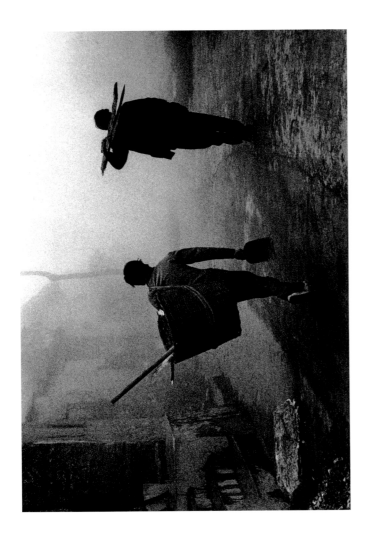

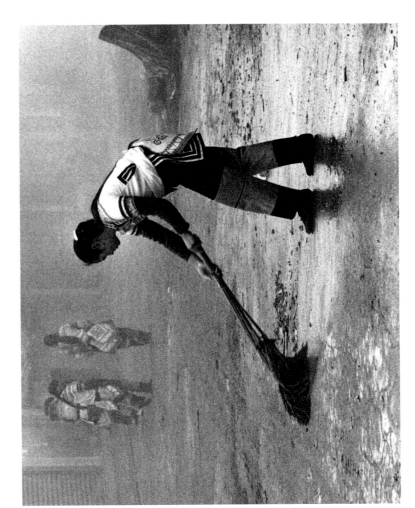

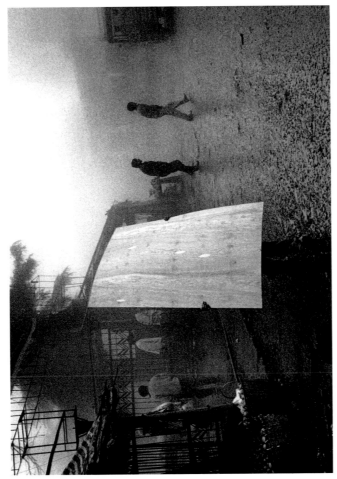

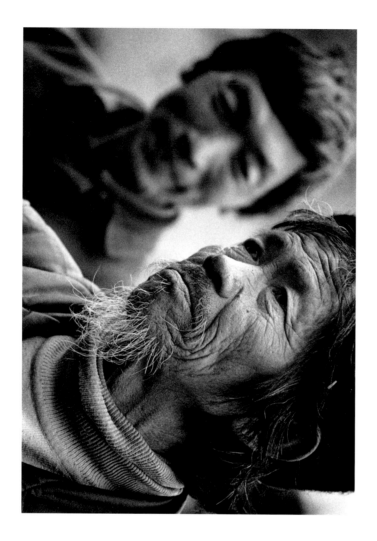

Old man of the prairie, two or three homes,
a frontier village, few neighbors around

A swaying dance for the local festival
pipes and drums worship the god of fields.

Ale is sprinkled, wetting straw dogs,
they burn incense, bow to the wooden idol.

The shamanka dances in frenzy,
dust shows on her stockings of gauze.

—WANG WEI (A.D. 699–761)
from *Sightseeing in the Moors
Outside of Liang-Zhou*

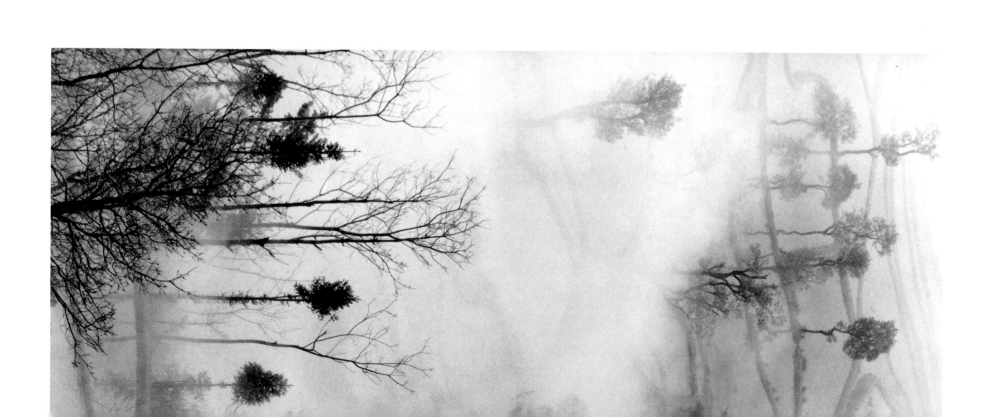

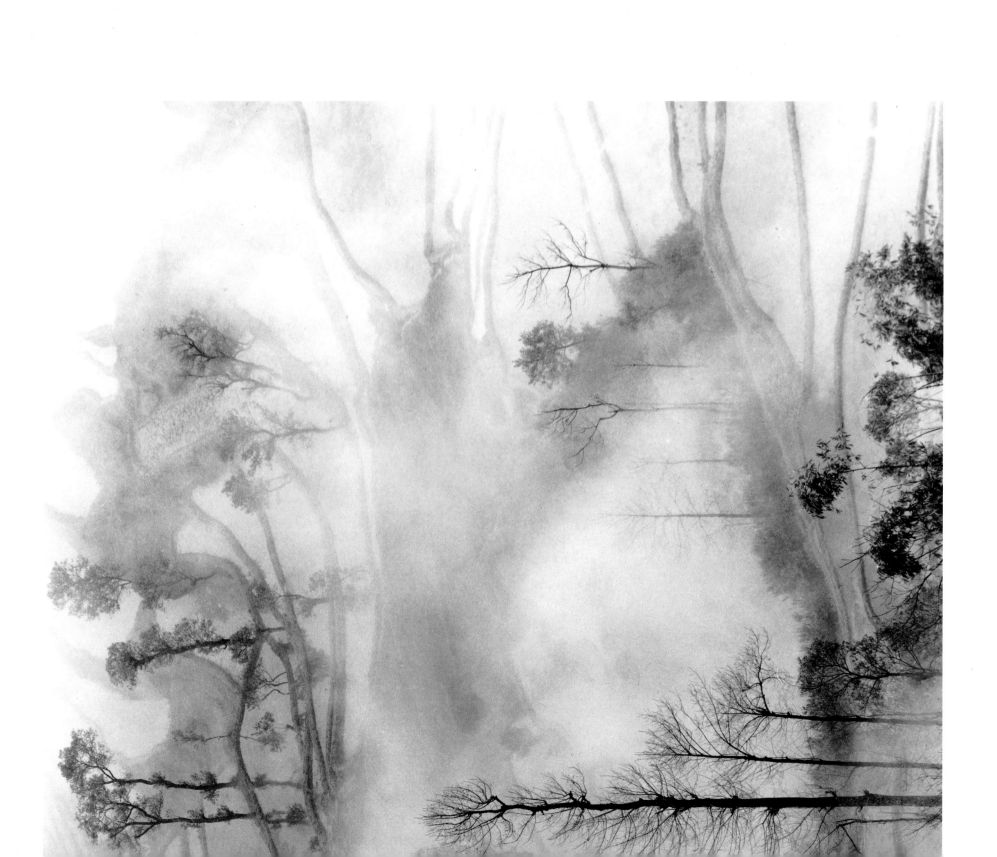

Zhaotong, Yunnan Province, 1997

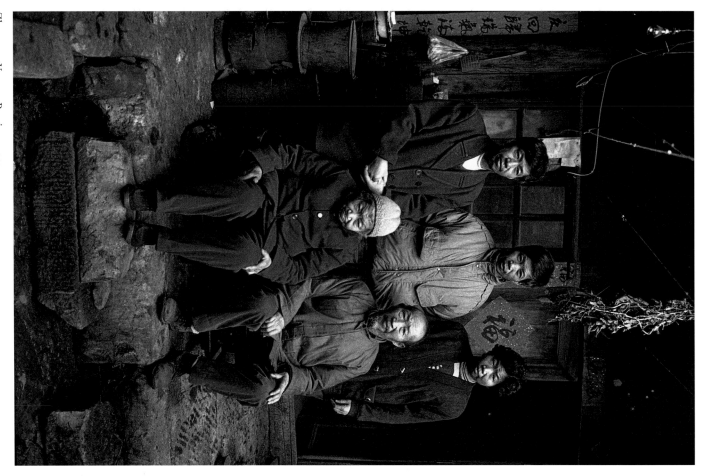

FOR THIRTY YEARS I have lived and worked in Kunming and have observed the tremendous changes that have occurred here. I left the city for two months on a trip to New York in 1997. Upon my return, I found the city so greatly transformed that I lost my way. The old Wucheng Street had disappeared from the map. Big buildings and impressive highways had blossomed everywhere, as if by magic. Some old friends who used to be quite poor had suddenly become millionaires, driving big cars and living in splendid villas. While I witness these changes through my work as a photographer, my own life remains much the same as before. —W. J.

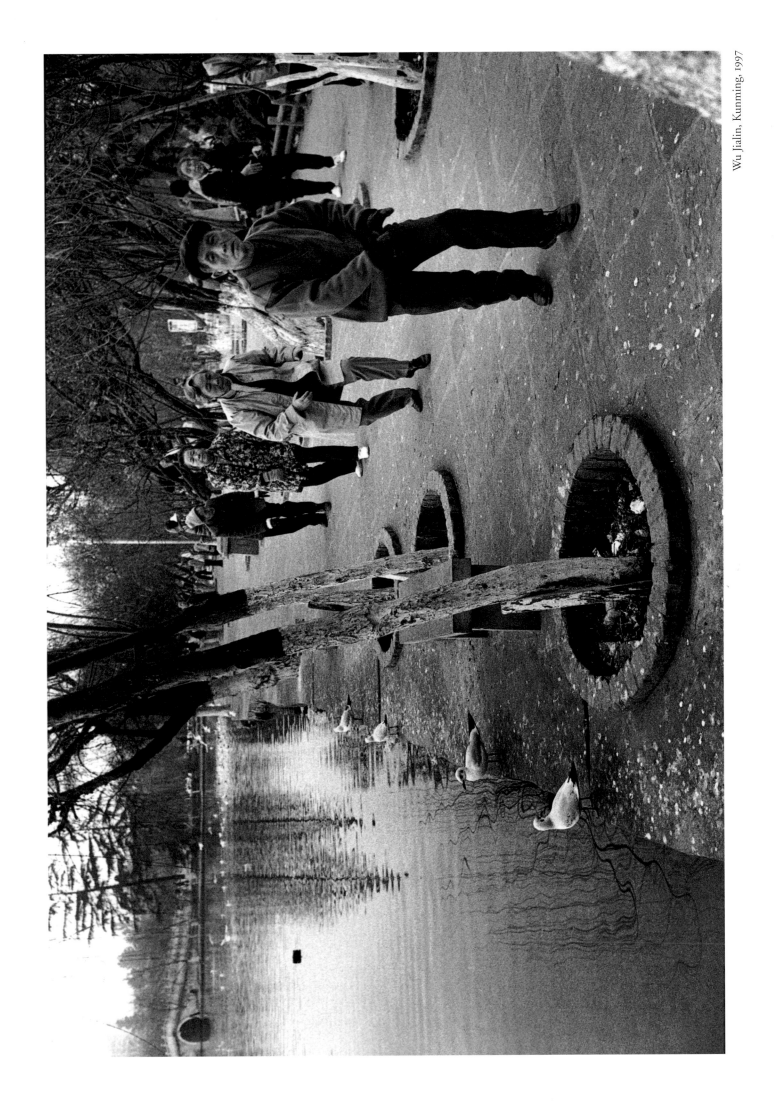

Wu Jialin, Kunming, 1997

Wu Jialin, Xian Wei, 1991

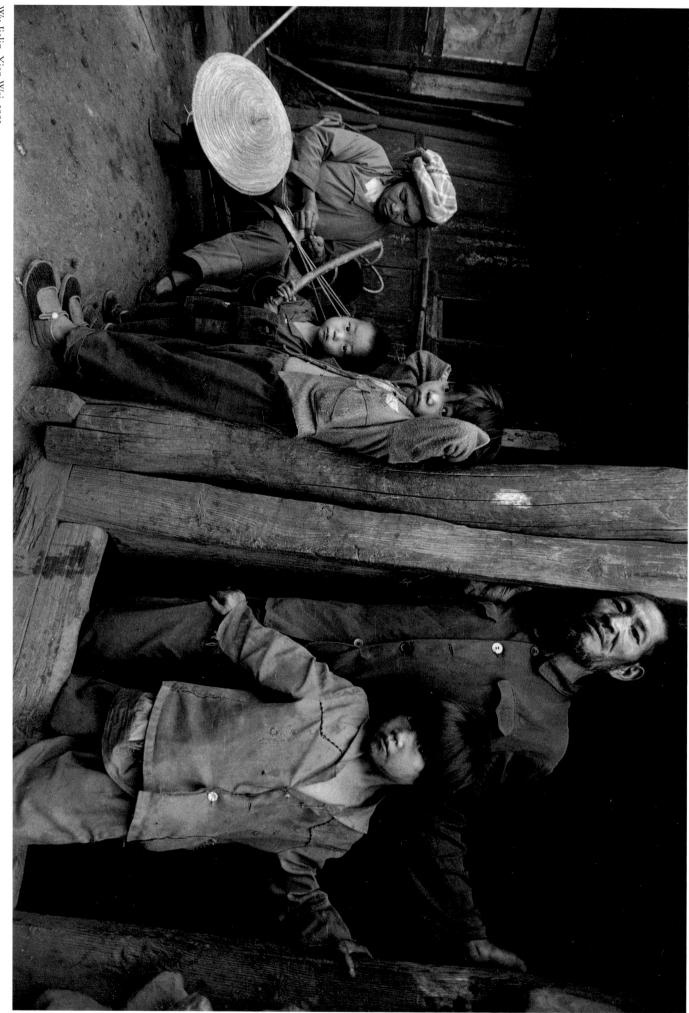

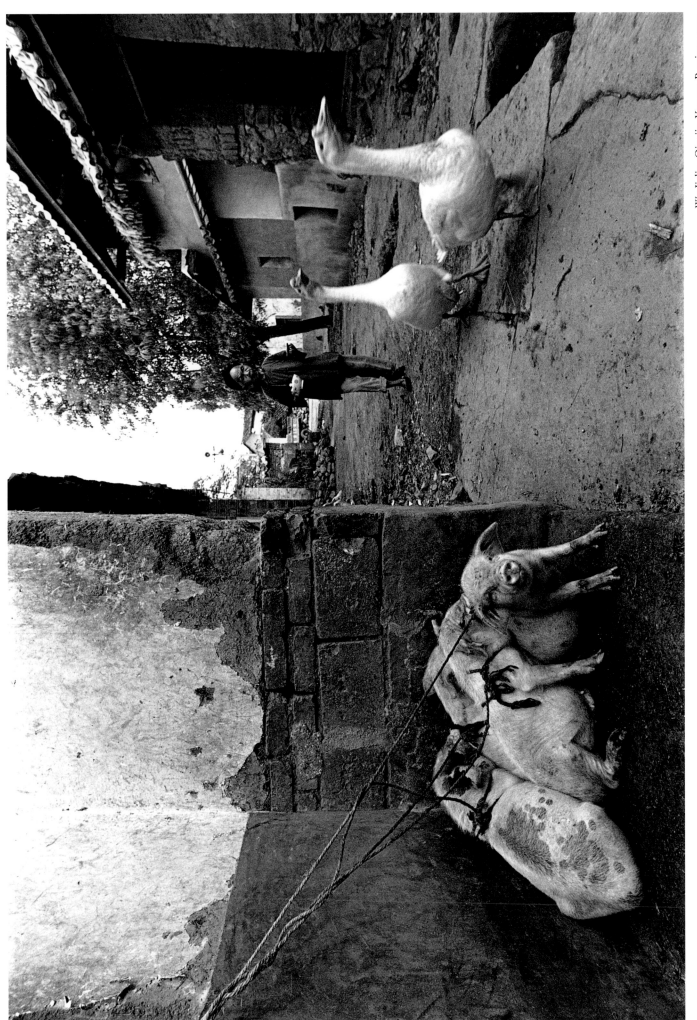

Wu Jialin, Qiaojia, Yunnan Province, 1992

Wu Jialin, Jinghong, Yunnan Province, 1991

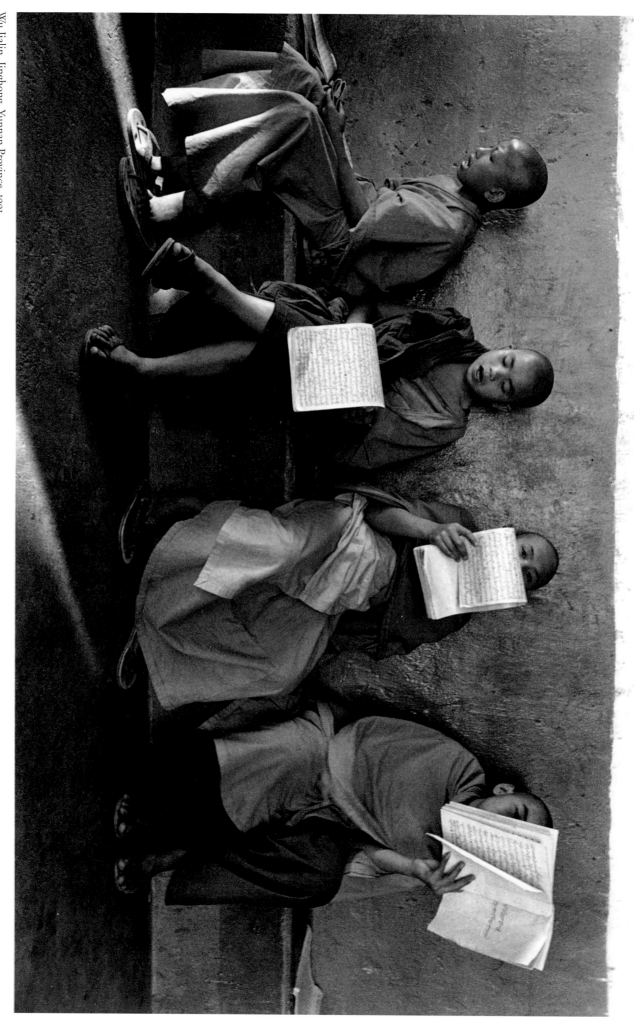

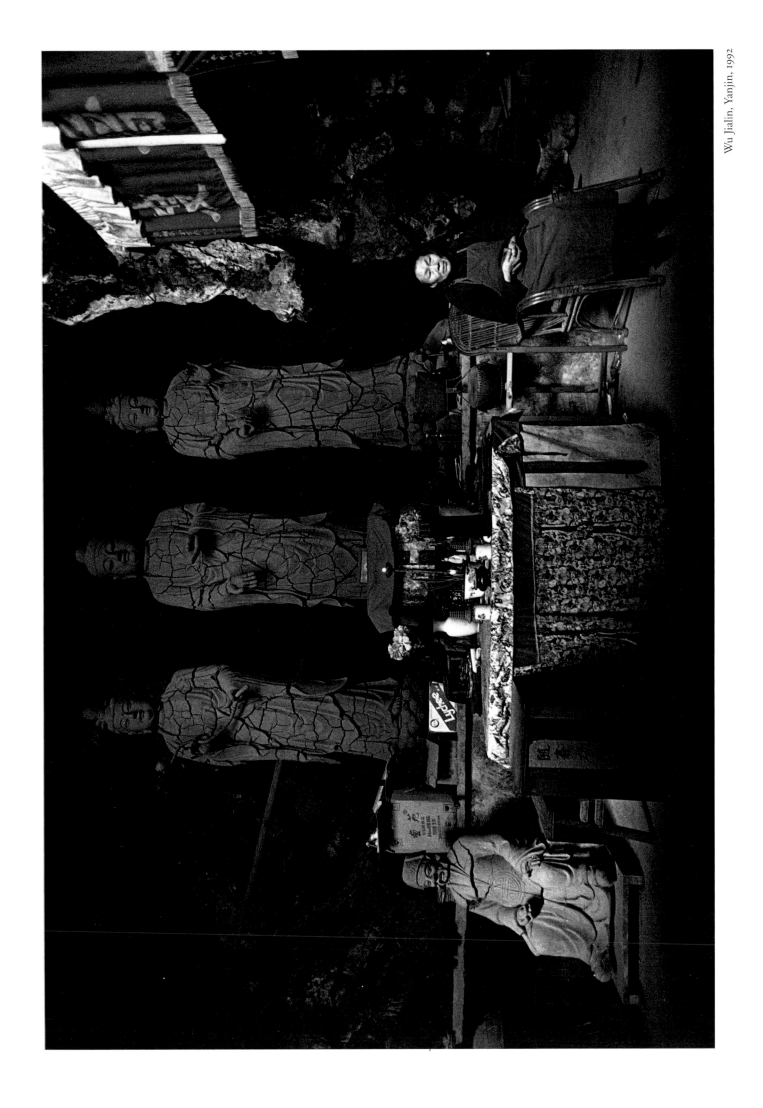

Wu Jialin, Yanjin, 1992

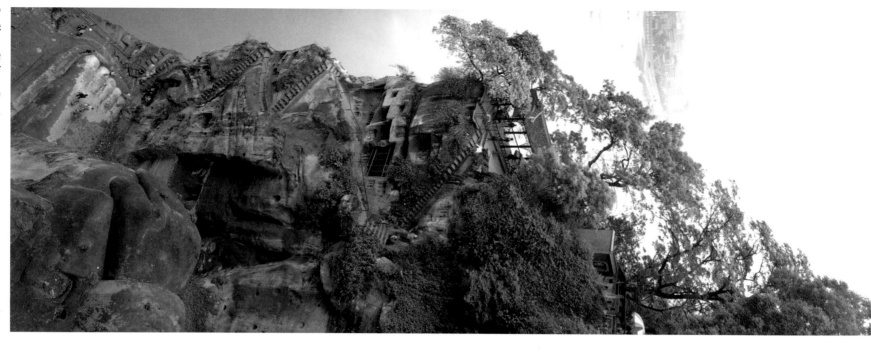

Le Shan, Sichuan Province, 1986

LOIS CONNER THE VOICE OF THE LAND

I AM INTERESTED IN LANDSCAPE and how culture can be revealed through it. These photographs describe my relationship to both the mythical and the veritable China.

Either I was born a traveler/adventurer, or my curiosity is insatiable, or both. I am an obsessive collector and observer of the landscape. What initially sends me out into the unknown is often a photograph or painting that haunts me because of its absolute unfamiliarity. What I end up uncovering is unpredictable, surprising, and often exhilarating. Trying to describe that encounter visually through photography is nearly impossible. It's also invigorating trying to twist what the camera faithfully describes into something of fiction. The camera's elongated rectangle can perhaps, with the confluence of light, circumstance, chance, and a dozen other factors, conjure up a world, one seemingly half-imagined, or one that breathes with the life of thousands of years of history. Sometimes it simply acknowledges the beauty of the land.

My journey through the Chinese landscape has lasted fifteen years. Although the geographical area that I initially went to explore still holds me firmly in its grip, my perceptions have changed. Guilin has become familiar, though still breathtaking and sublime. It is a real place, where most people barely take notice of the land as they go about their daily lives. The first time I saw representations of the Guilin limestone formations was in an art history class at Yale. Learning that these mountains (which bear a strange resemblance to a scanning electron photomicrograph of the human tongue) are not fabrications of artistic imagination was a revelation. Yet a complex life exists within. For more than two thousand years the area has been a muse for poets, writers, and painters who came to see and experience this landscape, to make part of it theirs. Guilin has been the microcosm through which I have investigated and experienced China, its land and culture; Guilin has offered something tangible on which to base my comparisons. This is where I became a photographer. —L. C.

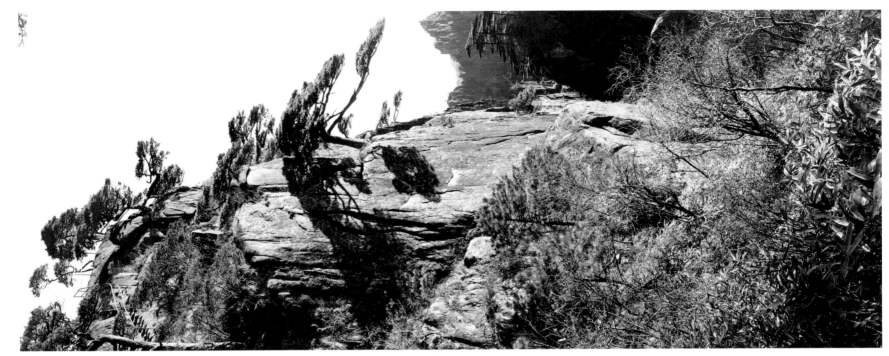

Lois Connor, Huang Shan, Anhui Province, 1984

No one in sight
On the empty mountain
But their voices are heard.

The sun slants deep
Into the mountains
And the green moss
Lights up again.

—WANG WEI
(A.D. 699–761)

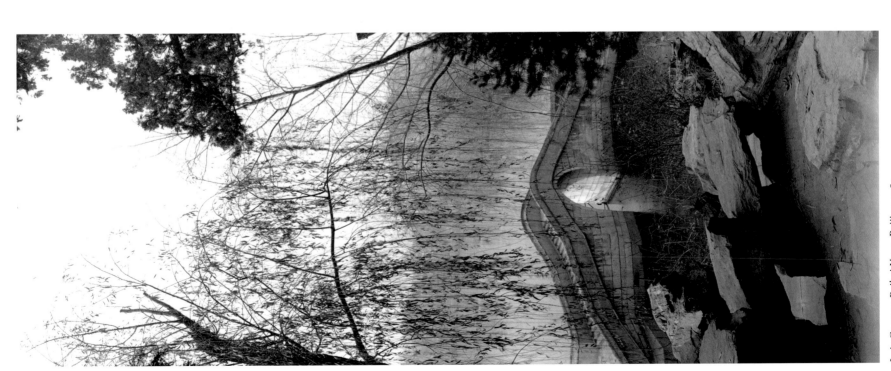

Lois Connor, Beihai Yuan, Beijing, 1984

Lois Conner,
Zigui, Sichuan Province, 1997

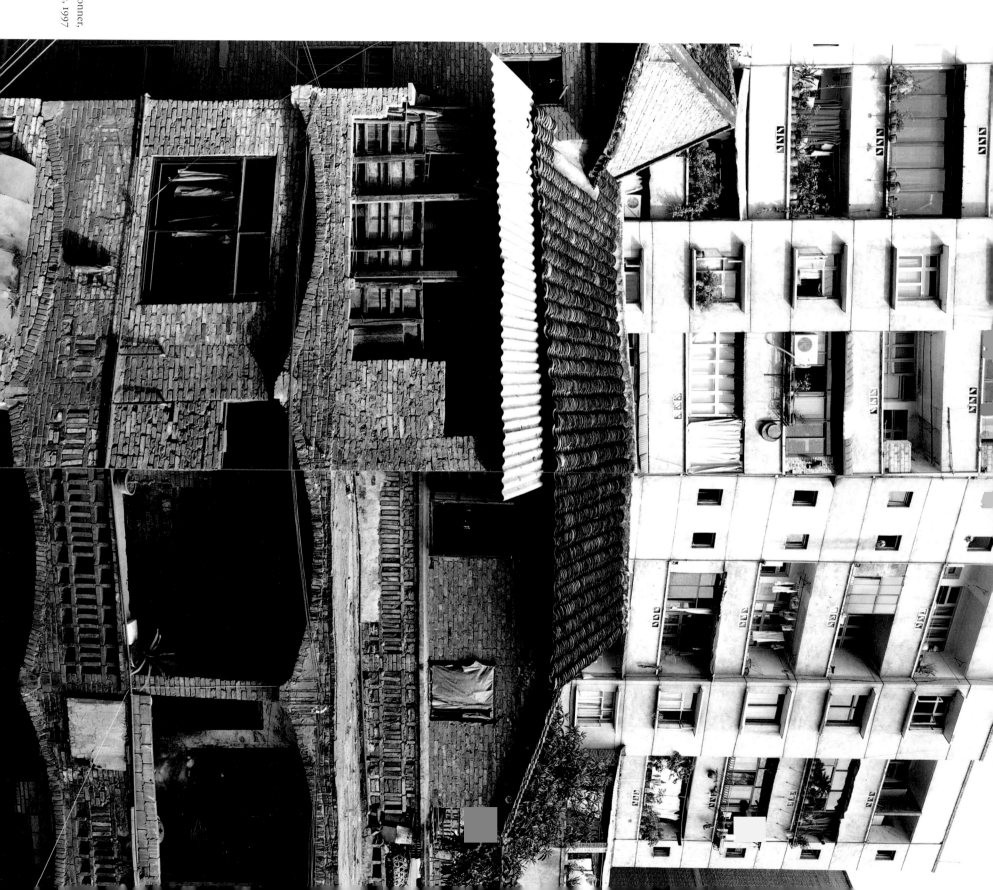

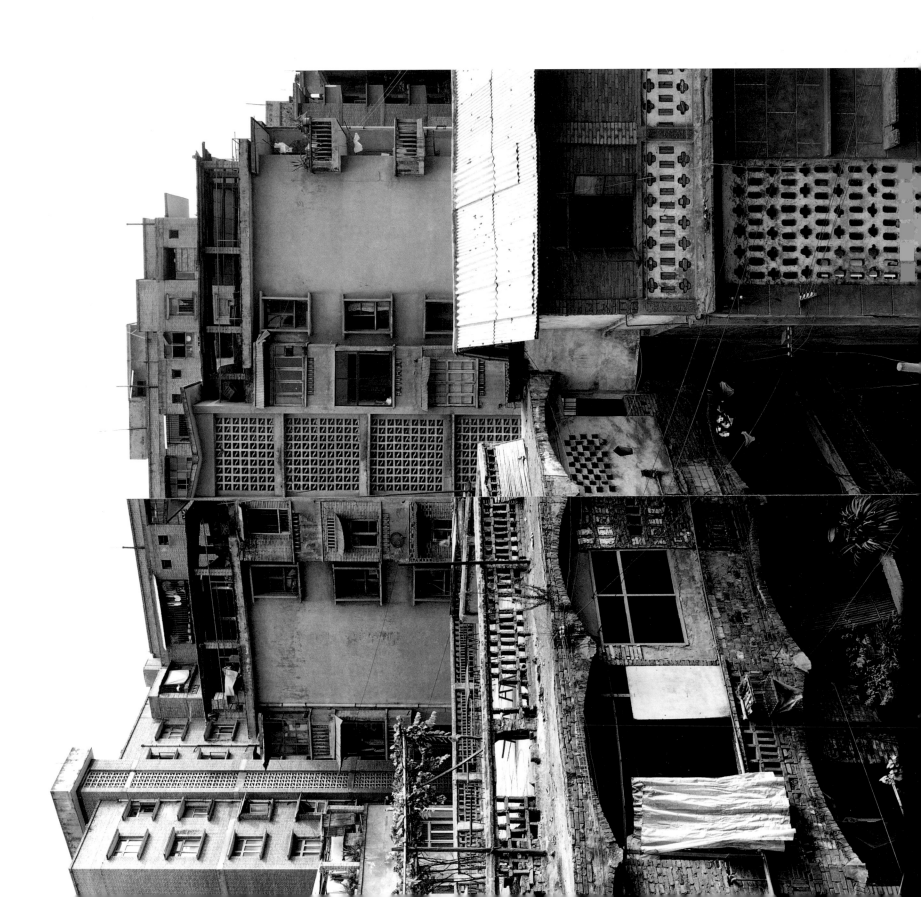

Lois Conner, Xi Hu, Zhejiang Province, 1984

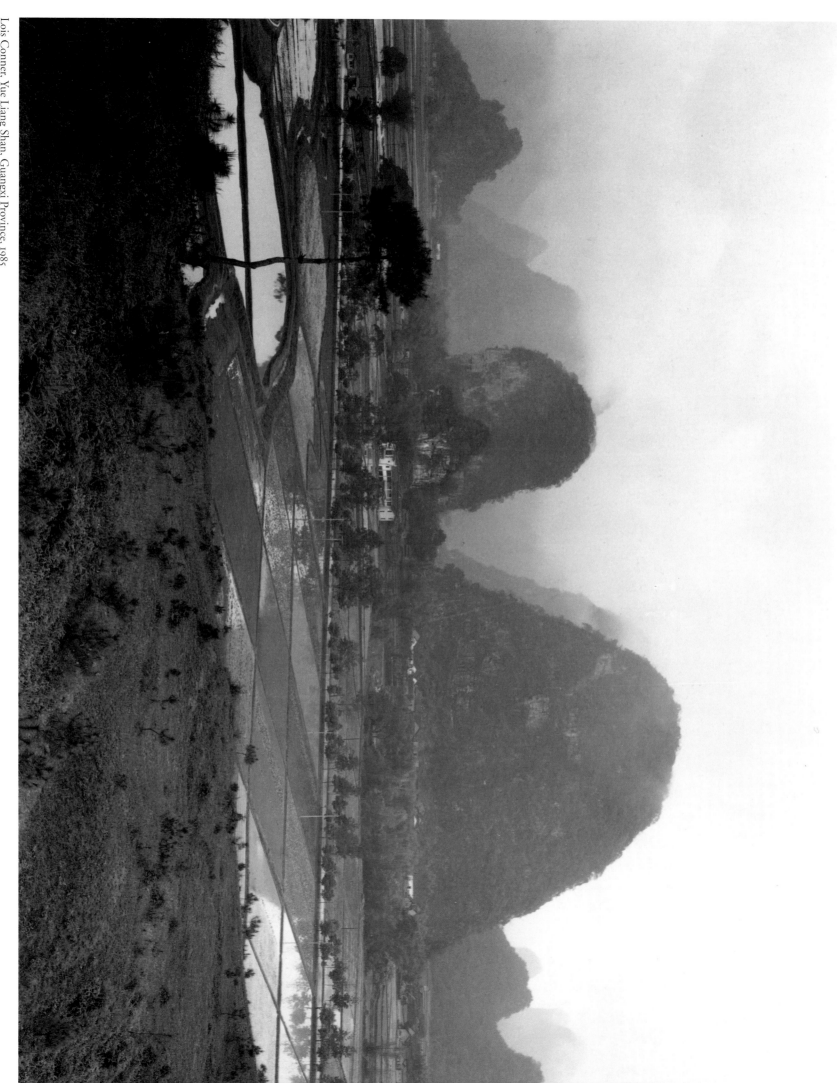

Lois Conner, Yue Liang Shan, Guangxi Province, 1985

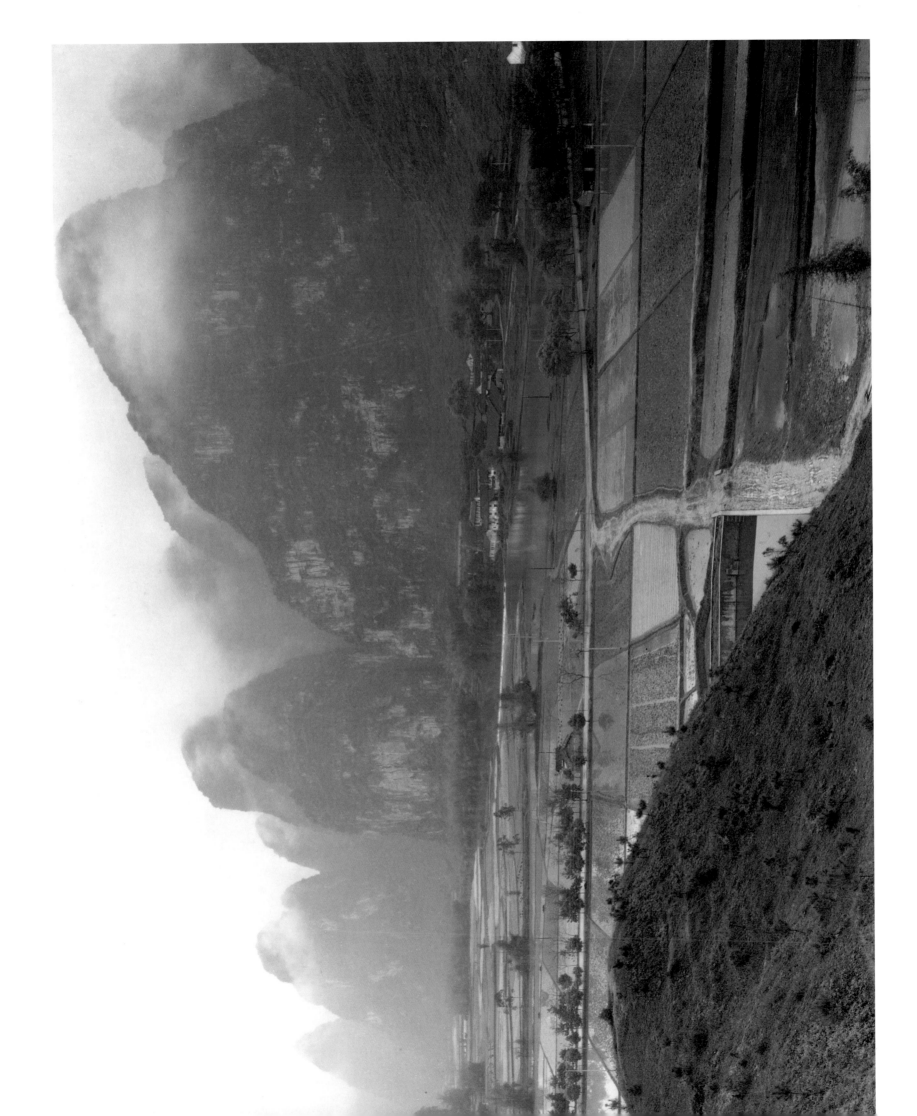

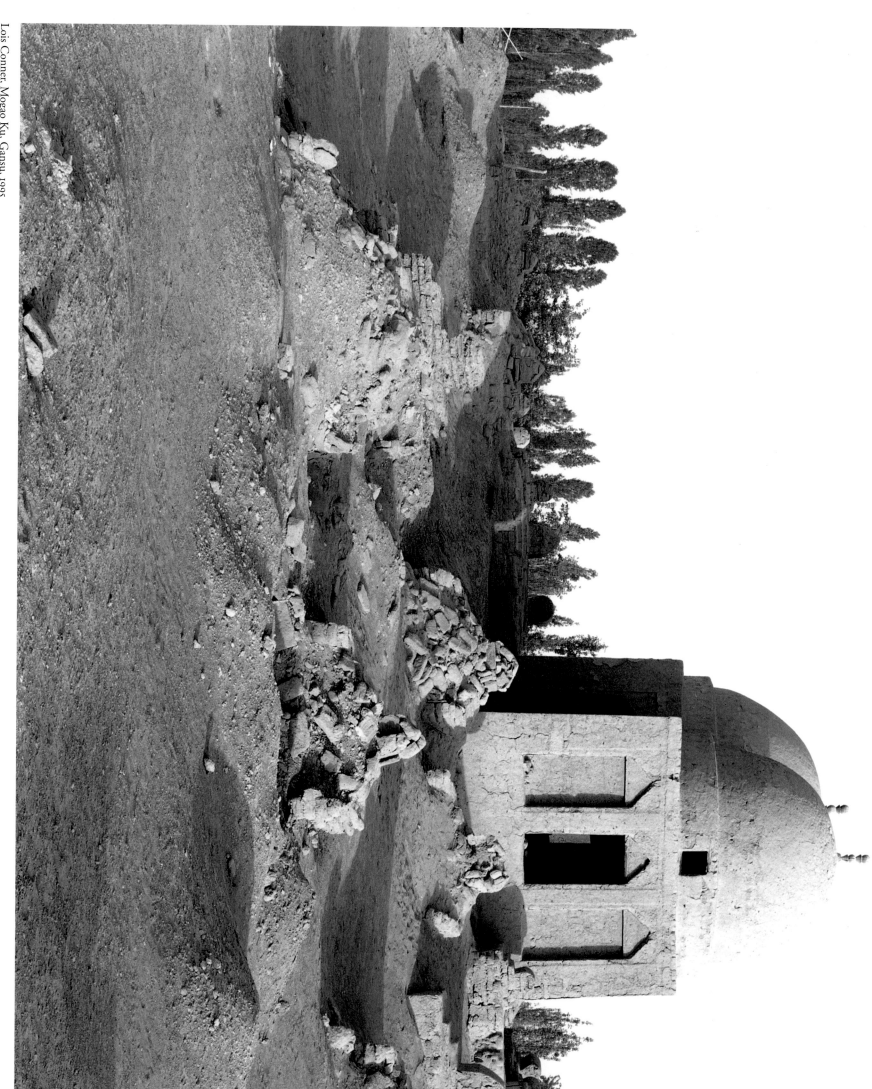

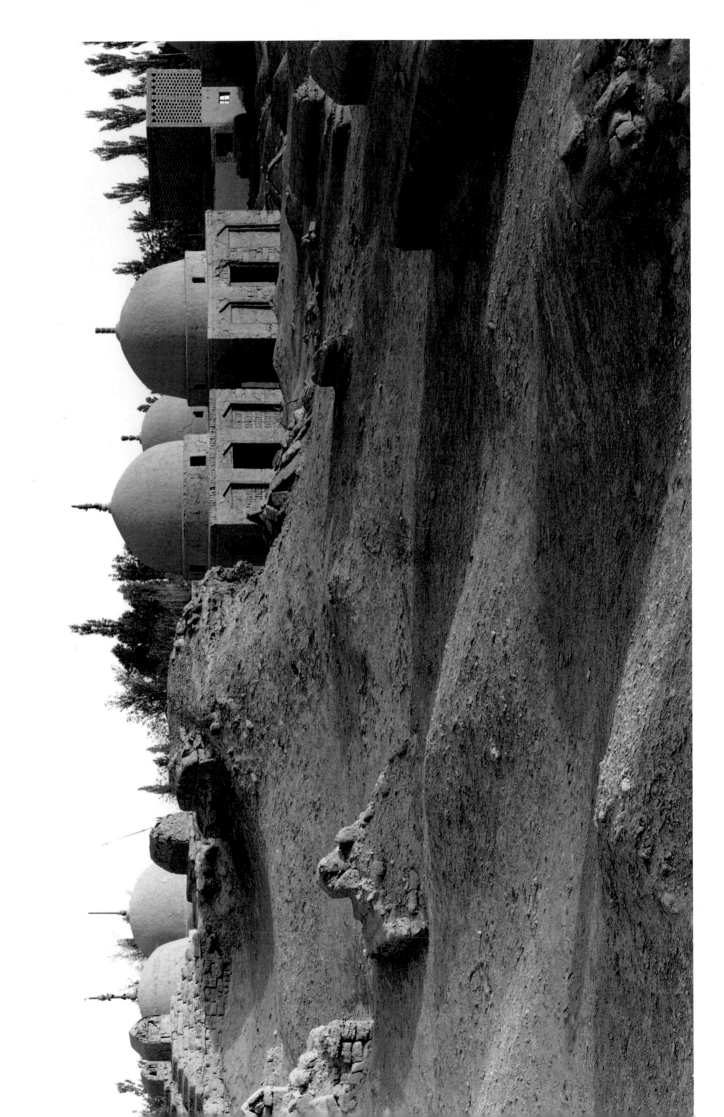

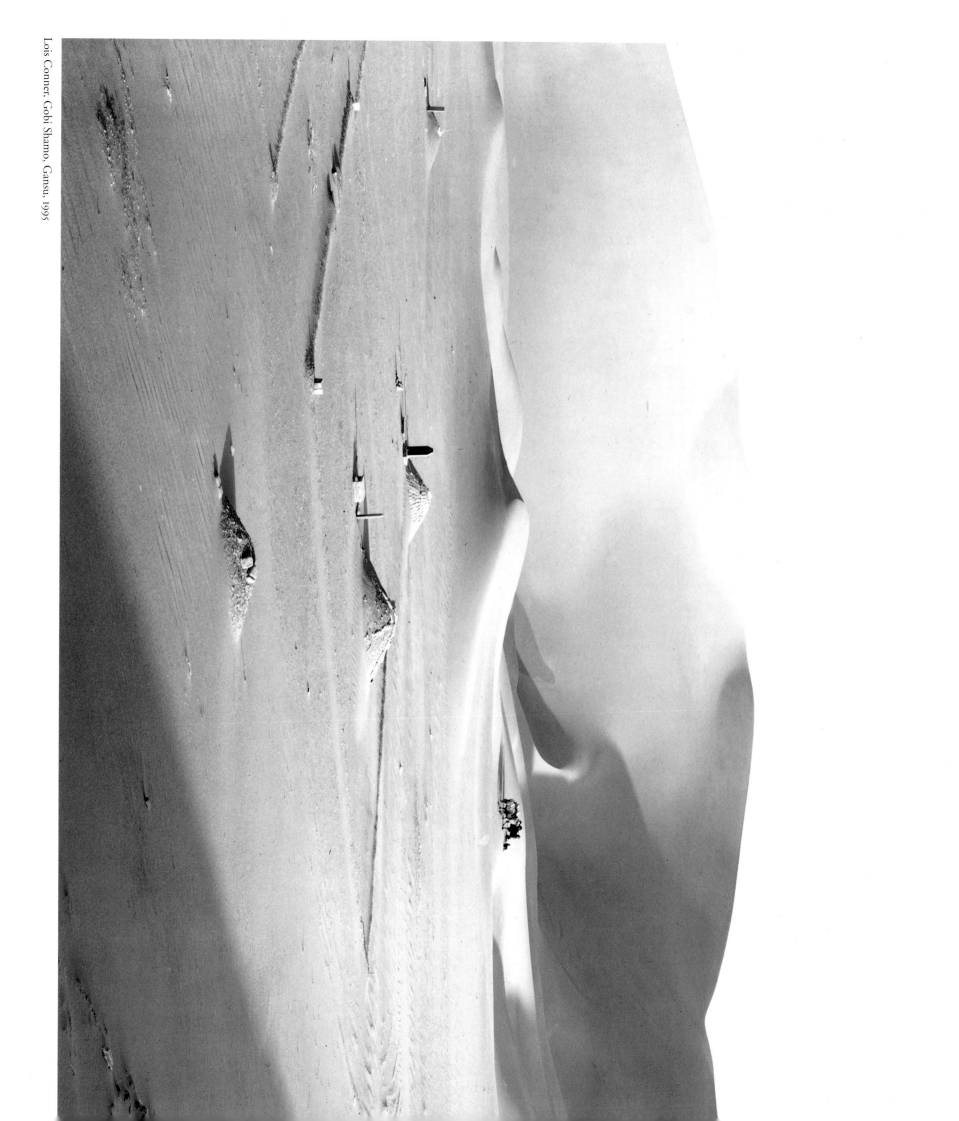

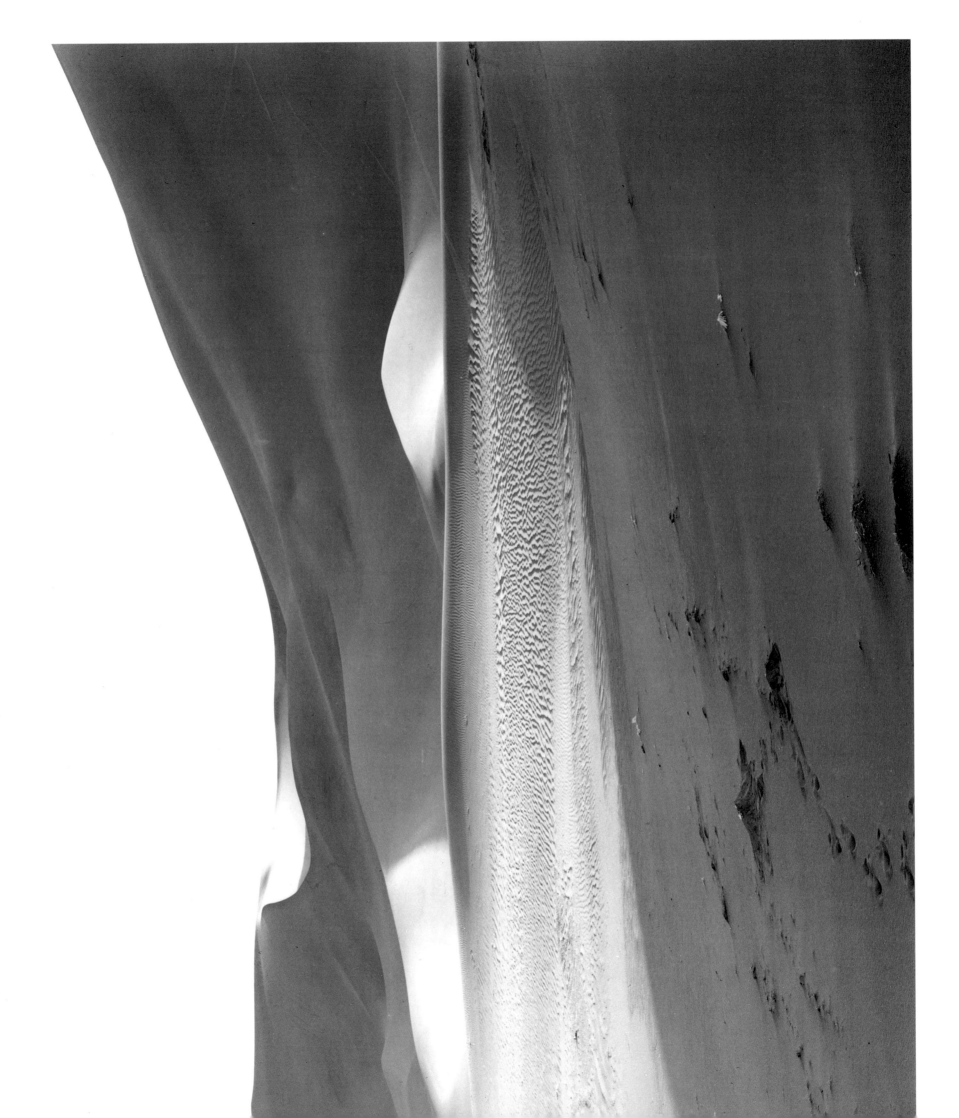

Kunming, 1995

A couple from the Va ethnic community, Simong, 1982

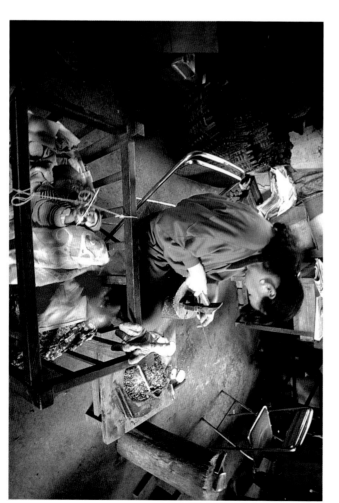

Apprentice silversmith, Lijiang, Yunnan Province, 1994

In a car of the Jijie-to-Gejiu narrow-gauge railroad, Yunnan Province, 1990

The cuckoo is on the mulberry tree,
Her young on the hazel.
Good people, gentle folk—
Shape the people of this land.
Shape the people of this land,
And may they do so for ten thousand years!

—Anonymous
(Ninth–seventh century B.C.),
from *The Book of Songs*

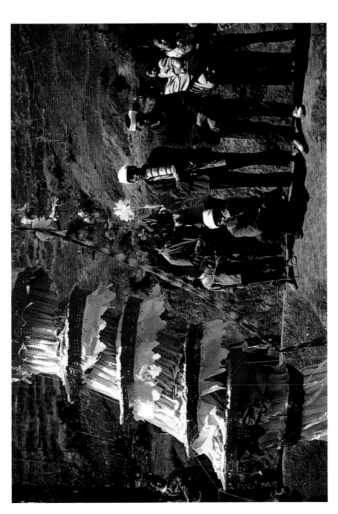

Funeral in Wumengshan Mountains, Huize, Yunnan Province, 1992

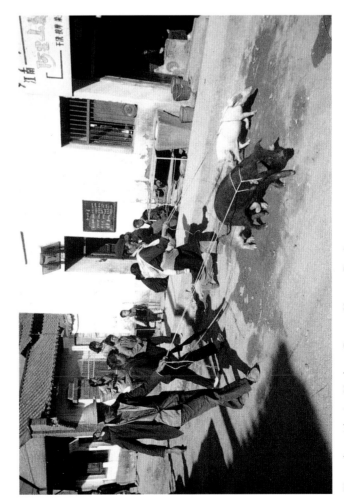

To market with pigs, Yunlong County, Yunnan Province, 1995

I'm golden as a harvest,
as a ripe tangerine among
green leaves.
I'm fresh-mown hay, a shore of
exploding sand.
I'm golden. Every golden evening,
gilding the inscriptions on
crude monuments, my dreams
engender history.
Perhaps, as the time approaches,
I'll grow silent.
I'll rise again and again,
like the sun from the
fathomless sea,
announcing to the world,
in the voice of the spectrum,
rearranging all the characters
and the words:
The East is merely a myth no longer!

—Gu Cheng (b. 1956),
from "Capital 'I'"

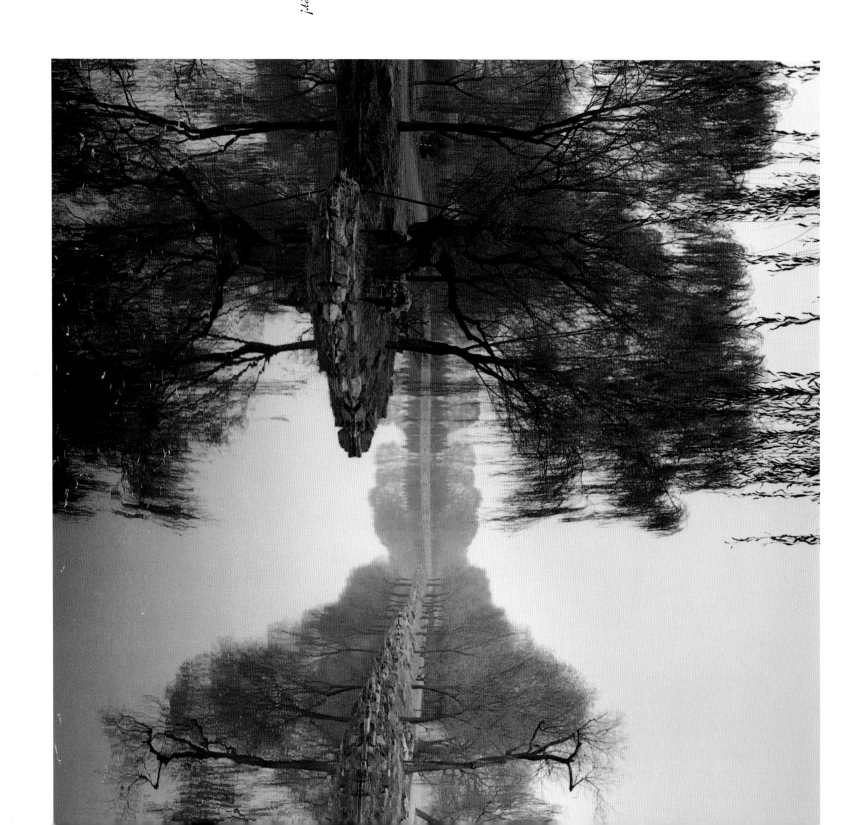

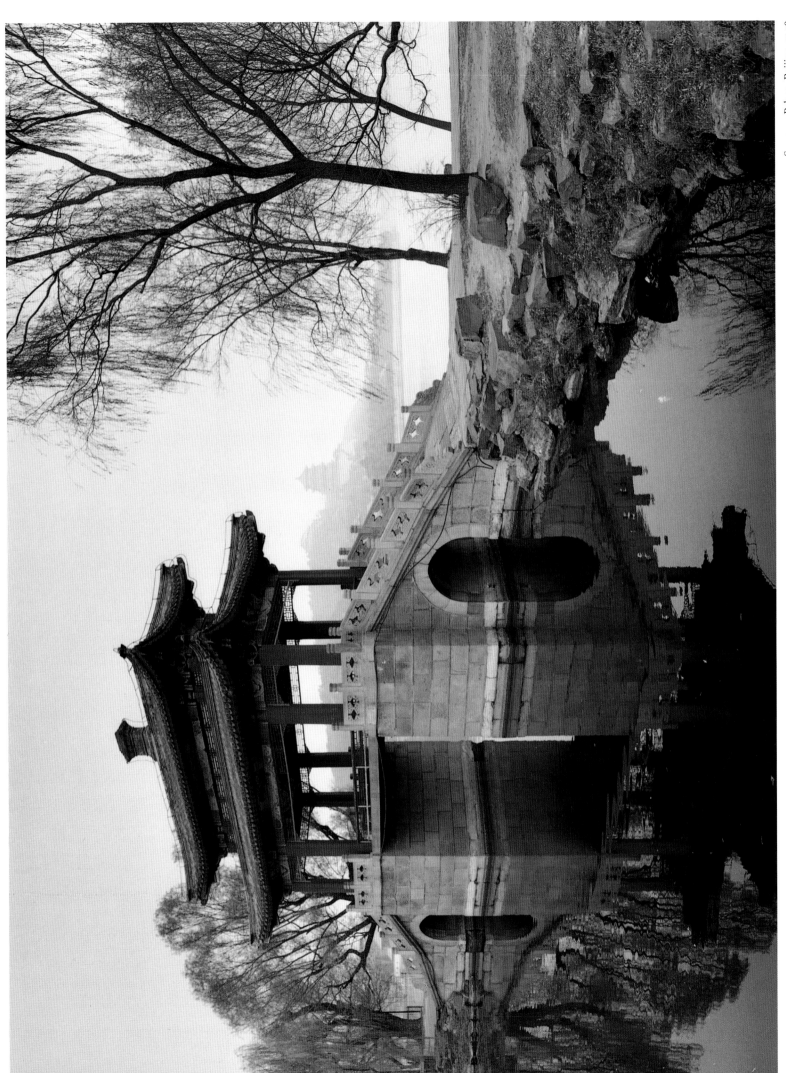

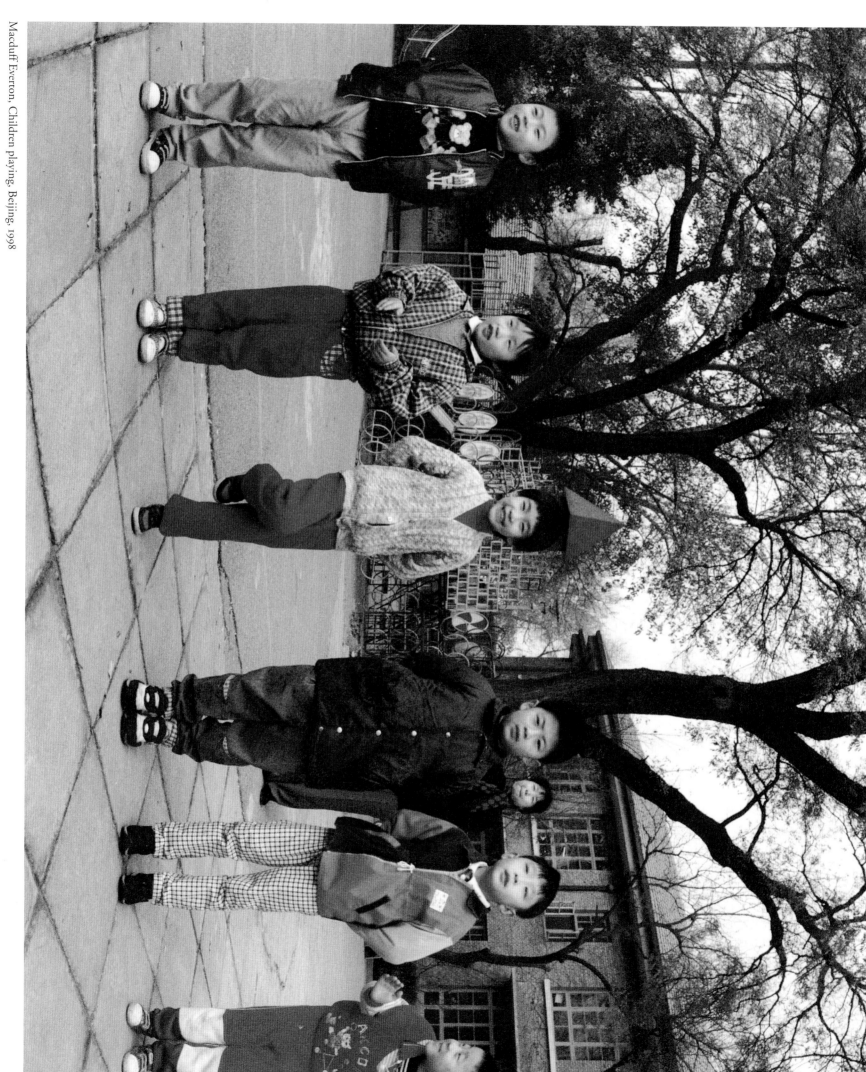

Macduff Everton, Children playing, Beijing, 1998

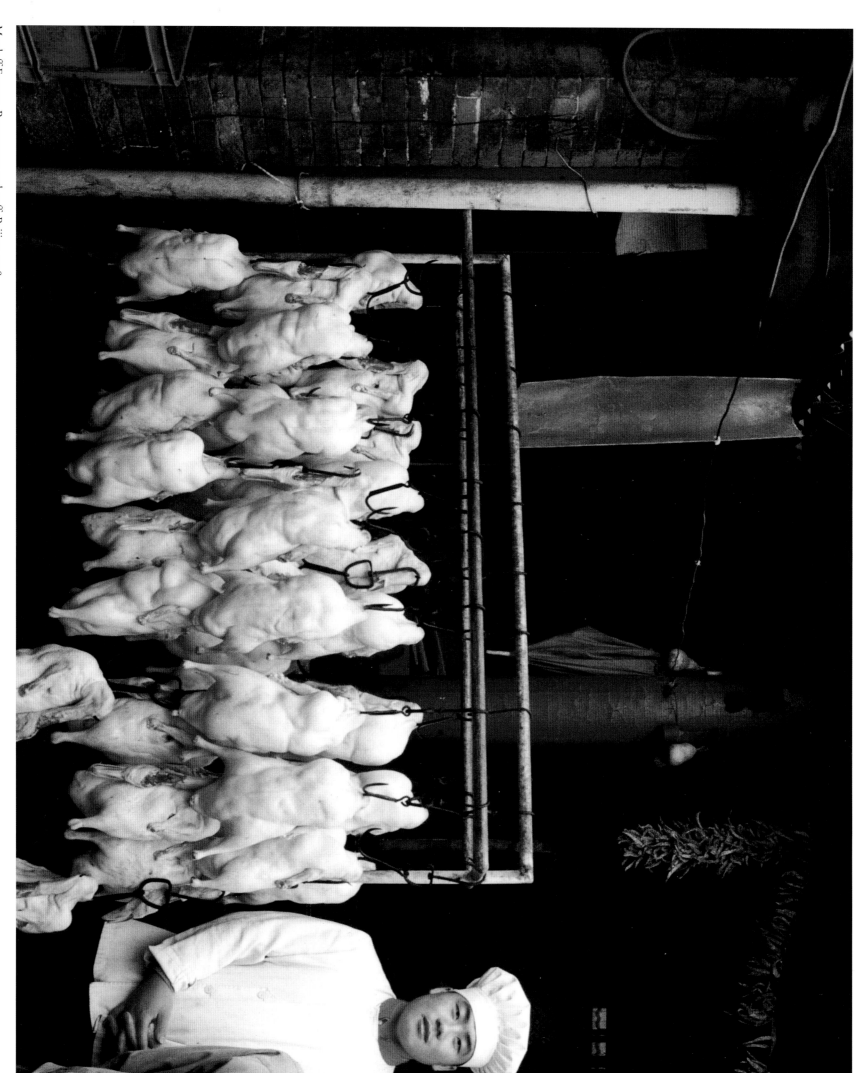

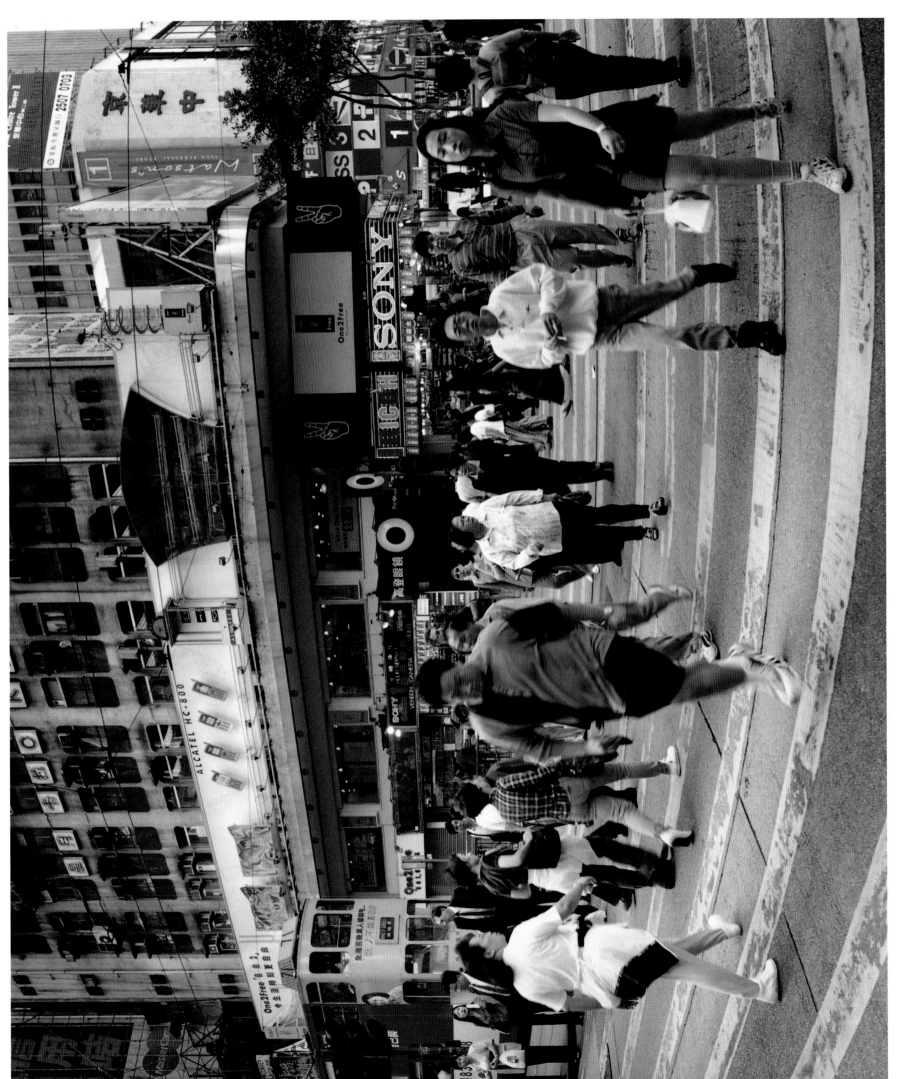

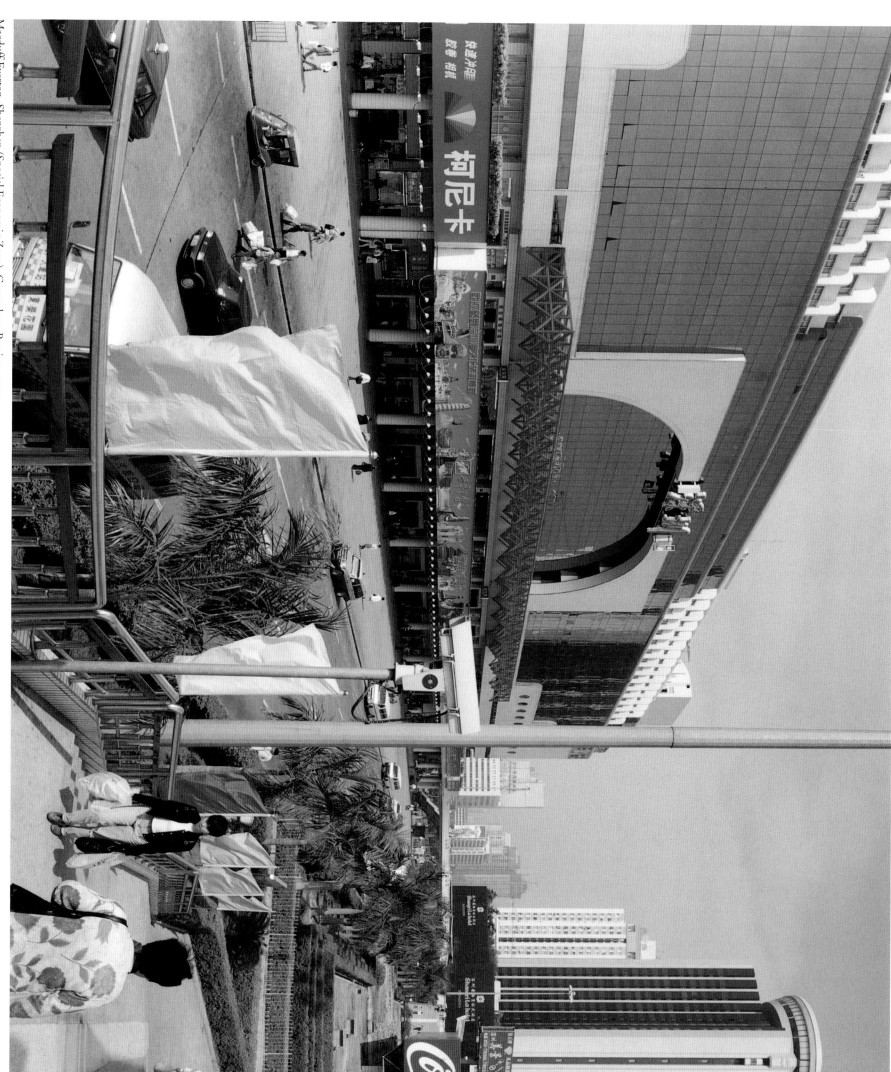

Macduff Everton, Shenzhen (Special Economic Zone), Guangdong Province, 1995

ZHANG HAI-ER SILENCE

Maioqian Street,
Guangzhou, 1987

Behind the painted doors and
 embroidered curtains
There used to be music and dancing;
Hunting or fishing parties were held
In the emerald forests or beside
 the marble pools.
The melodies from various states
And works of art and rare fish and horses
Are all now dead and buried.
The young girls from east and south
Smooth as silk, fragrant as orchids
White as jade with their lips red,
Now lie beneath the dreary stones and
 barren earth.
The greatest displeasure of the largest
 number
Is the law of nature.
For this ruined city,
I play the lute and sing:
"As the north wind hurries on,
 the battlements freeze.
They tower over the plain
 where there are neither roads nor
 field-paths.
For a thousand years and a myriad
 generations,
I shall watch you to the end in silence."

—BAO ZHAO (A.D. 414–466),
 from Tedious Ways

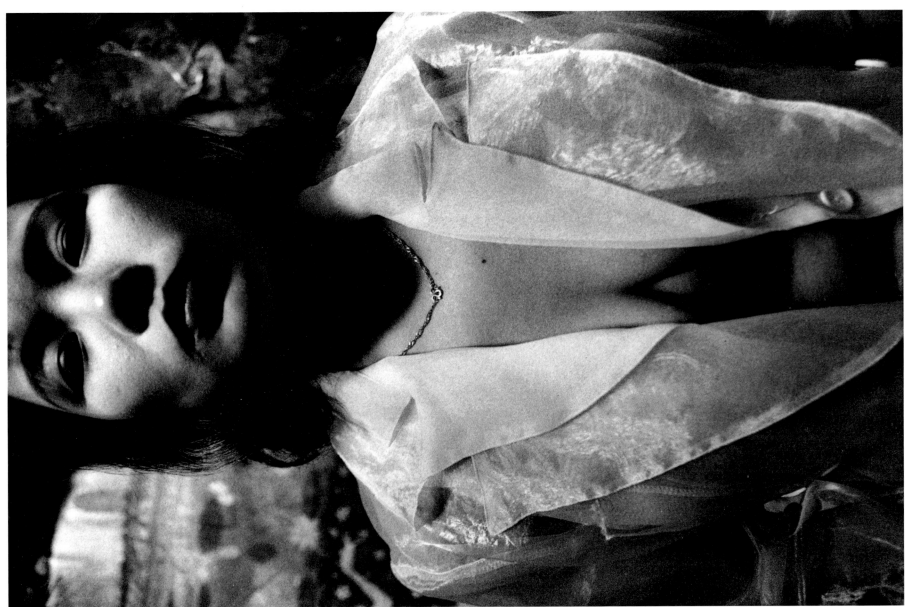

Zhang Hai-er,
Miss Lin,
Shanghai, 1989

Zhang Hai-er,
Miss Lin,
Shanghai, 1989

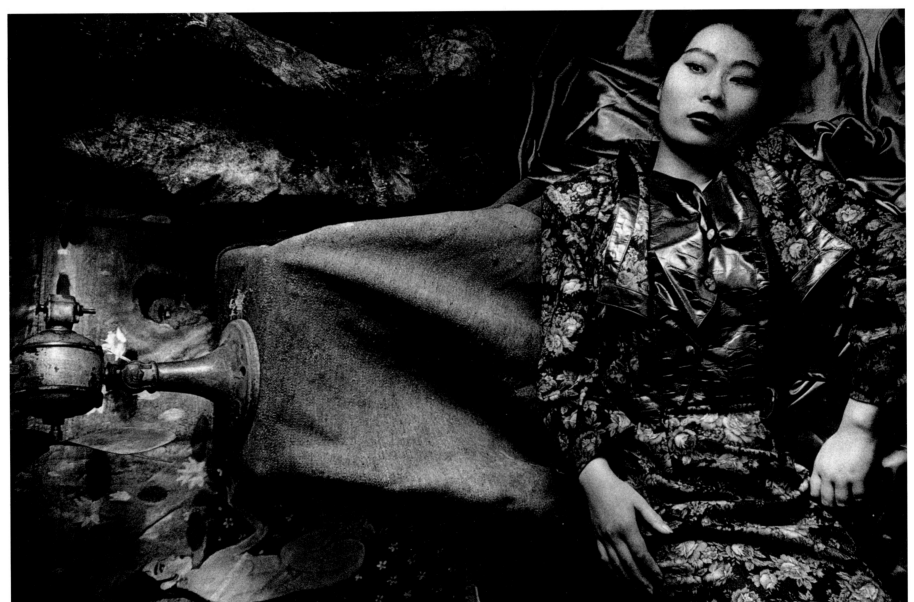

Zhang Hai-er,
Miss Li,
Guangzhou, 1989

Zhang Hai-er,
Miss Jiang,
Beijing, 1989

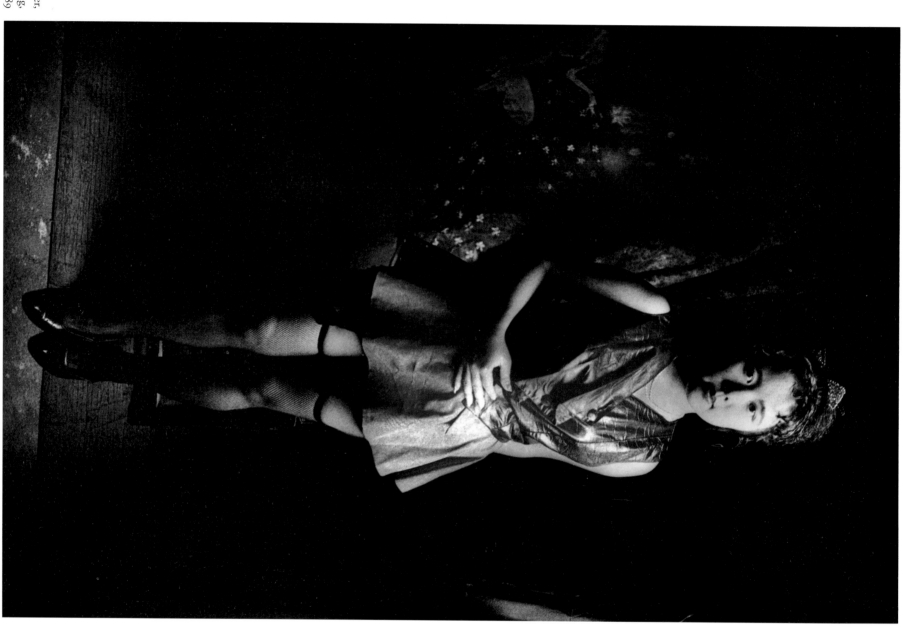

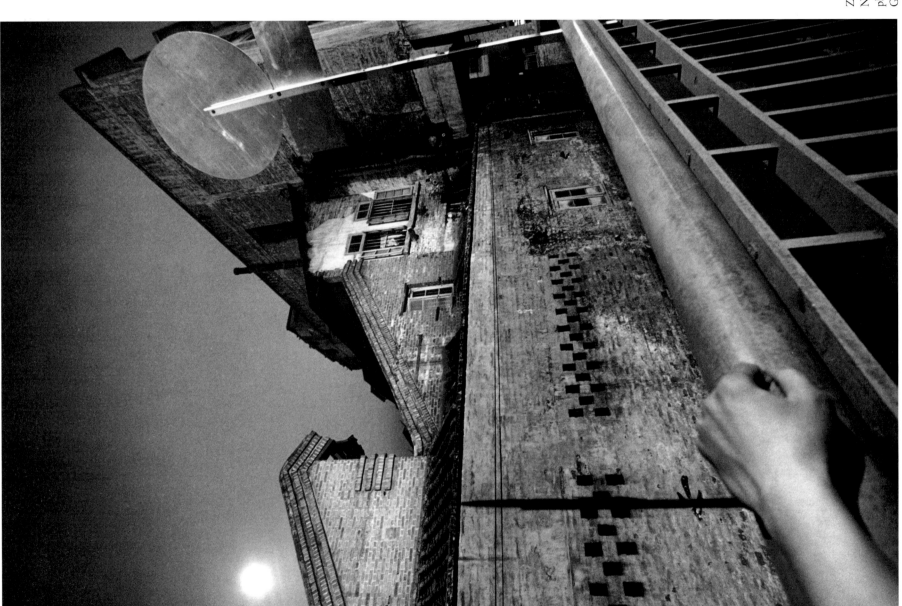

Zhang Hai-er,
Night scene with the
photographer's left hand,
Guangzhou, 1987

TO MOST AMERICANS, China is a giant, vexing puzzle. But beyond its daunting linguistic and cultural barriers, China is a strikingly ordinary place. The Chinese people prosper and go hungry; raise families and live alone; barely make ends meet and spend lavishly on flashy consumer products; run their own businesses and punch time clocks at big factories; defy authority and go along to get along; celebrate life and suffer depression; and die.

The China I first visited in 1984 is gone. The People's Republic has become one of the world's largest and fastest growing economies, has raised the standard of living for much of its population, and has launched countless satellites into space. Economic reforms that were introduced in the provinces during the late 1970s and early 1980s were made official policy by the Beijing leadership and have opened new realms of autonomy for many.

But much in China is the same as it was in 1984. Most citizens still live in the countryside. Most Chinese are poor by any standard. An immensely powerful bureaucracy sharply defines the limits of personal freedom.

Decades of political campaigns have undermined the faith of the people, and individualism, for good and for ill, has supplanted communalism. While people tend to direct their lives inward, the older Chinese still take pride in reminding youngsters that during the worst of the Mao years, they "ate bitterness," figuratively and literally, as they often choked down bitter weeds and animal feed to survive. If hard times return, they tell their grandchildren, they can do it again. These days, however, urban Chinese kids have taste buds more suited to McDonald's fries than bitter dregs.

The economic reforms authored by Deng Xiaoping have altered society and the Chinese people so thoroughly that there is no turning back. China in 1999 is packed with fundamental contradictions, the biggest of which is between its lofty economic aspirations and the scant rights of its people. China's history, its recent past, and its venerable antiquity show that while there's no predicting when it will arrive, change is inevitable. —B. P.

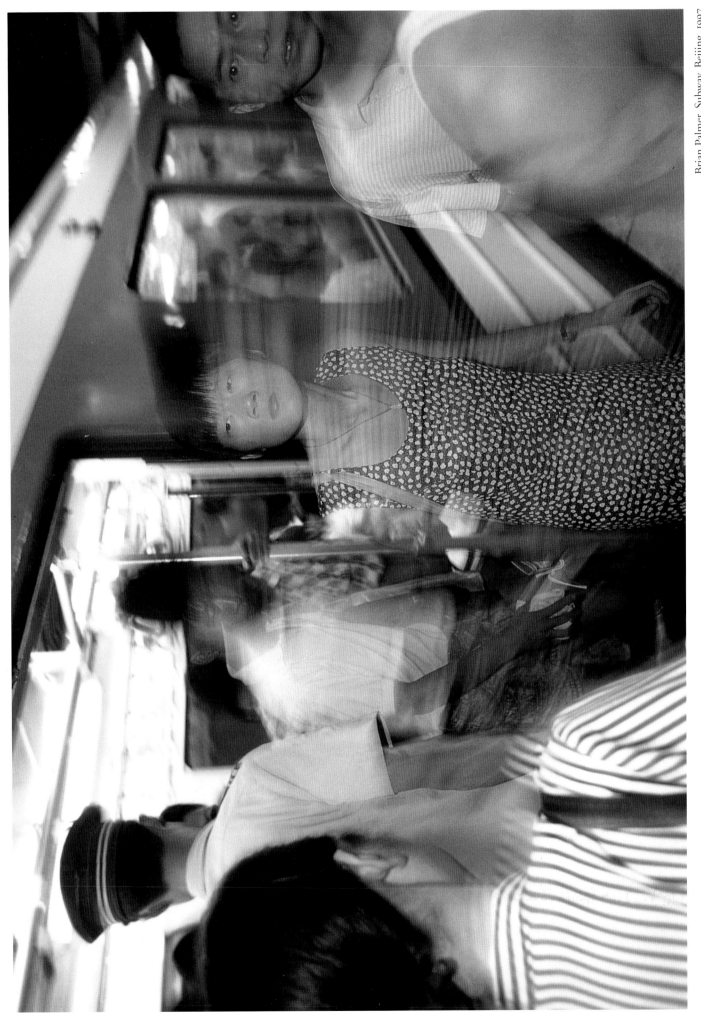

Brian Palmer, *Subway, Beijing,* 1997

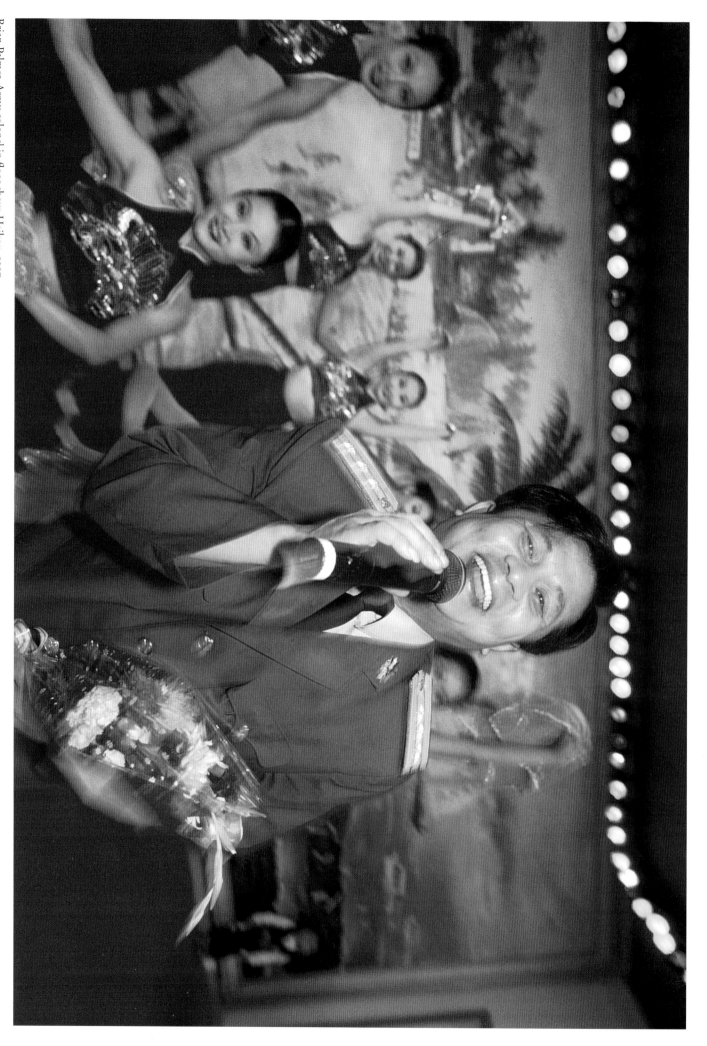

Brian Palmer, *Army colonel in floor show, Haikou, 1997*

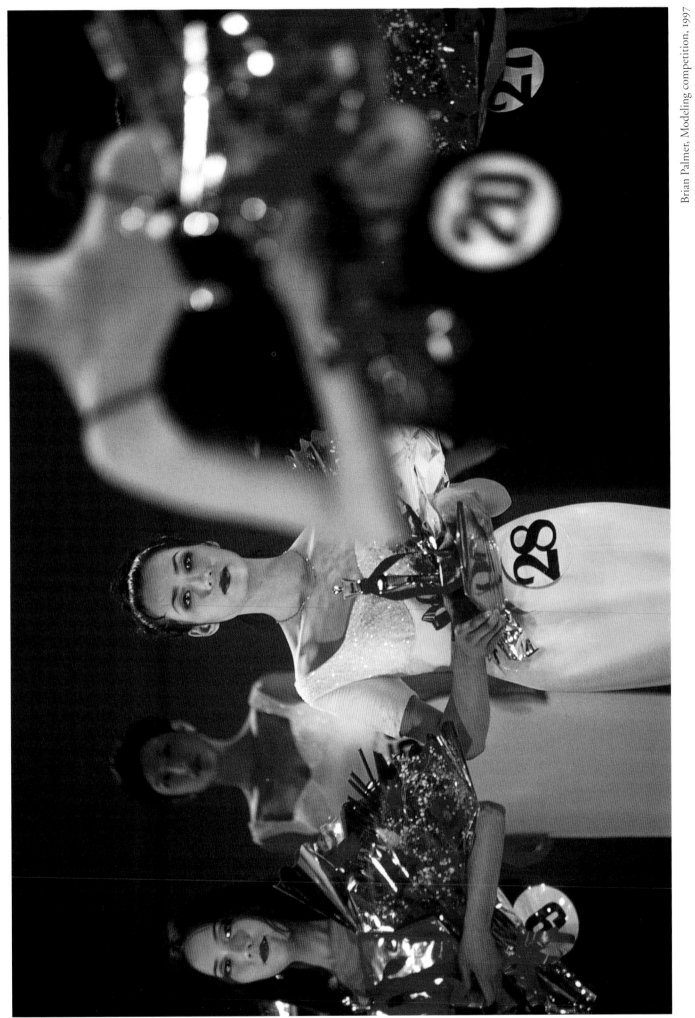

Brian Palmer, Modeling competition, 1997

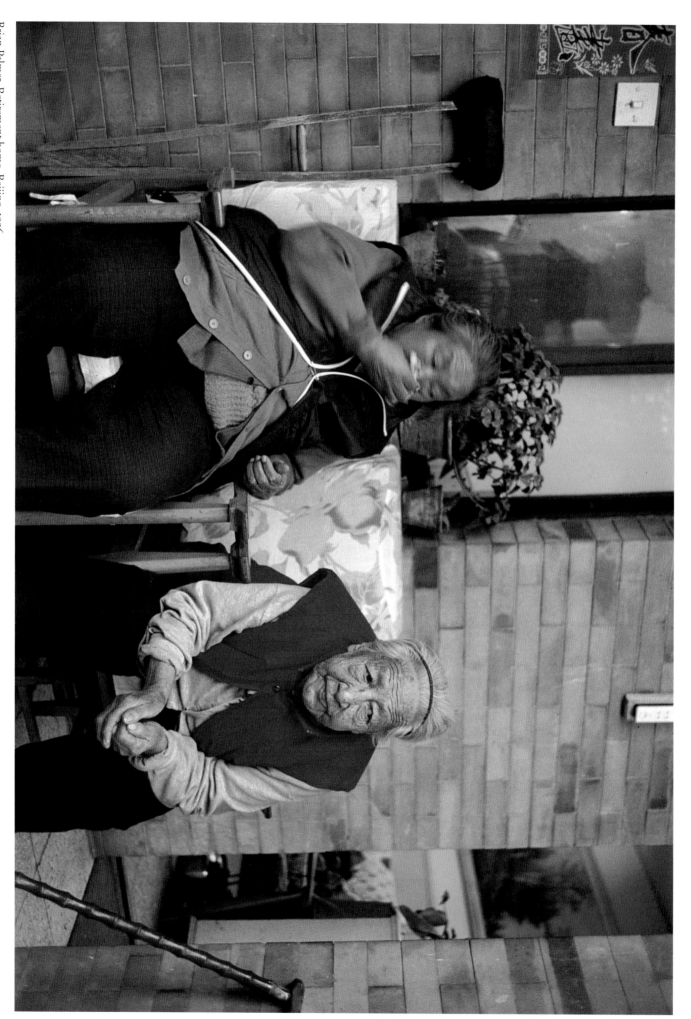

Brian Palmer, Retirement home, Beijing, 1996

Brian Palmer, Model workers, 1996

Brian Palmer, *Mourners at Deng Xiaoping Memorial, Beijing*, 1997

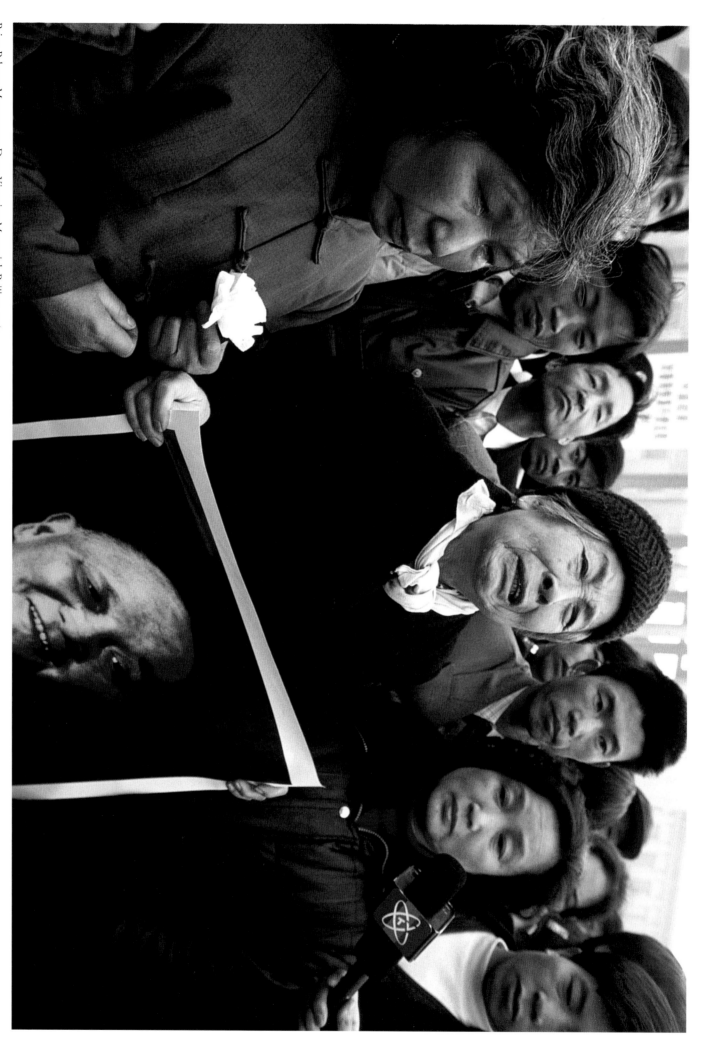

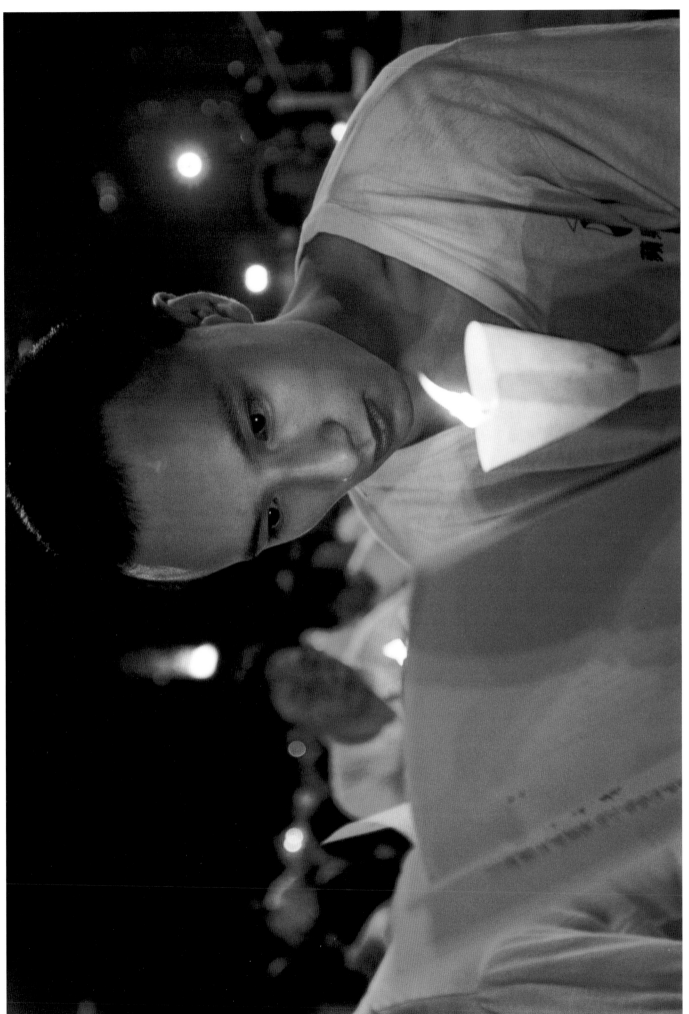

Brian Palmer, Hong Kong hand-over memorial service, Victoria Park, 1997

UNTIL 1980, when I first traveled to China, I had never thought of visiting my ancestral homeland. In fact, I had never thought of China as my homeland, though my father was born there. For me, California-born, being Chinese was not a matter of place. Being Chinese inhered in behavior, in myth.

The following year, in 1981, I returned with my father to his birthplace, Wing Wor. My visit exposed an aspect of my life I had felt but never seen. Time collapsed as my past was continuously reformed by the present. Wherever I turned, I saw the familiar in the unfamiliar. I recall photographing a village garden and suddenly seeing vegetables my father had grown in our backyard, which in Sacramento had looked exotic, out of place. Later, photographing these country Chinese performing ceremonies for various spirits and deities, I remember how the same acts by my family at home had struck me as comic or nonsensical. In China, however, such rituals seemed absolutely natural.

By 1987, the year of my fifth visit, the consequences of China's uneasy alliance with the West had become apparent. High-rise apartment buildings introduced modern conveniences but disrupted age-old social patterns. And freer economic policies, while enriching some, squeezed those on fixed incomes with higher costs. For the first time, despite their increased freedom and material gains, I heard people in China openly question if the quality of their lives had improved. The future was beginning to appear no less frightening than the past.

I emerged from China with both the art and the sense of connection that I so hungered for. A psychologist might say that my search had been caused by "cultural marginalization." Maybe. Yet, if my education furthered some inner division, it also gave me the means to give voice to it. In emphasizing the autobiographical dynamic of my photographs, however, I do not mean to deny other readings of them—documentary, political, formal. In my journeys to China, I was continuing a voyage begun by my father when he first left his village in 1931. My own passage has been somewhere between East and West, need and knowledge, then and now. —R. L.

Reagan Louie, Shanghai, 1987

Reagan Louie, Suzhou, 1987

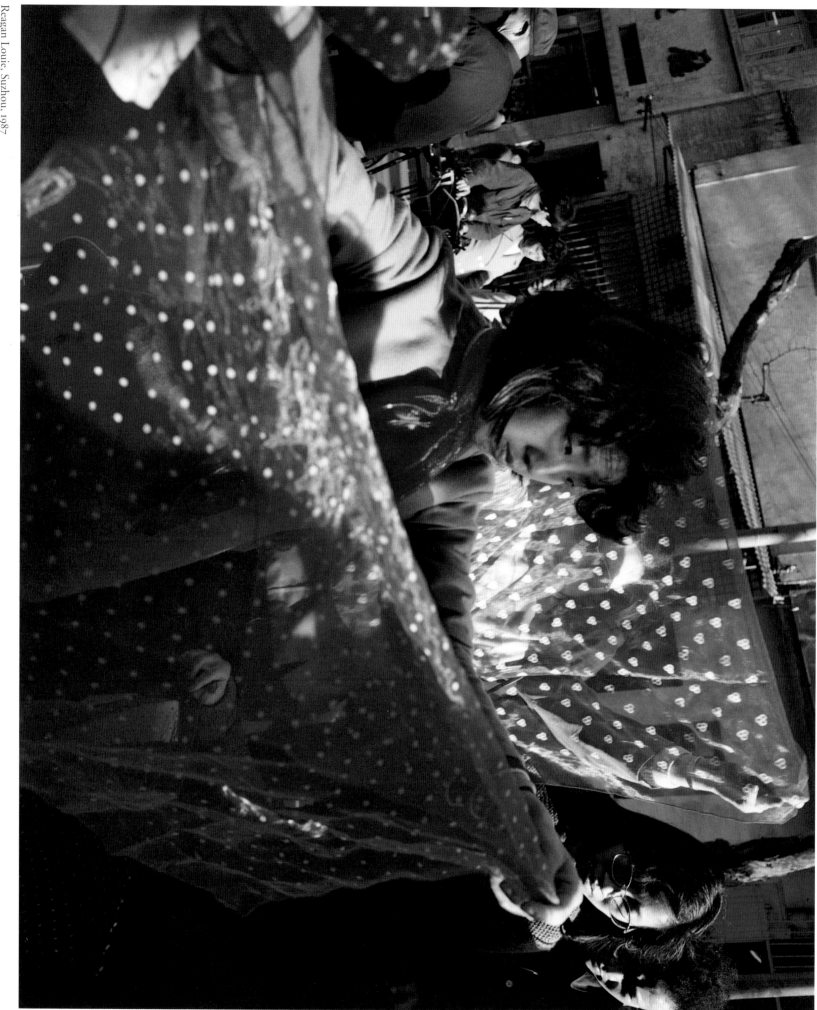

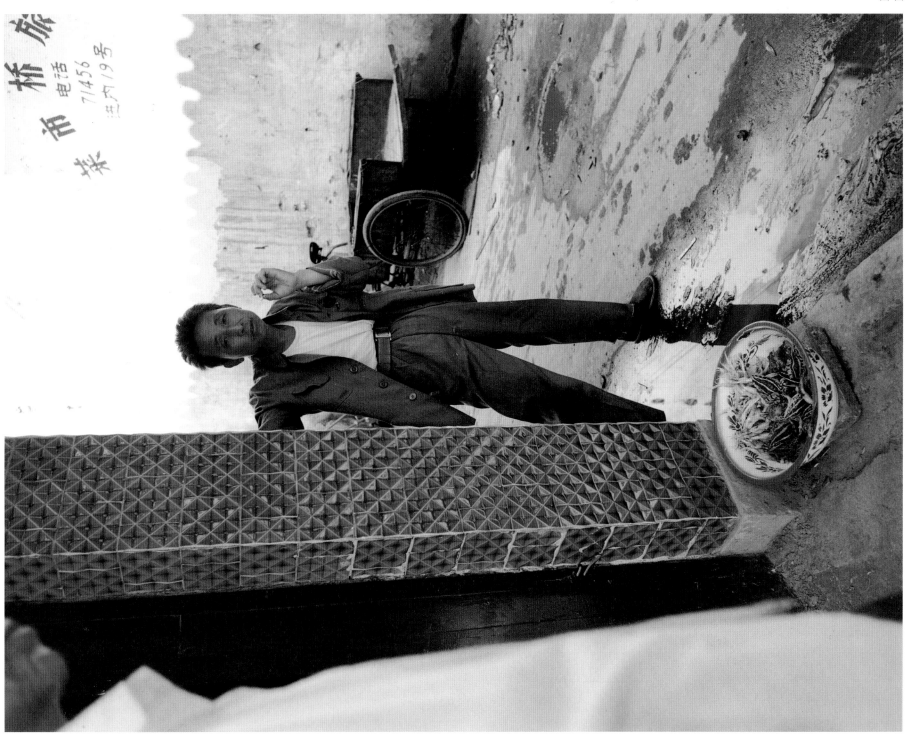

Reagan Louie,
Hangzhou, 1987

Reagan Louie, Hotel Lobby, Xiangshan, Zhejiang Province, 1987

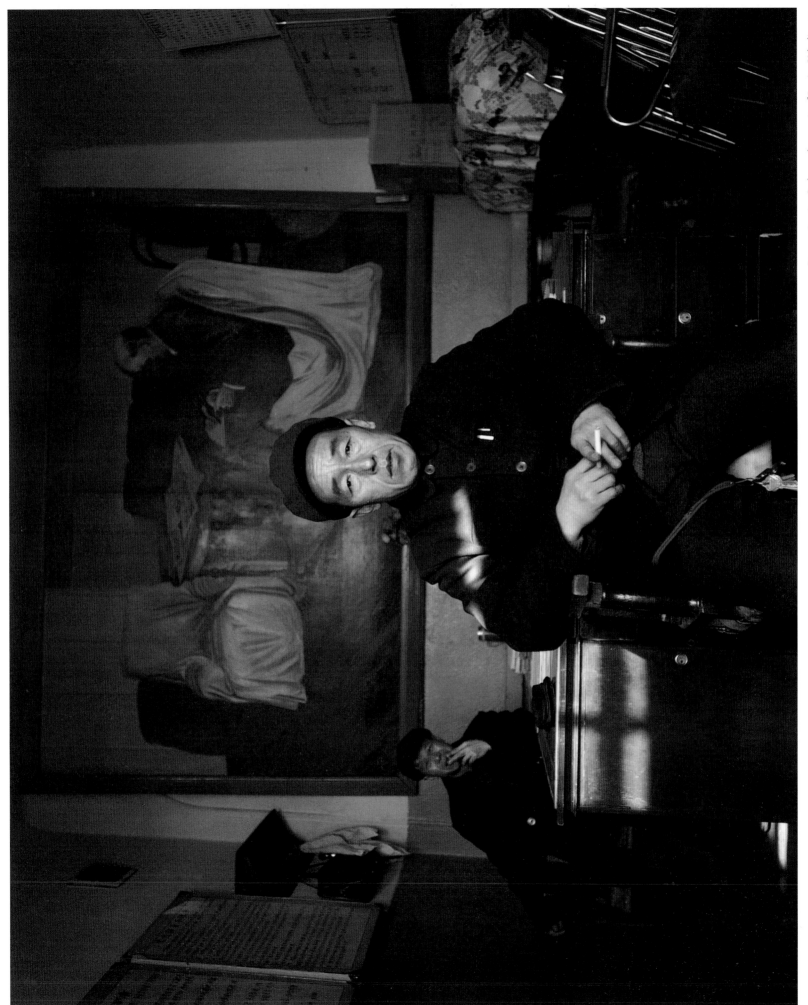

Reagan Louie, Cadre and portrait of Lenin, Yaboli, 1987

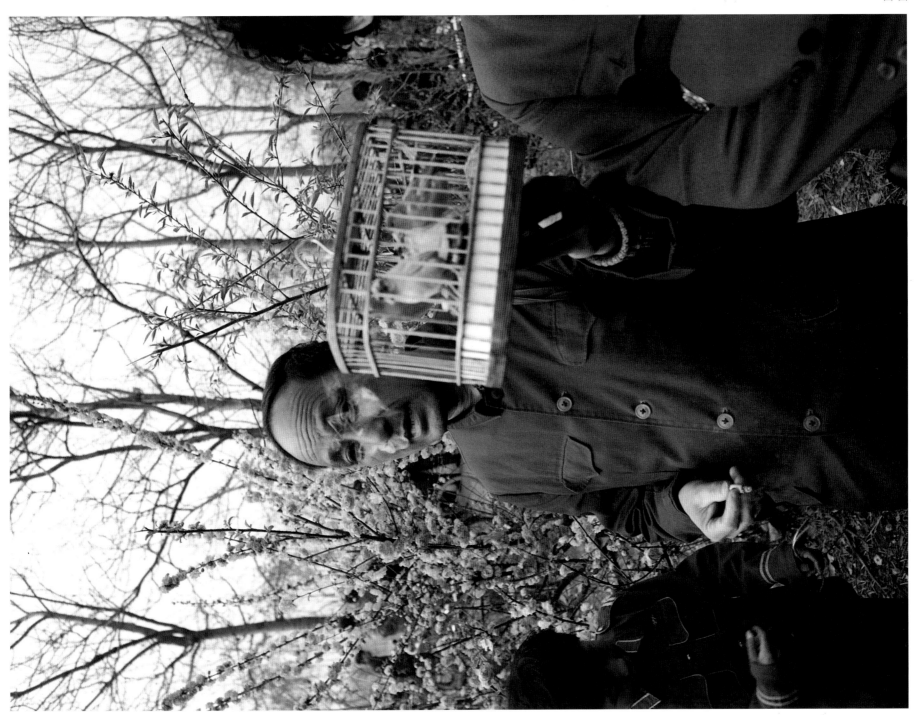

Social phenomena have been a subject of concern in my work—I try to present people's attitudes and experiences through the details of their surroundings. I began my career as a painter, often using the camera as a tool to study ideas for projects. In my first photographic series, "Standard Family," I explored the results of the Chinese government's one-child policy as it affected the younger generation, and in the process I observed the situations of old-age couples living by themselves. These people belong to the generation of my own parents and by photographing retired couples living in Beijing who are representative of different social classes, from workers to university professors, I began to better understand the past. Today's Chinese families are quite different from those of the old days, when members of several generations lived together

and shared the household duties. Among the people I photographed for the "Parents" series, the children had moved away and the couples seemed to enjoy their independence. In these pictures you see nothing of youth culture, such as posters of movie stars or pop singers, and rarely did I find portraits of political figures as you commonly see in earlier photographs (two couples I visited had hung portraits of Zhou En-lai). Today the old folks prefer to display scrolls of calligraphy, flowers they have grown, or their pet birds. By presenting them among their possessions, I hope to show not only differences of taste and social status but also the ways in which government policies have marked their lives. I try not to emphasize that point but those [in China] who see the work understand the meaning of these surface details. —W. J.

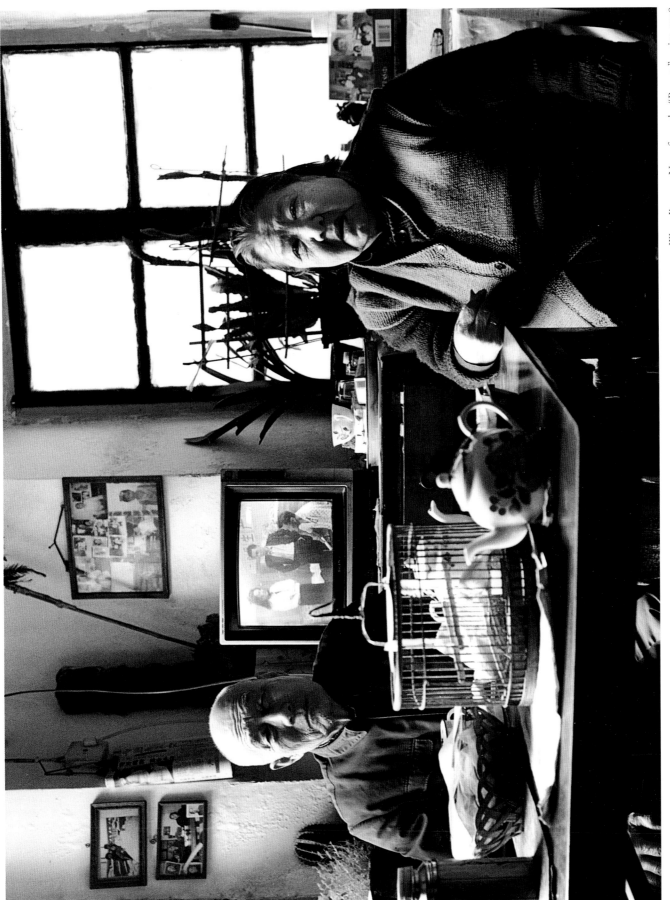

Wang Jinsong, No. 5 from the "Parents" series, 1998

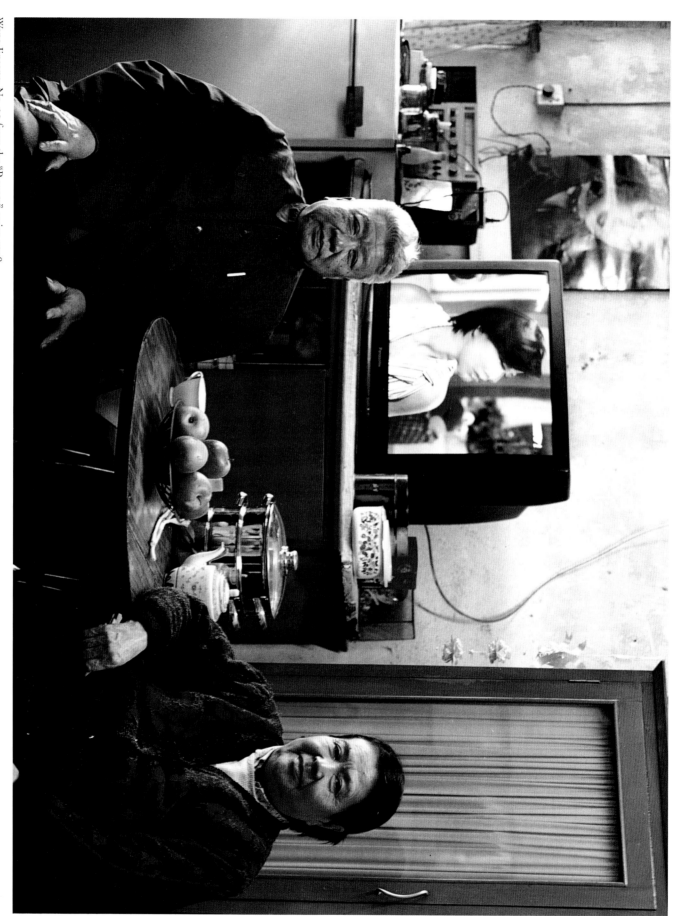

Wang Jinsong, No. 20 from the "Parents" series, 1998

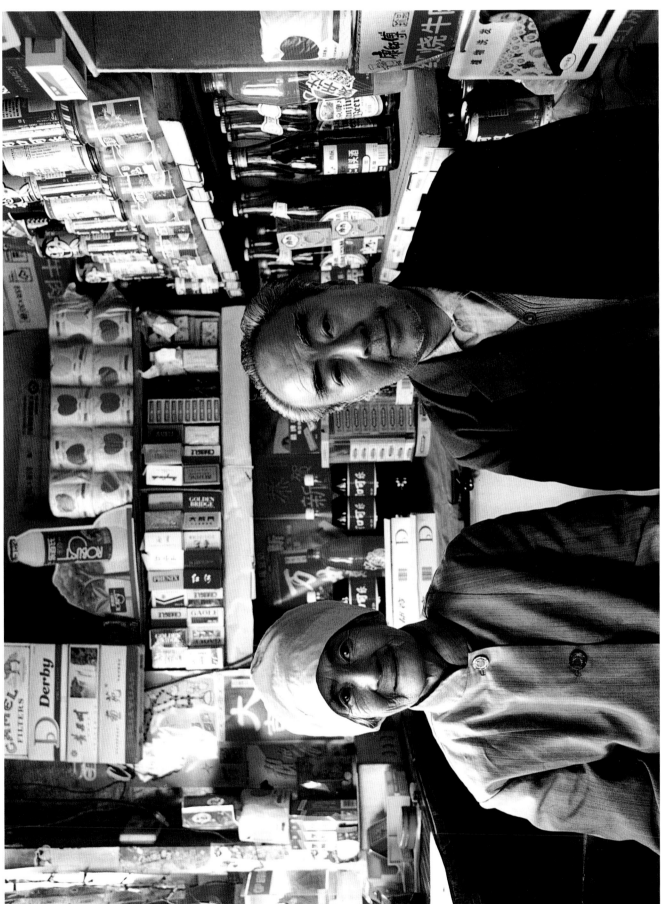

Wang Jinsong, No. 19 from the "Parents" series, 1998

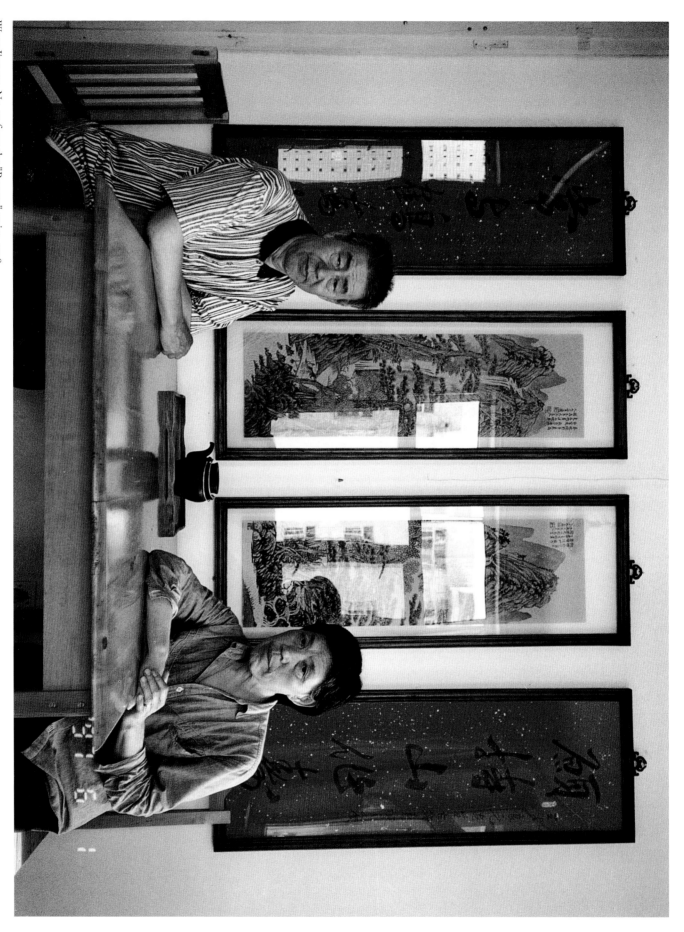

Wang Jinsong, No. 12 from the "Parents" series, 1998

Wang Jinsong, No. 11 from the "Parents" series, 1998

141

Wang Jinsong, No. 2 from the "Parents" series, 1998

Wang Jinsong, No. 1 from the "Parents" series, 1998

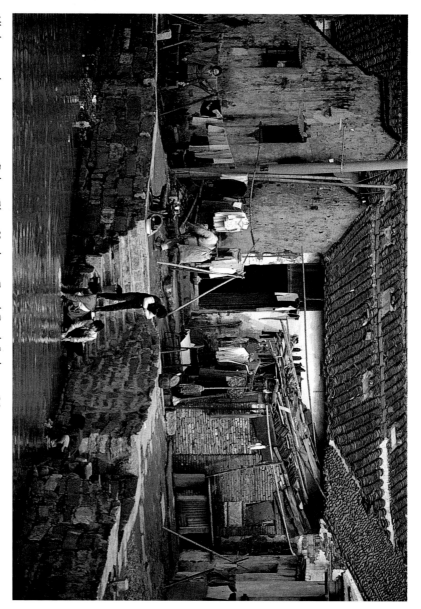

All photographs, pages 144–149: Robert Glenn Ketchum, Grand Canal, Suzhou, 1986–1995

SINCE THE MID-1980s, I have visited China on a regular basis; what I have witnessed over the years is epic. The country has modernized at an unparalleled pace and yet the enigma of China is that some things seem barely to change at all. Its five-thousand-year history continues to emanate from the landscape in spite of recently built freeways, office towers, and apartment blocks. The collision between ancient and modern has been particularly magnified in Suzhou. With its network of canals that dates from the eighth century B.C., this city has often been compared to Venice, though many of the brick homes and arched bridges that give Suzhou its appeal were probably already built when Marco Polo arrived during the thirteenth century and "discovered" silk. The Grand Canal and the waterways compose one of the great industrial transportation complexes in Western China, and are the lifeblood of commerce for cities along the way. The canal is choked with the traffic of boats and barges moving goods everywhere. It throbs with the sputtering sound of two-stroke gasoline engines, and on still, cold days the pollution hangs in the air with a pallor that makes the winter even more gray.

I have taken great pleasure in wandering these streets, following them to their end just to see where they go, and taking photographs along the way. As the years pass, these images will remind me that some of my travels were measured in distance, and others were measured in time. —R. G. K.

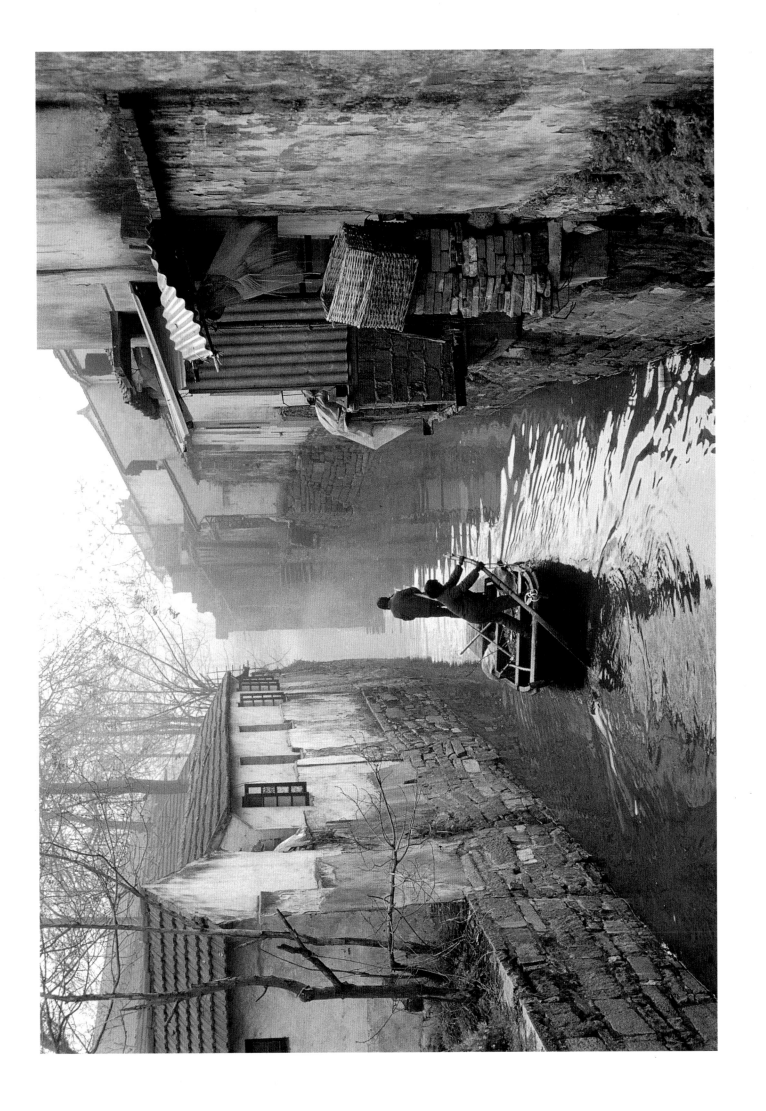

ROBERT GLENN KETCHUM GRAND CANAL

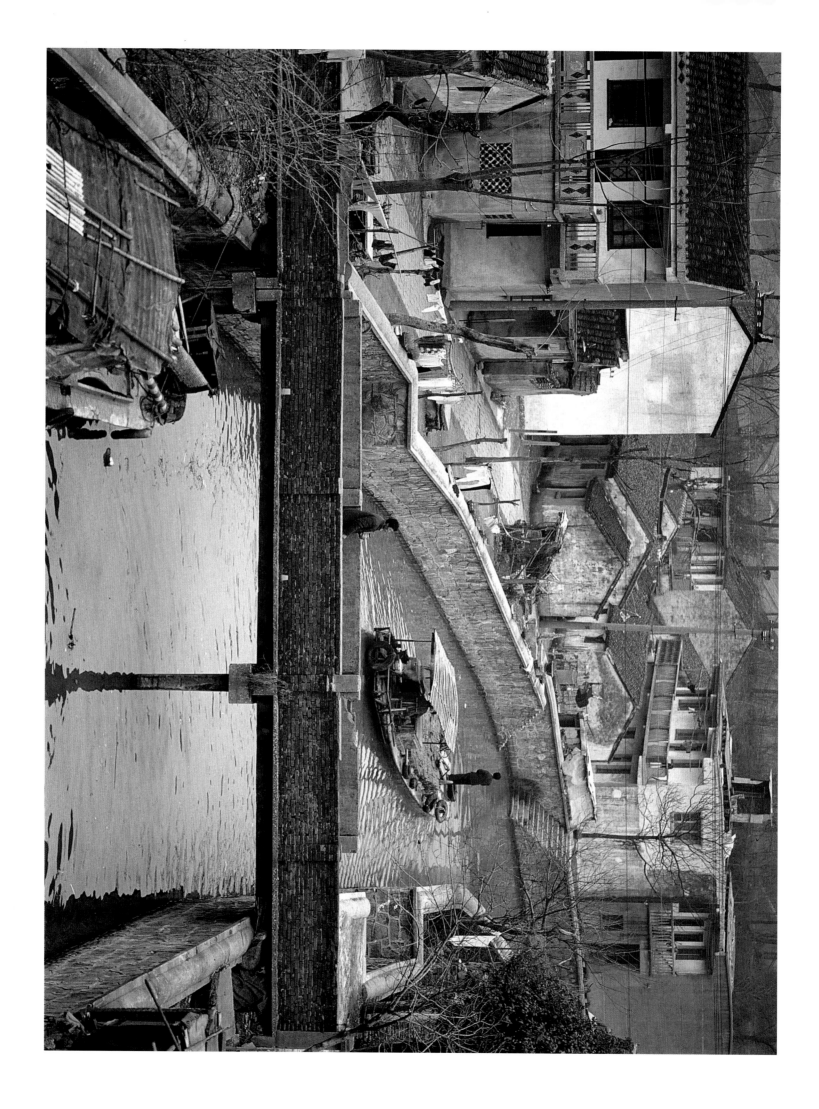

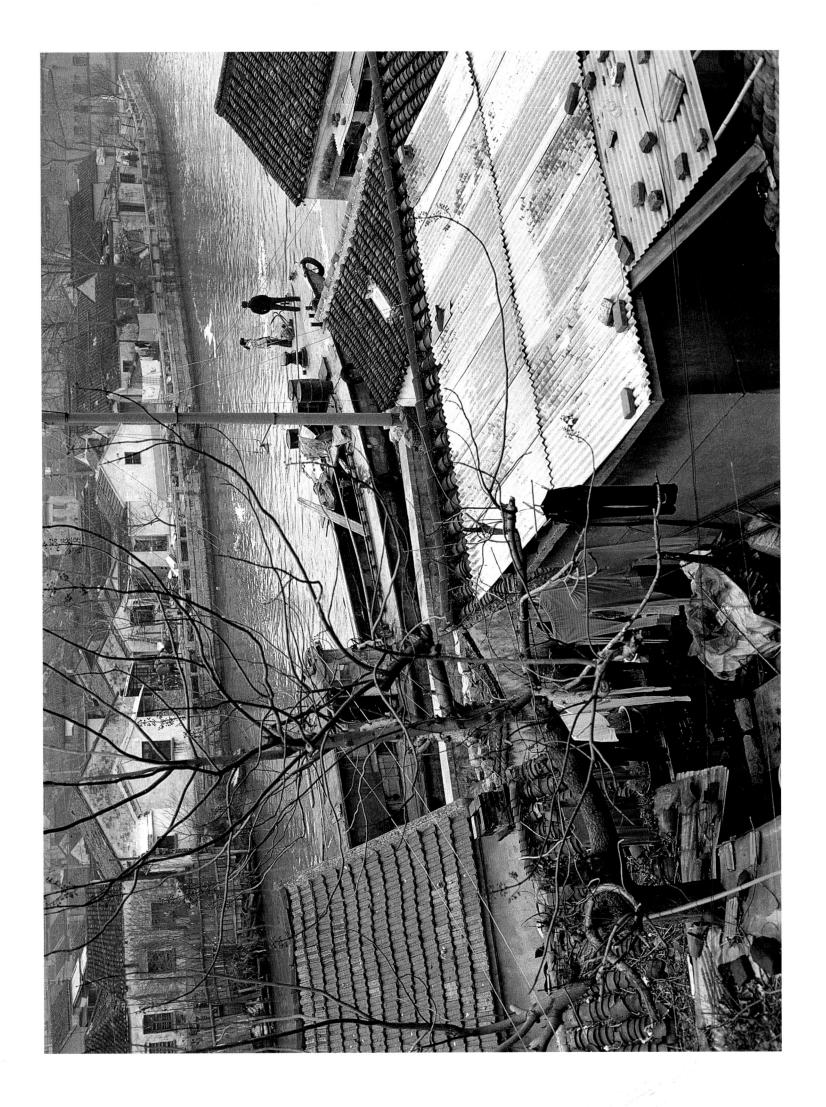

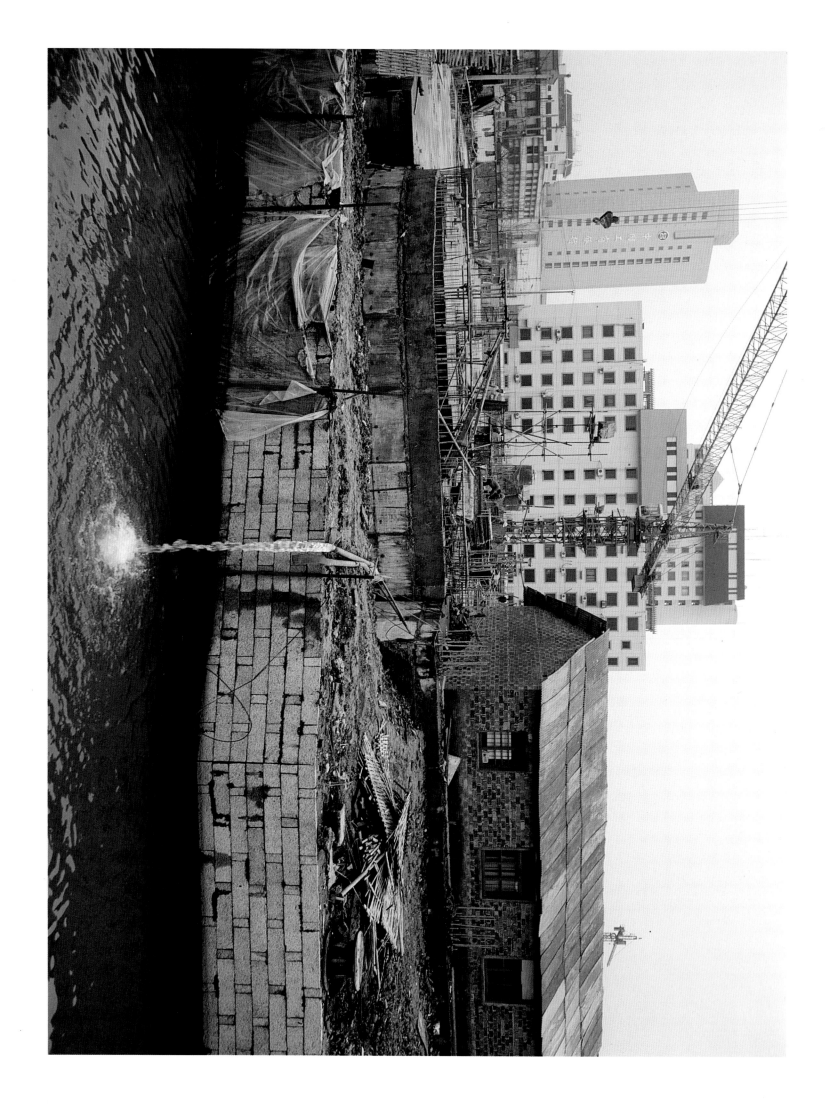

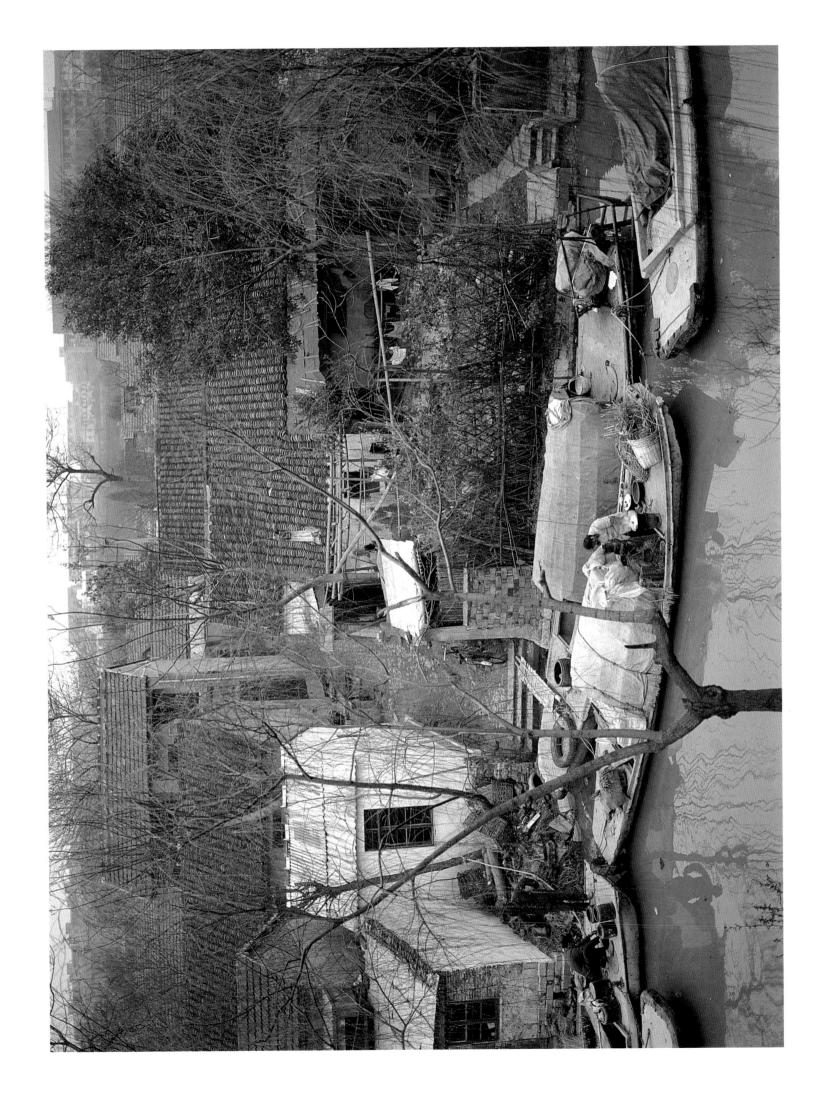

Cabbage-seller's lunch, Beijing, 1994

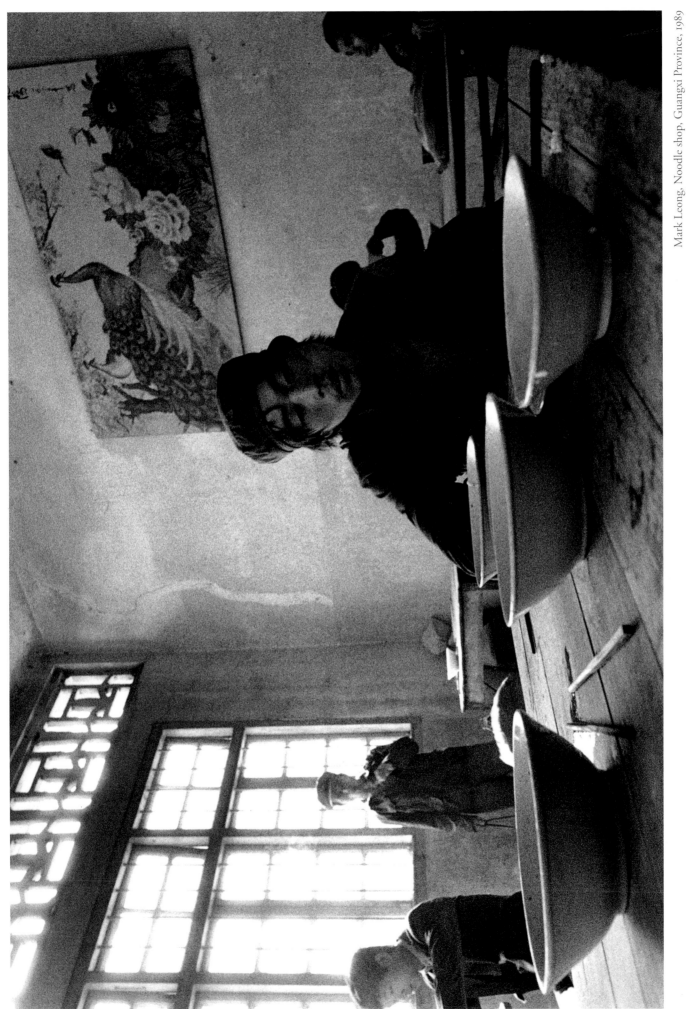

Mark Leong, Noodle shop, Guangxi Province, 1989

152

The old home I remembered was not in the least like this. My old home was much better. But if you asked me to recall its peculiar charm or describe its beauties, I would have had no clear impression, no words to describe it. And now it seemed this was all there was to it. Then I rationalized the matter to myself, saying: "Home was always like this . . . it is not so depressing as I imagine; it is only my mood that has changed, because I am coming back to the country this time with no illusions."

—LU XUN (1881–1936),
from *My Old Home*

Top: Mark Leong, Village chief,
Guangdong Province, 1995
Right: Mark Leong, My oldest
living relative in China,
Guangdong Province, 1995

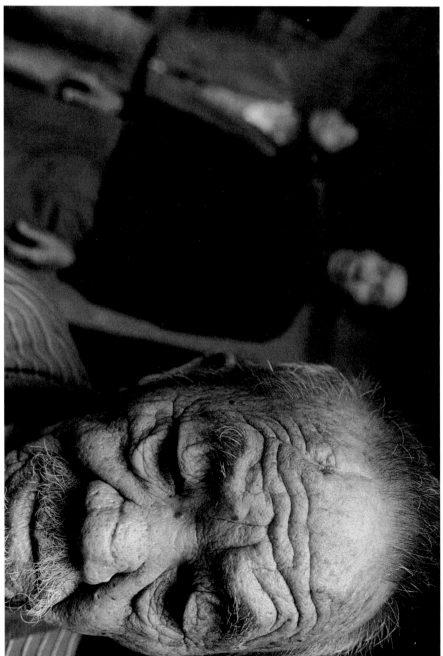

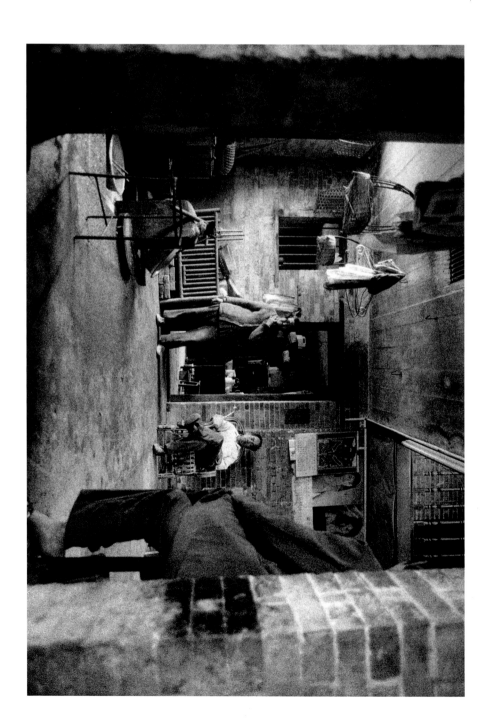

I can't remember the tale,
but hear his voice still, a well
of dark water, a prayer.
And I recall his hands,
two measures of tenderness
he laid against my face,
the flames of discipline
he raised above my head

—LI-YOUNG LEE (b. 1957),
from "The Gift"

Top: Mark Leong, *Villagers,*
Guangdong Province, 1995
Left: Mark Leong, *Address labels*
of relatives in America,
Guangdong Province, 1995

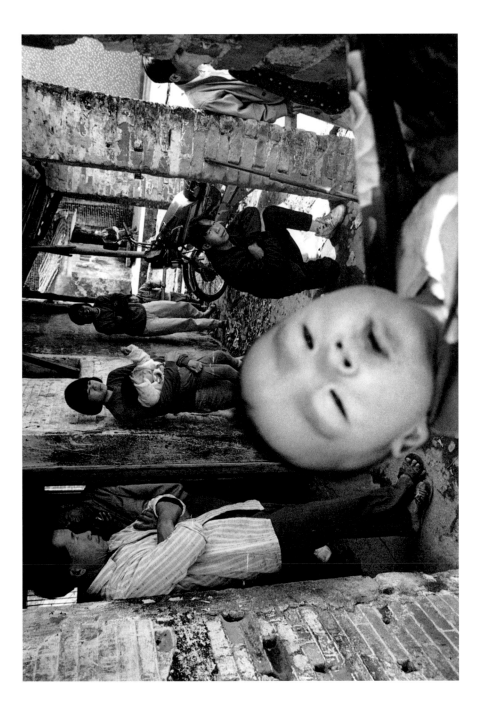

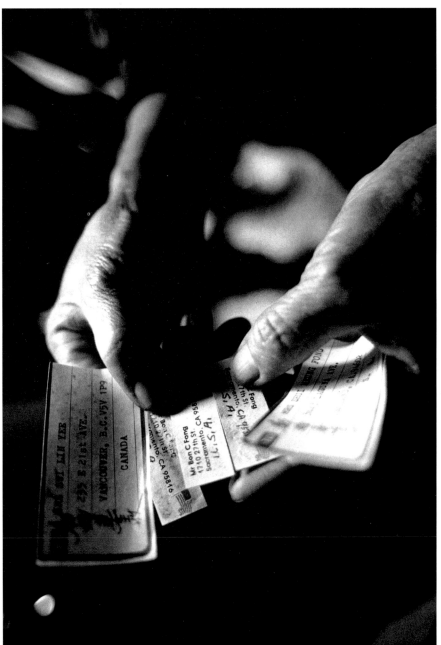

Mark Leong, *Video artist, Beijing, 1997*

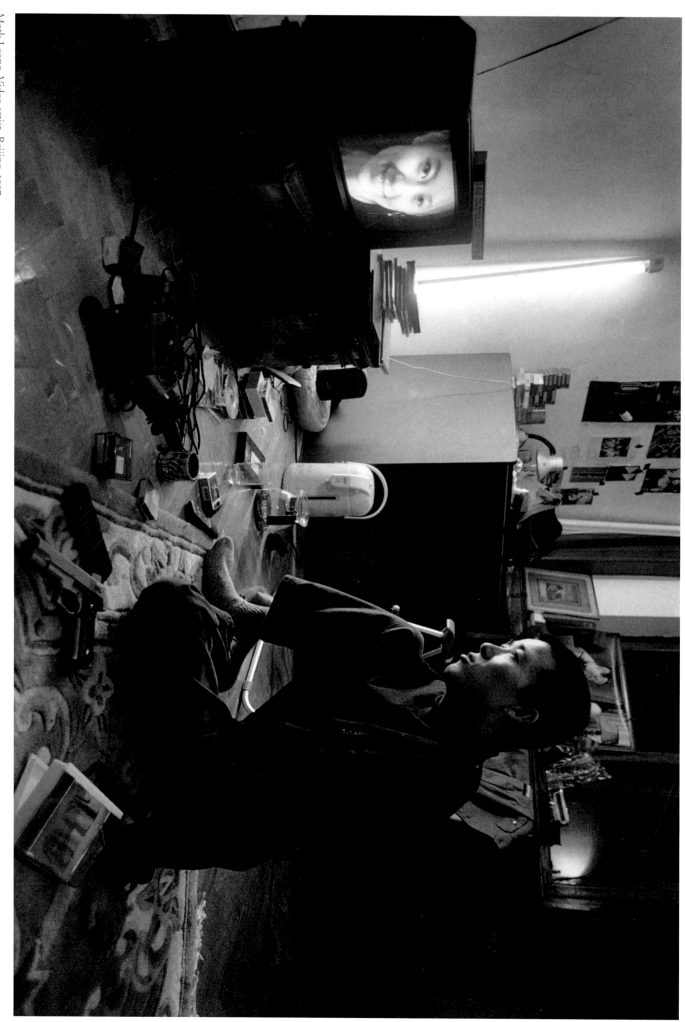

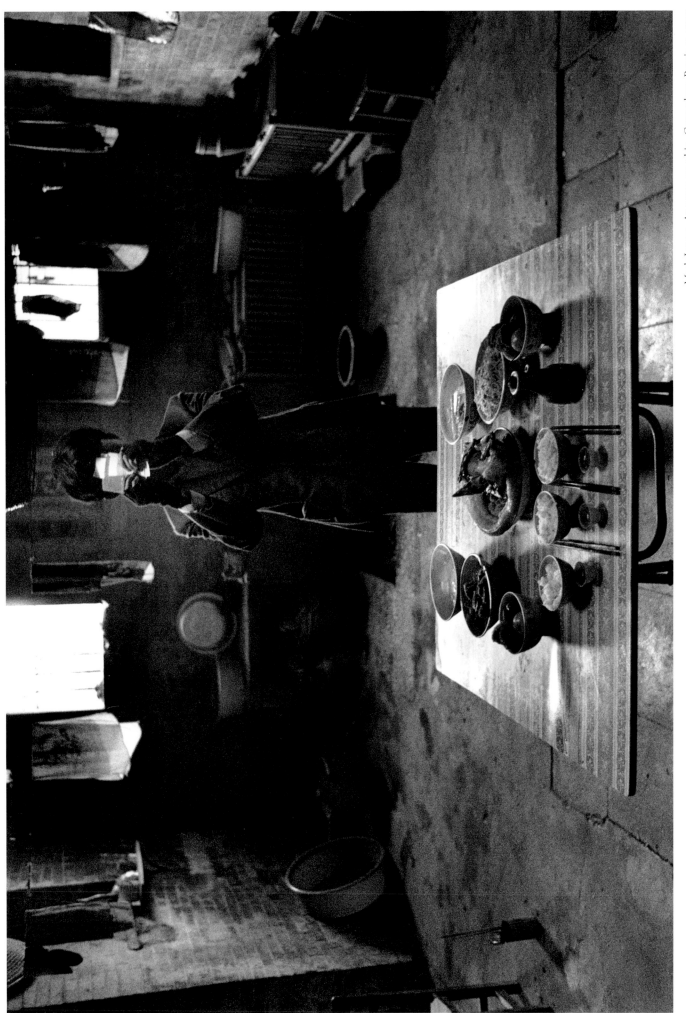

Mark Leong, Ancestor worship, Guangdong Province, 1990

LIFE REVEALS its hidden implications at unlikely moments, and sometimes not at all. We have no reason to disbelieve the world we see before us, but it takes a lifetime to understand its meaning. In the end, perhaps we are not much wiser. So many seemingly trivial things, things we neither choose nor consciously leave behind, become important. We experience dullness and defeat, romantic nights and distant journeys. To keenly observe a world of everyday people and places, to find those who will shape our inner spaces, is to be a walking bystander. —Z. N.

ZHENG NONG
WALKING BYSTANDER

Hunjiang River, 1995

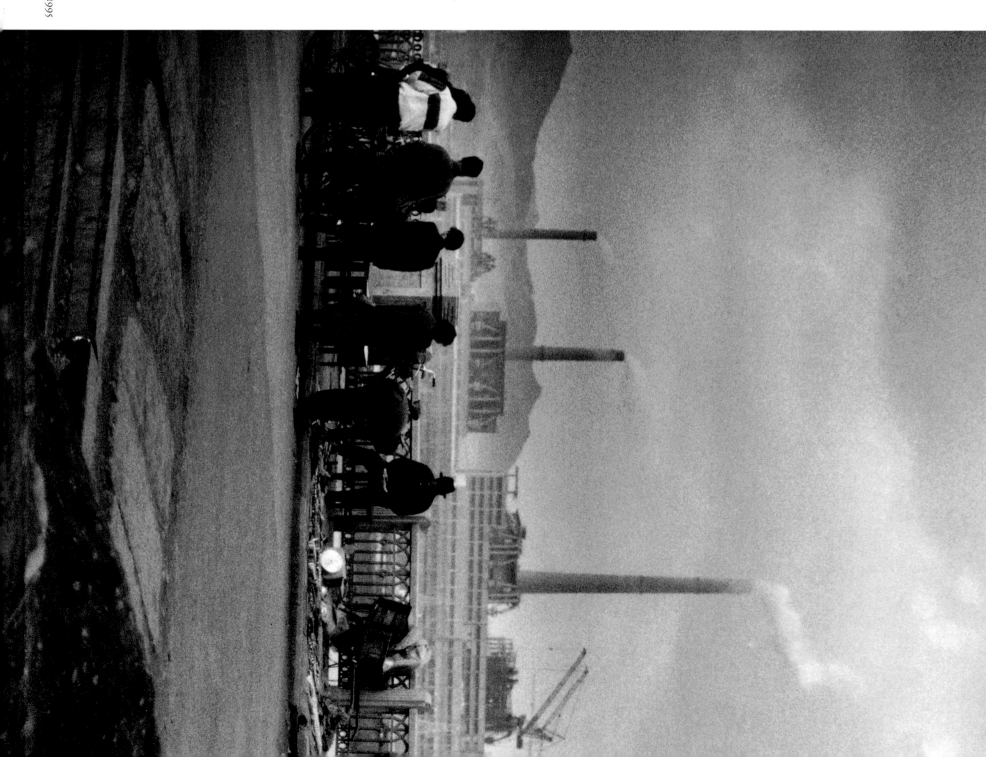

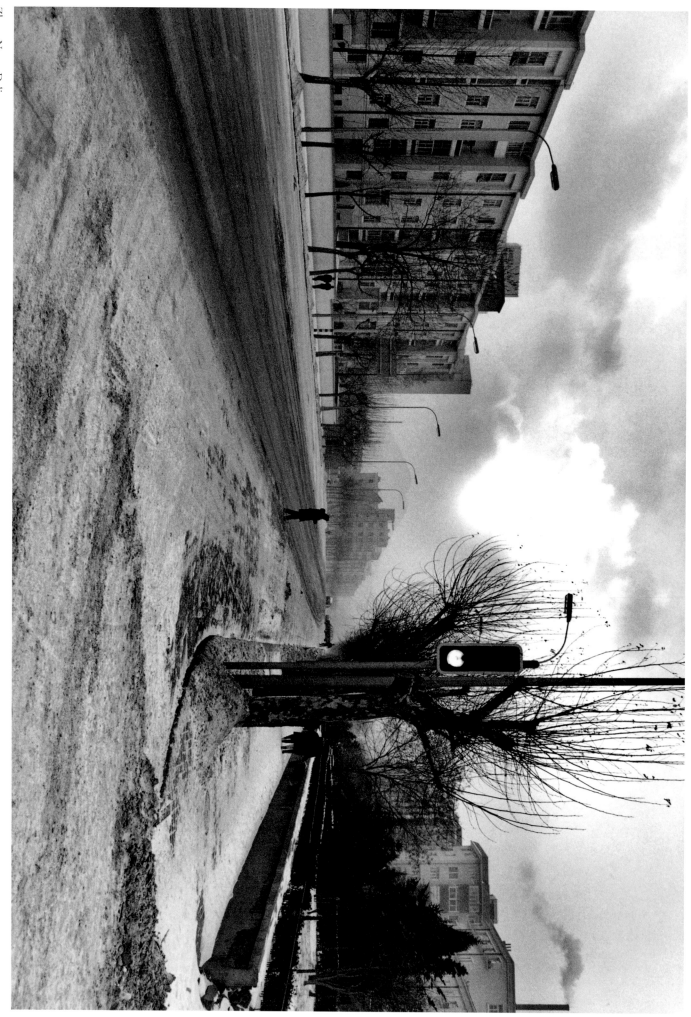

Zheng Nong, Dalian, 1994

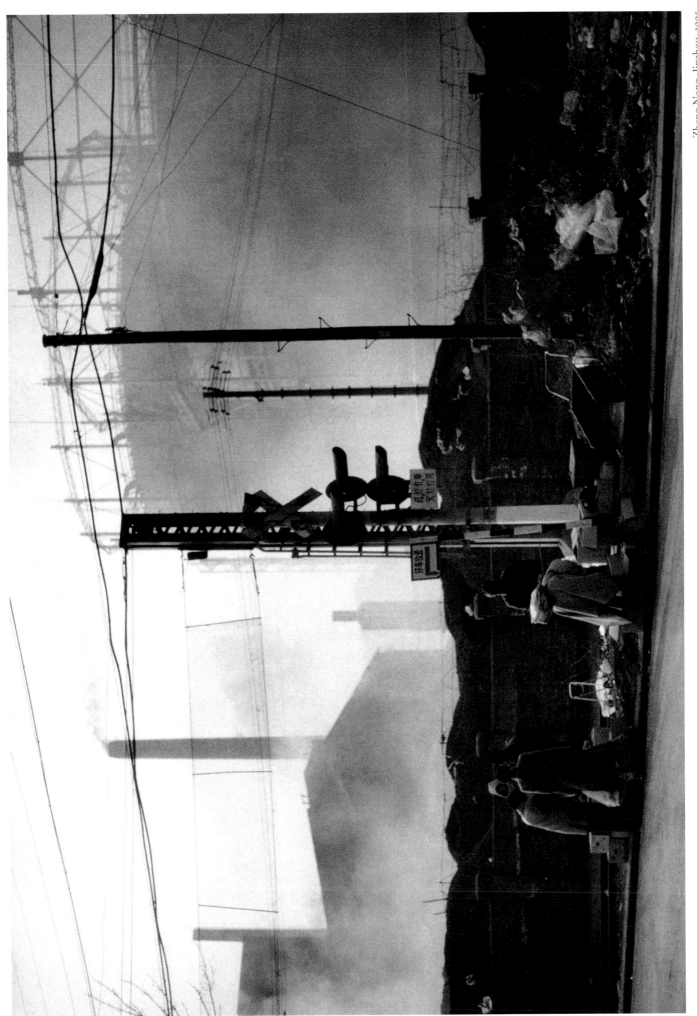

Zheng Nong, Jinzhou, 1995

Zheng Nong, Shenzhen, 1996

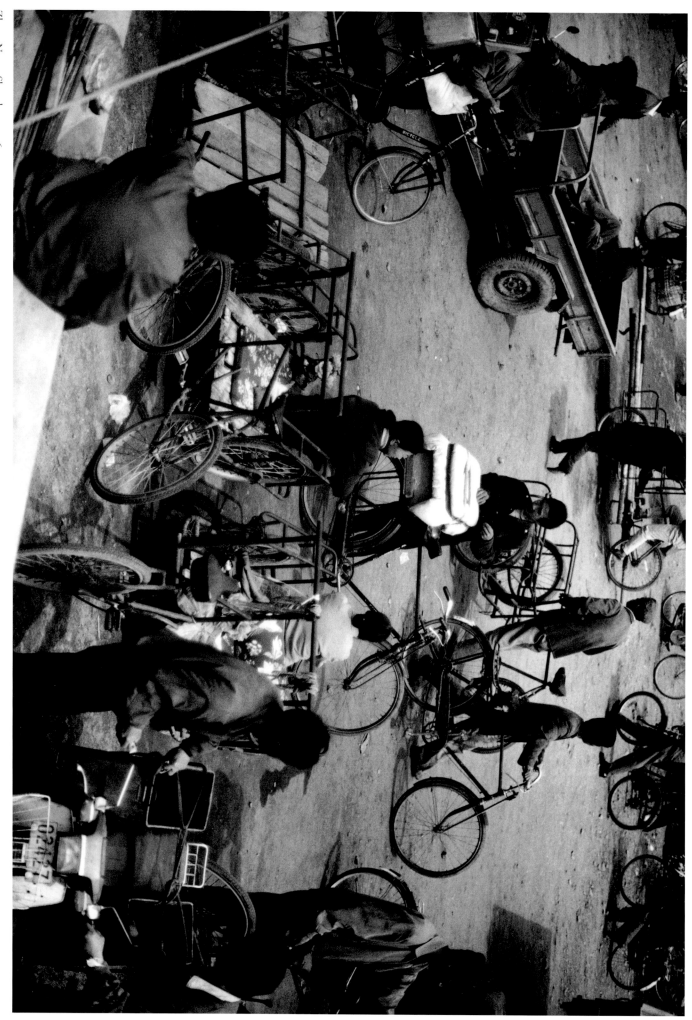

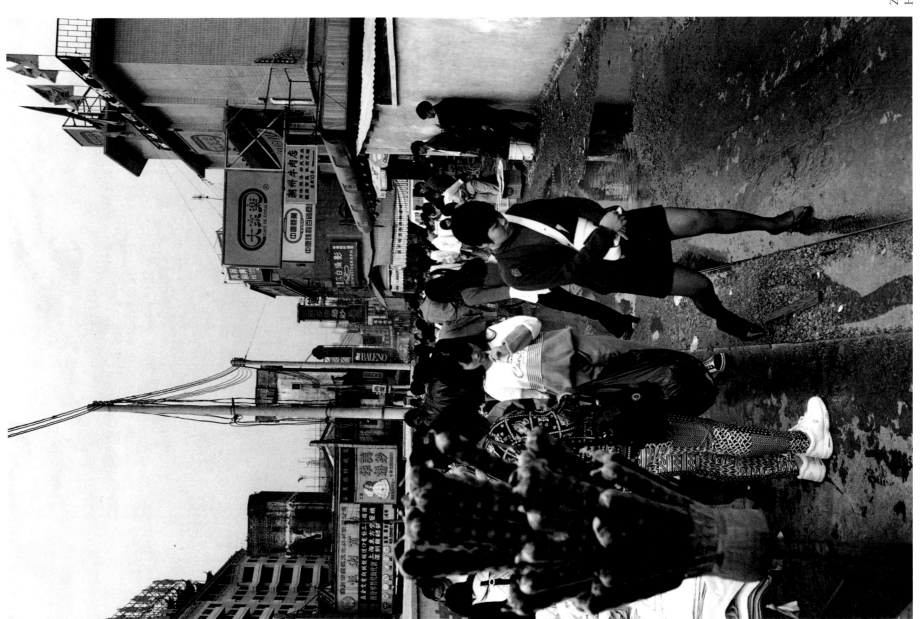

Zheng Nong,
Hunjiang River, 1995

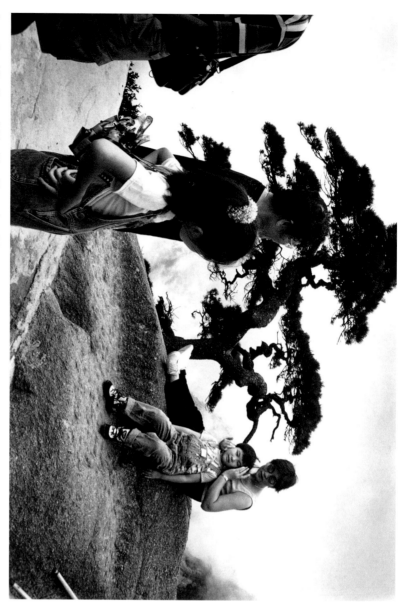

Stuart Franklin, Farewell Pine Tree, Huangshan Mountains, 1998

THE PHOTOGRAPHS here are part of a study that investigates the bewildering junction of nature and society as it exists in China today. These images reveal the contradictory relationship that prevails: at the same time that we love nature we destroy it. As the ecologist Liang Cong Jie has commented, people are trying to remember what we have had in the past, but it is already lost. Historically, only the rich could afford the leisure to enjoy nature. For the rest, survival has depended on its transformation.

In the Huang Shan mountains near Shanghai, we find nature as if it had been codified and formalized. Here are the pine trees, rocks, and clouds of China's collective memory, remaining as altar and oracle amid the last scraps of wilderness. This landscape has offered solace at times of

upheaval and reform since the Song Dynasty (A.D. 960–1297), when its representation in the art of scroll painting matured. Today, the region serves as a stage set for four million visitors who arrive with their cameras each year to carry the iconic wilderness home: eternally captured, personalized, and further miniaturized. To the north in Beijing (which like most cities in China is rapidly losing its old residential neighborhoods to multi-story apartment blocks), communities of single-story dwellings with courtyard gardens that once characterized the physical and social heart of this ancient city have been almost completely demolished. Along with the houses, places for rest and contemplation have all but disappeared. To compensate for their lost gardens, many people create tiny indoor landscapes with bonsai trees and *suiseki*, stones prized for their resemblance to mountains depicted in traditional paintings. Nature, or idealized miniature versions of what is left of it, is found and captured in the weekend street markets. In Beijing's Ritan Park, Buddhist priests and ballet dancers seeking peace amid urban chaos meditate or dance under pagoda trees that were planted long ago. In the western hills above the city, ancient ginkgoes and cypresses are venerated by city-dwellers who make frequent visits to public gardens that remain untouched by urbanization. —S. F.

Tourists photographing the Welcome Pine Tree,
Huangshan Mountains, 1998

STUART FRANKLIN ICONS OF NATURE

Stuart Franklin, Bonsai tree, bird, and flower market, Beijing, 1998

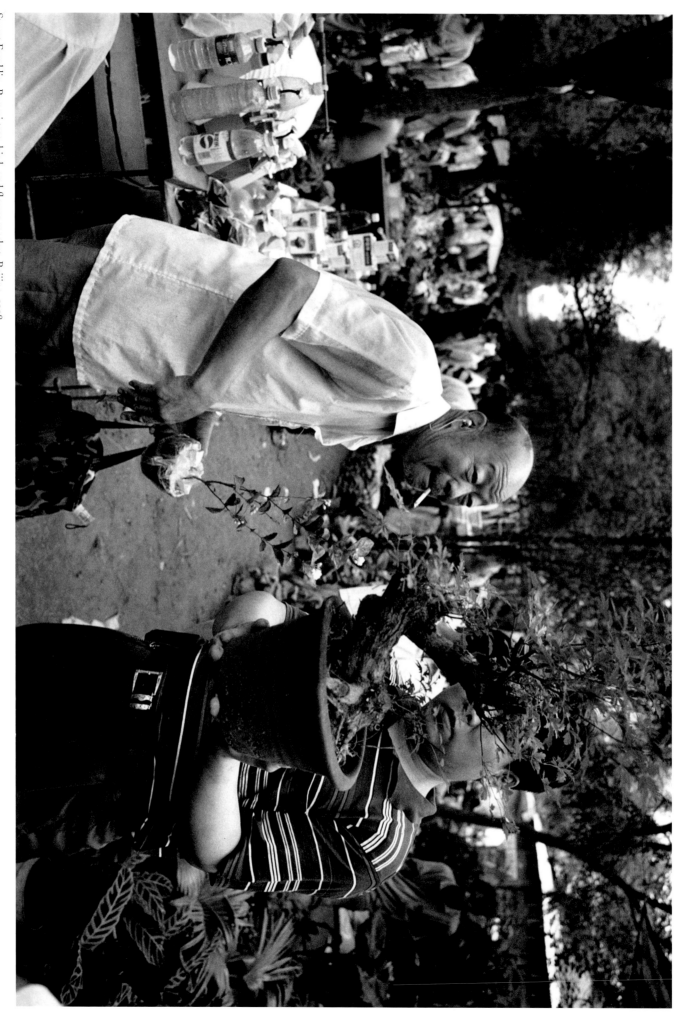

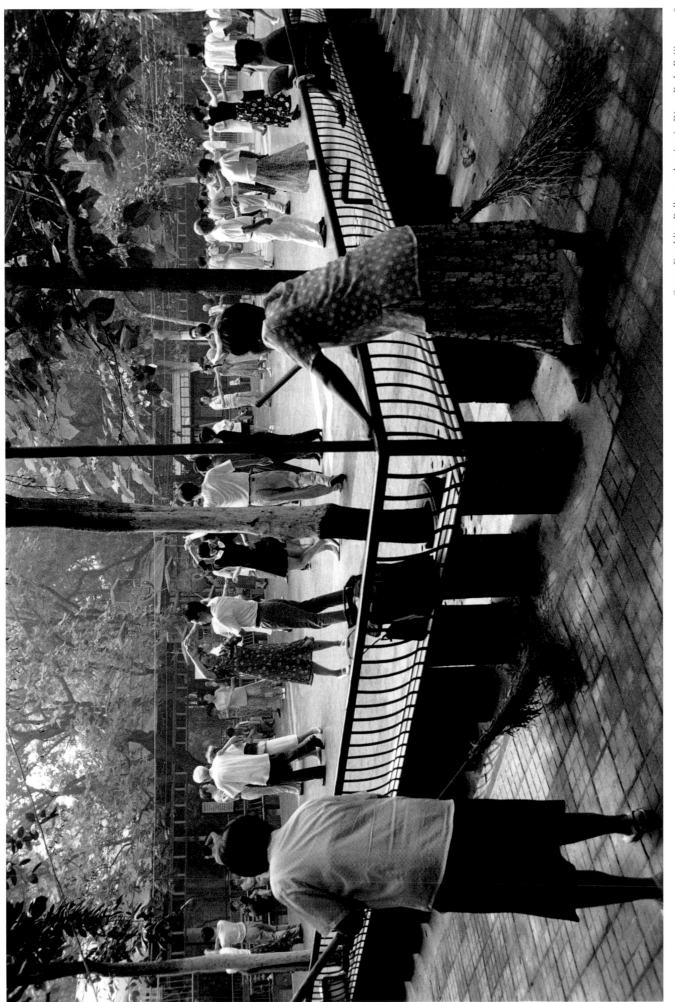

Stuart Franklin, Ballroom dancing in Ritan Park, Beijing, 1998

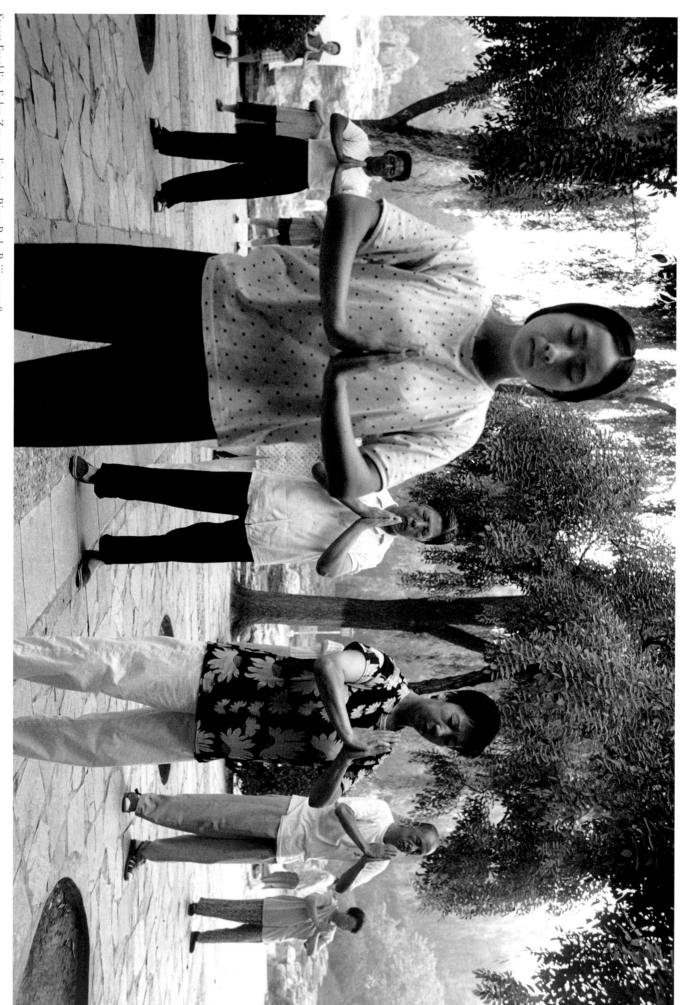

Stuart Franklin, Fulan Zen meditation, Ritan Park, Beijing, 1998

Stuart Franklin, Ritan Park, Beijing, 1998

And as the sensuous colors of physical things are stirred into movement, so the mind too is shaken.

—LIU XIE (A.D. 465–522), from *The Literary Mind Carves Dragons*

Road near Kashgar, Xinjiang Province, 1998

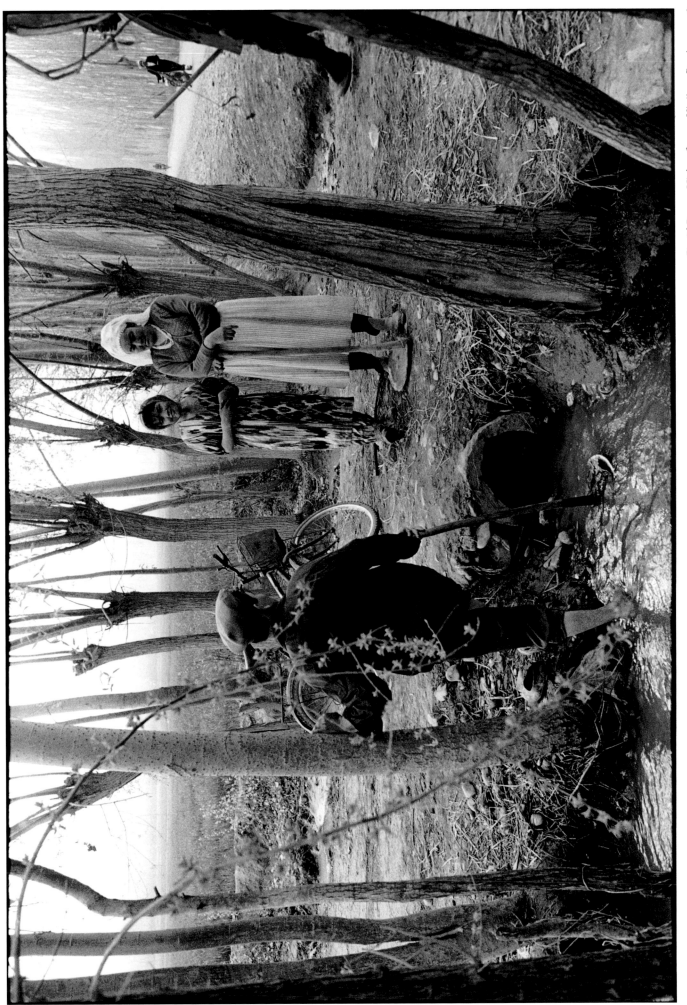

David Butow, Uighur farmer, Xinjiang Province, 1998

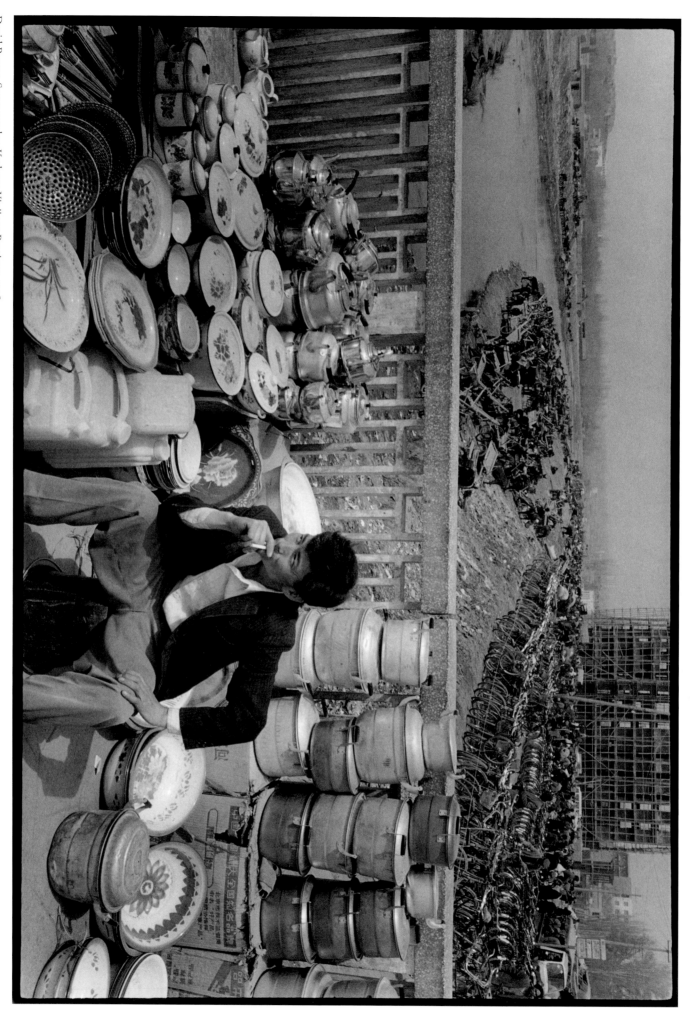

David Butow, *Street vendor, Kashgar, Xinjiang Province,* 1998

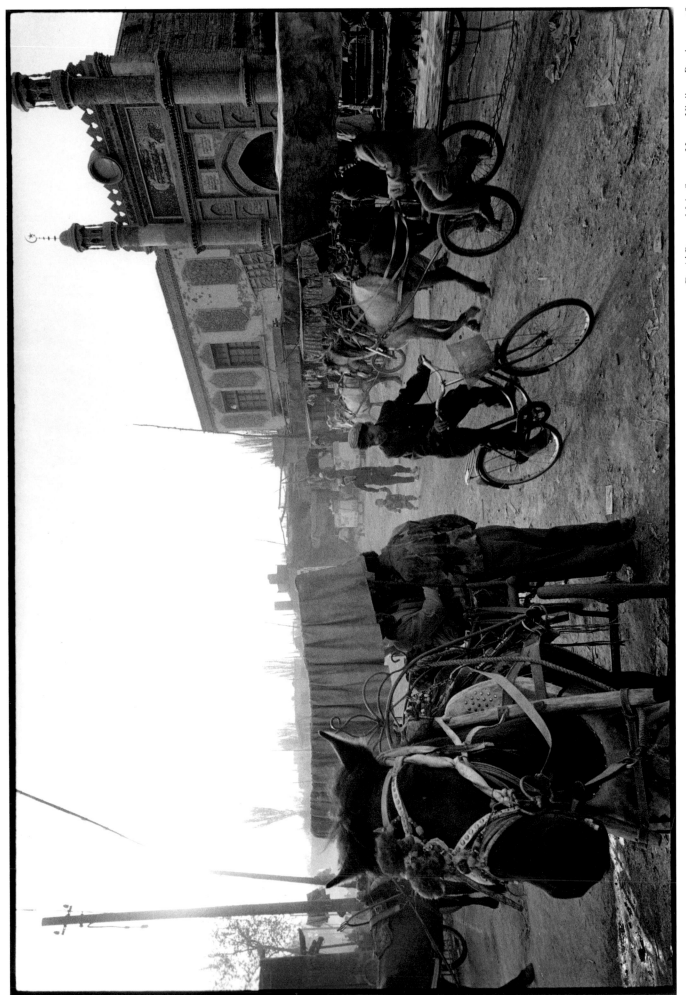

David Butow, Main Square, Hotan, Xinjiang Province, 1998

David Butow, Uïghur farmer clearing irrigation
ditch, Hotan, Xinjiang Province, 1998

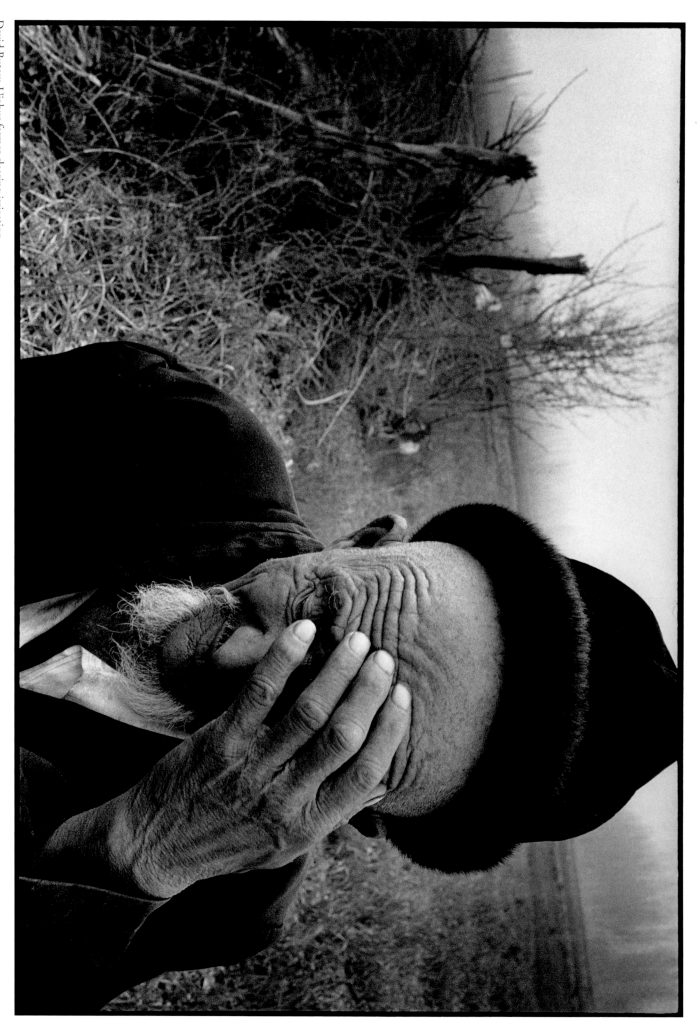

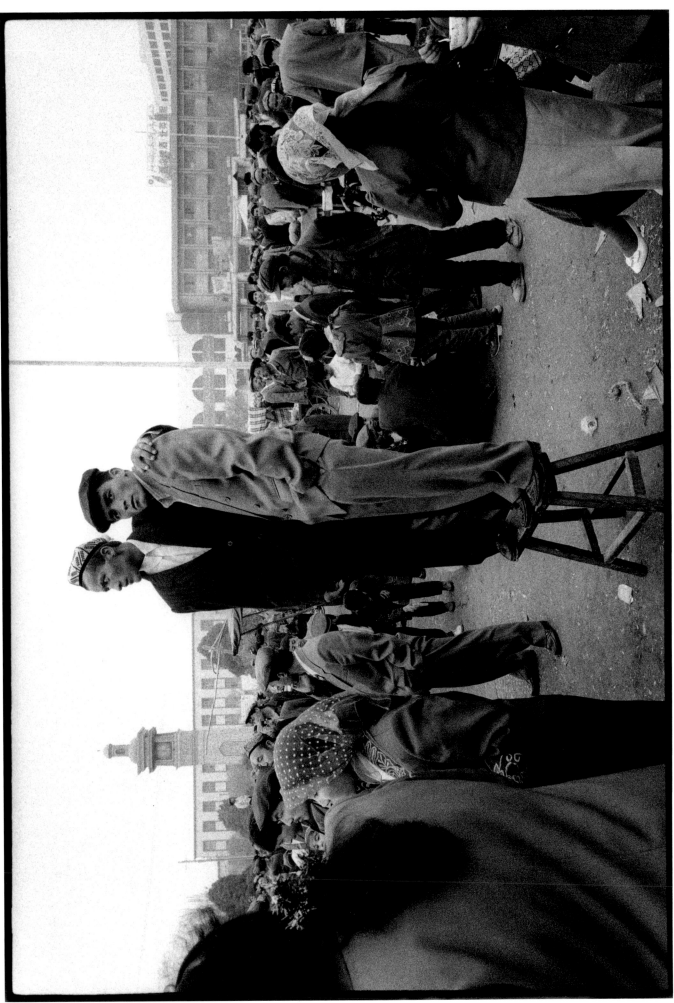

David Butow, Korban Festival,
Kashgar, Xinjiang Province, 1998

SONG OF LIANG-ZHOU

Sweet wine of the grape,
cup of phosphorescent jade
at the point of drinking, mandolins play
on horseback, urging us on.
If I lie down drunk in the desert,
don't laugh at me—
men marched to battle since times long ago,
and how many ever returned?

—WANG HAN (Tang Dynasty)

David Burow,
Sunday market, Kashgar,
Xinjiang Province, 1998

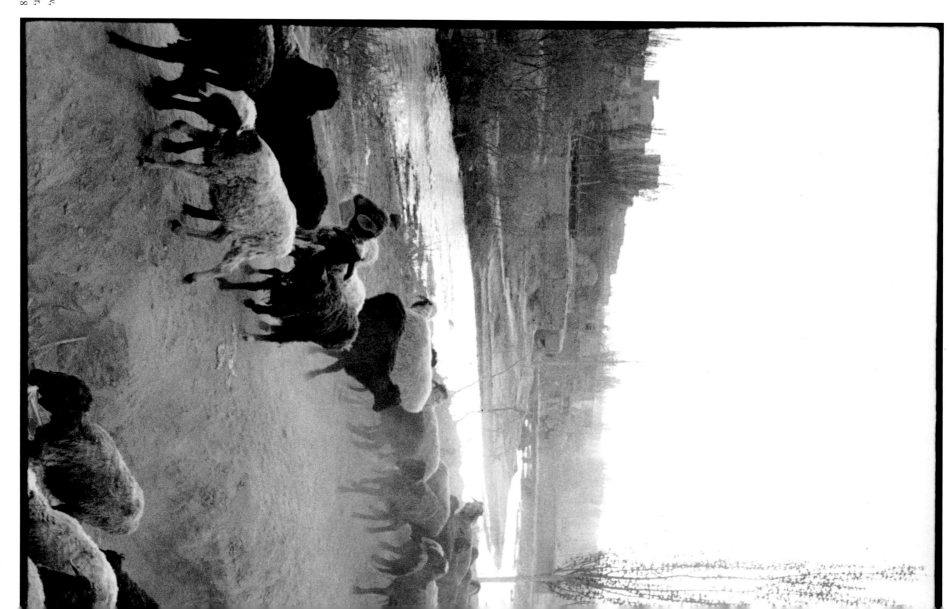

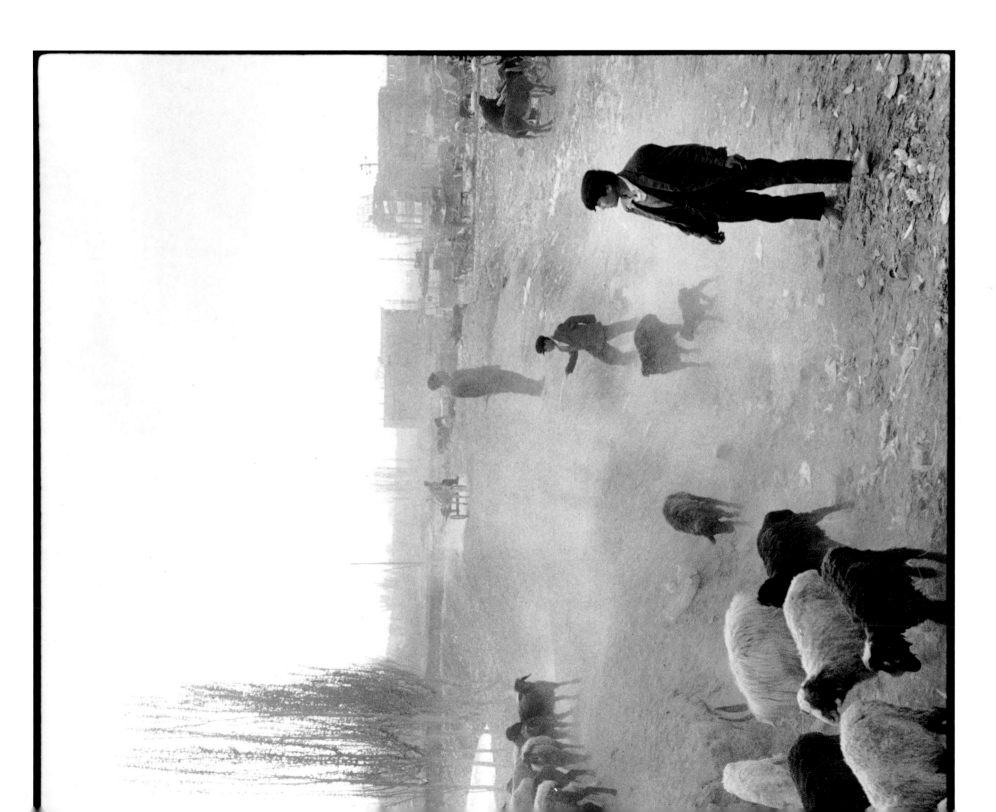

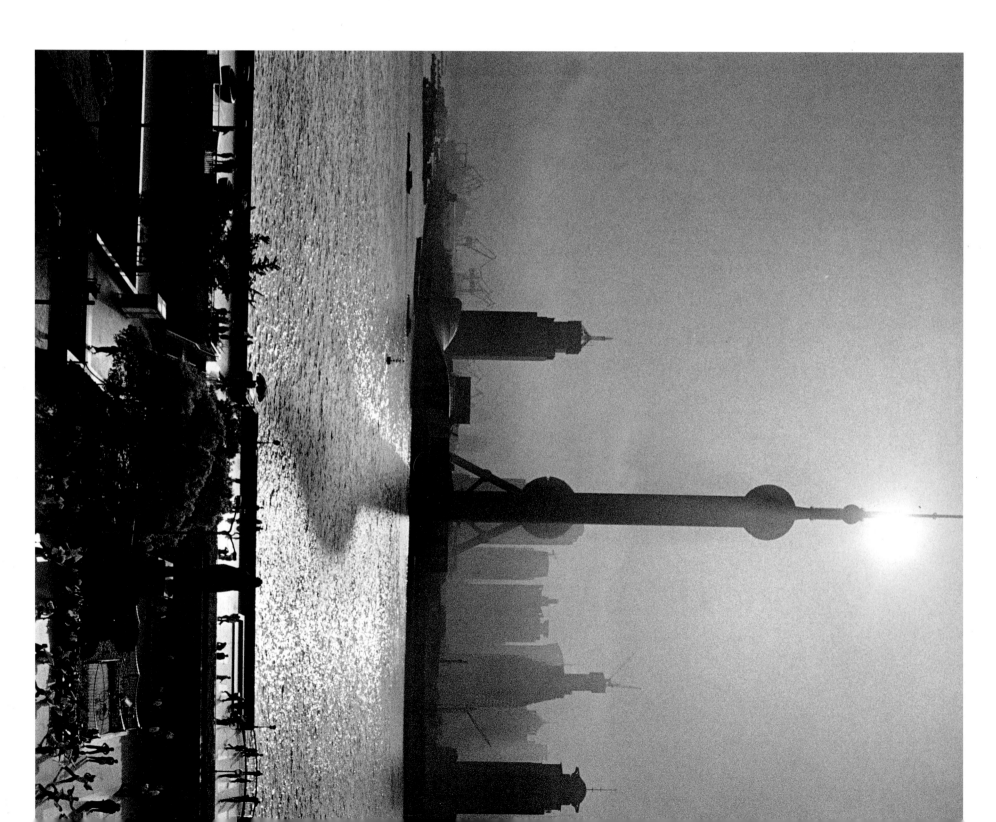

The Whangpoo changes color with the seasons.
Slight shifts in tone occur when the sky turns
from the clear blue to cloudy gray, but the basic,
overall transformation from a deep, earthen hue
to a pure, limpid green corresponds to nature's
yearly cycle. I rely on the changes in the color of
the Whangpoo to tell me of the passing of the
seasons. The interdependence between the river
and the human beings who live along its banks
is even more powerful: when they have drunk
enough from the Whangpoo, fair-skinned people
find that their faces have turned to the muddy
yellow of its waters.

The speed of the current also varies according
to the season. A swift undertow with treacherous
whirlpools sometimes lies hidden a mere twenty
or thirty centimeters below a placid surface, and
people say that those unlucky enough to fall in
are best forgotten: the difference between the
surface and what lies beneath it is that great.
At other times, usually when spring is turning
to summer, the undertow rises to the surface
and the river rages furiously along. At high tide,
when the current is especially swift, the junks
and sampans have to fight for all they are worth
to keep from being carried away.

—KYOKO HAYASHI,
from *The Whangpoo River*

SEBASTIÃO SALGADO
SHANGHAI, ELECTRIC CITY

View of Pudong district from
the Bund, Shanghai, 1998

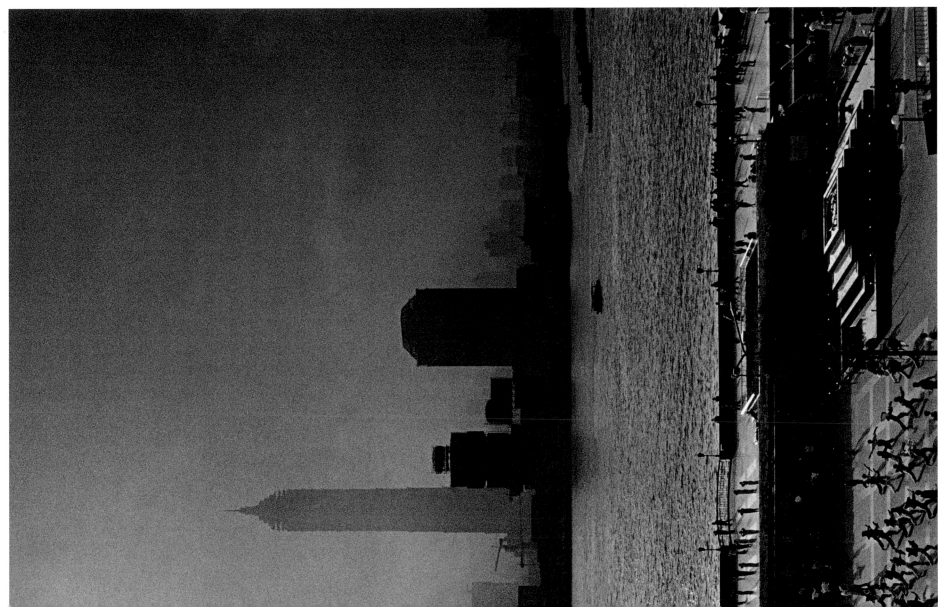

Sebastião Salgado, Construction workers resting, Shanghai, 1998

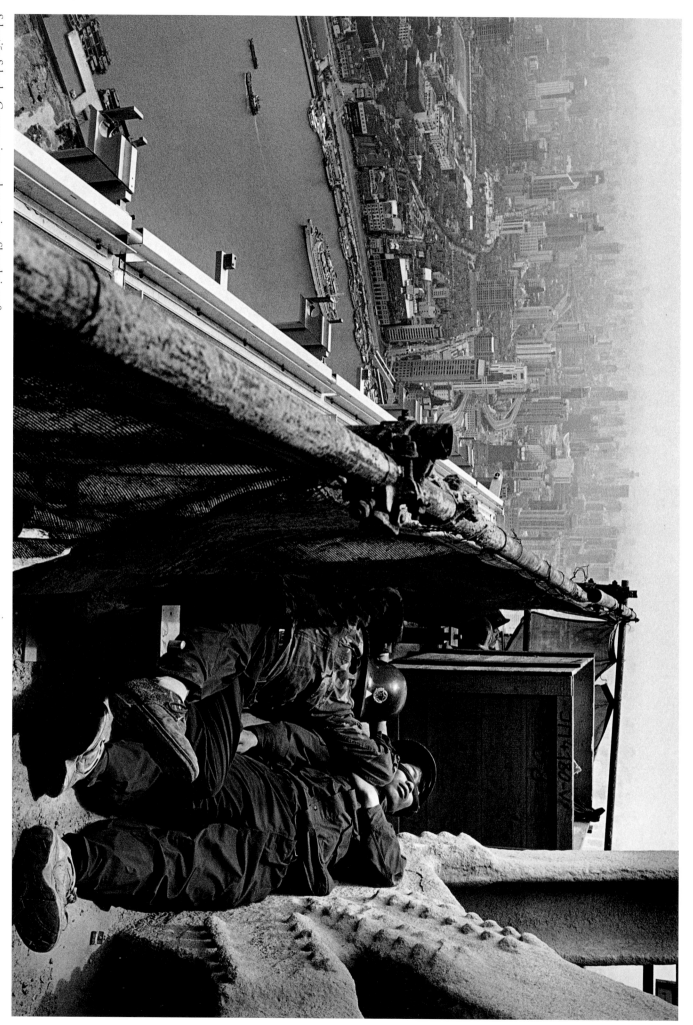

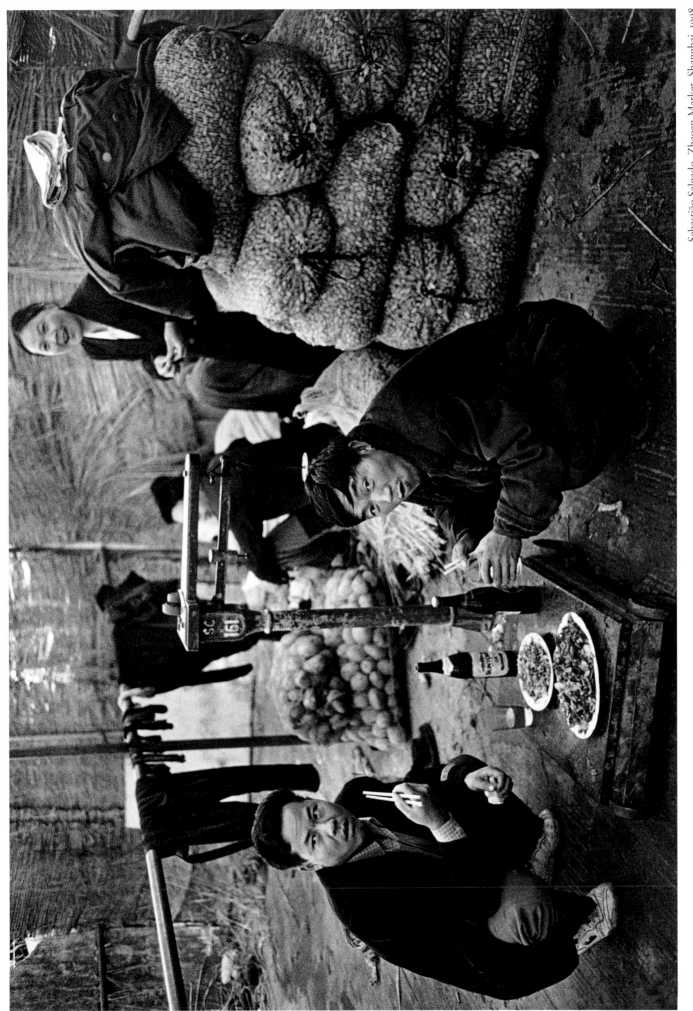

Sebastião Salgado, Zhaoen Market, Shanghai, 1998

Sebastião Salgado,
Tea room in the city's
center, Shanghai, 1998

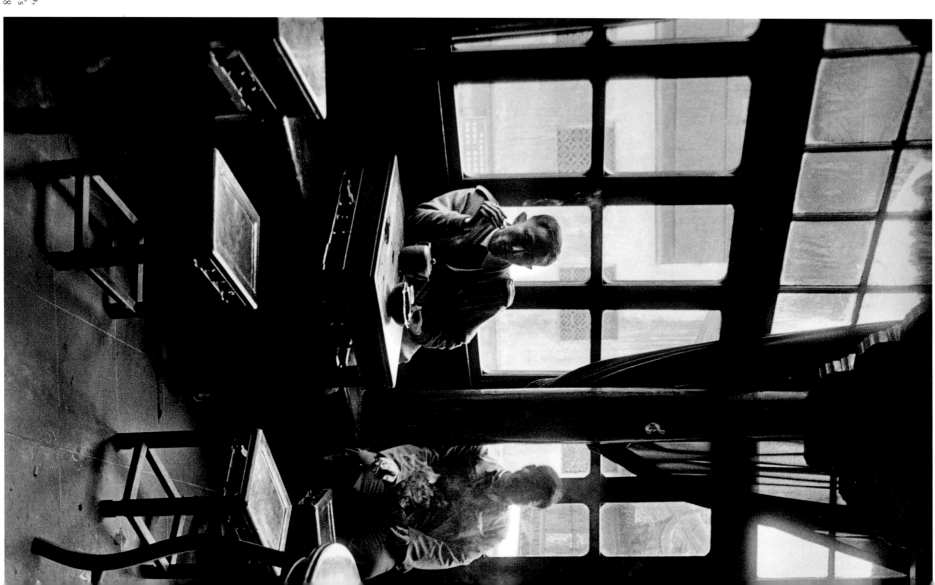

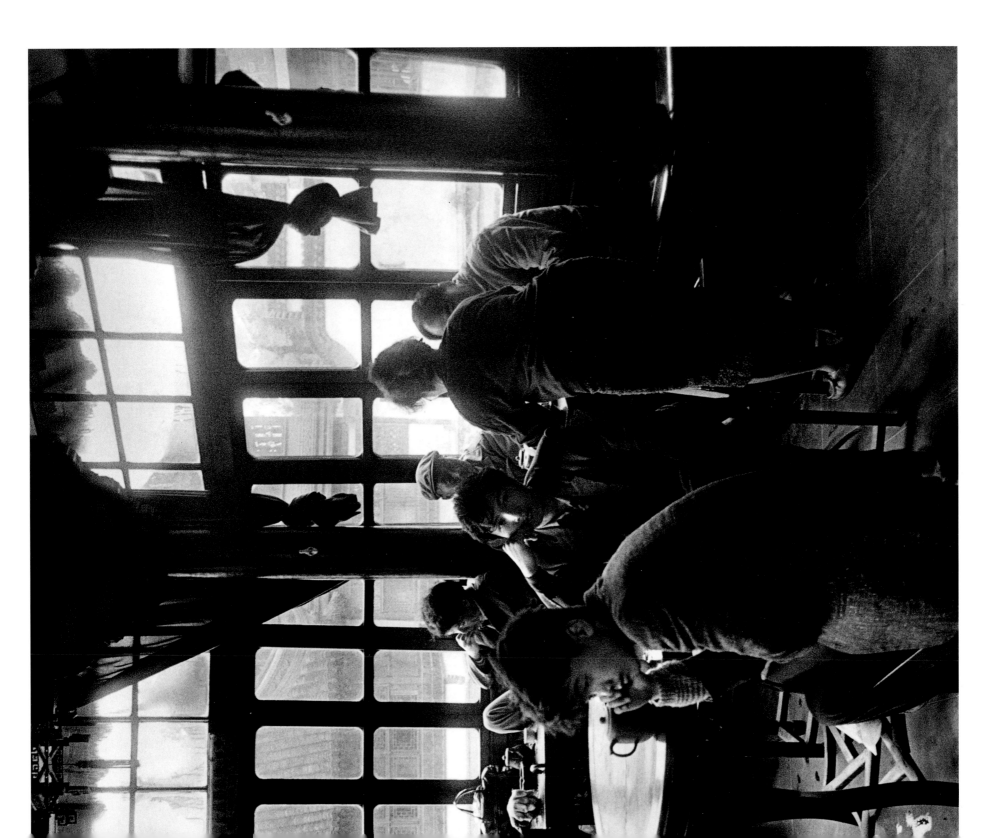

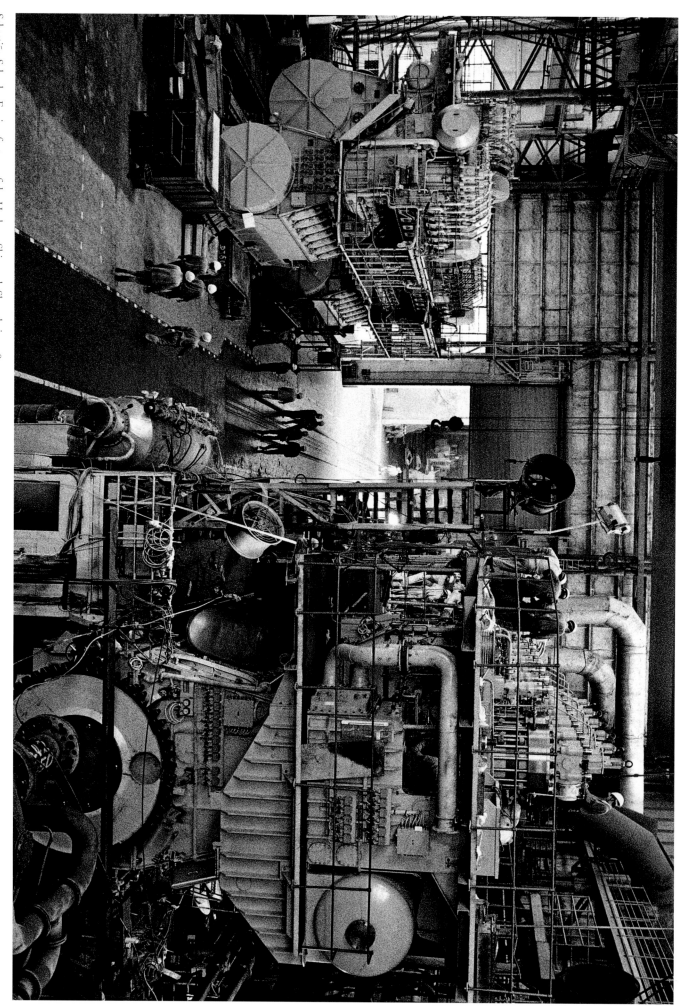

Sebastião Salgado, Engine factory of the Hudong Shipyard, Shanghai, 1998

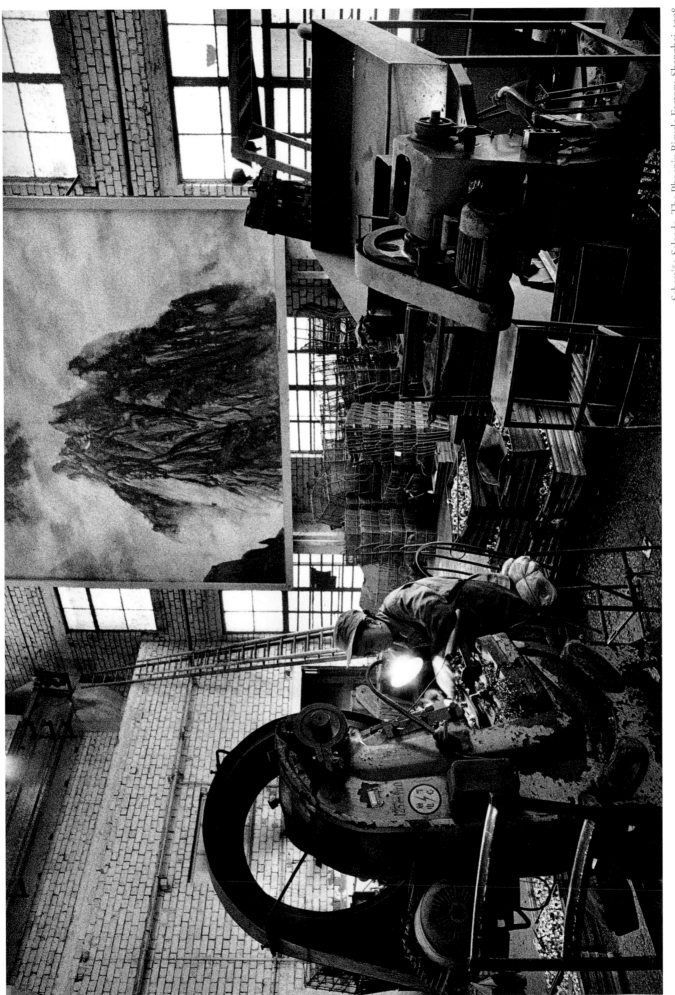

Sebastião Salgado, The Phoenix Bicycle Factory, Shanghai, 1998

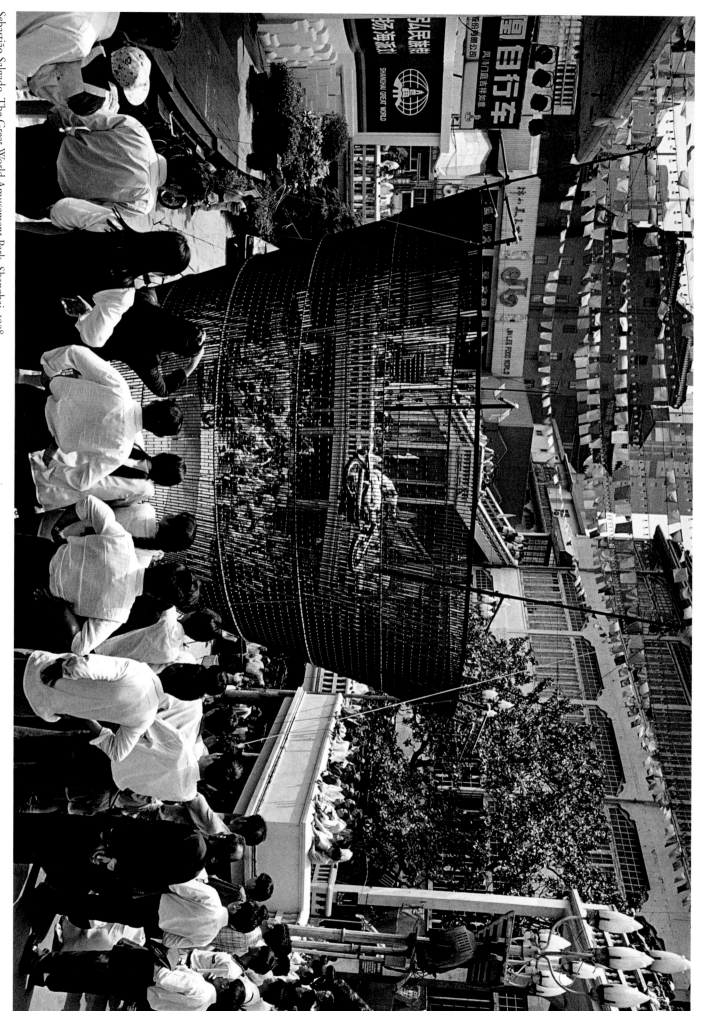

Sebastião Salgado, The Great World Amusement Park, Shanghai, 1998

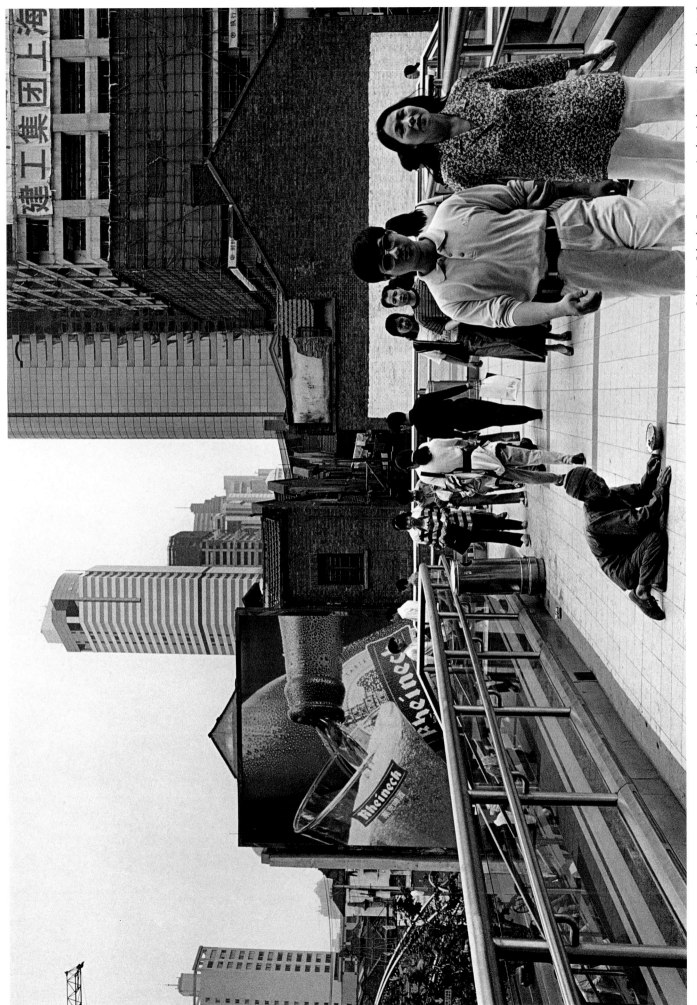

Sebastião Salgado, *Street scene in the city's center, Shanghai, 1998*

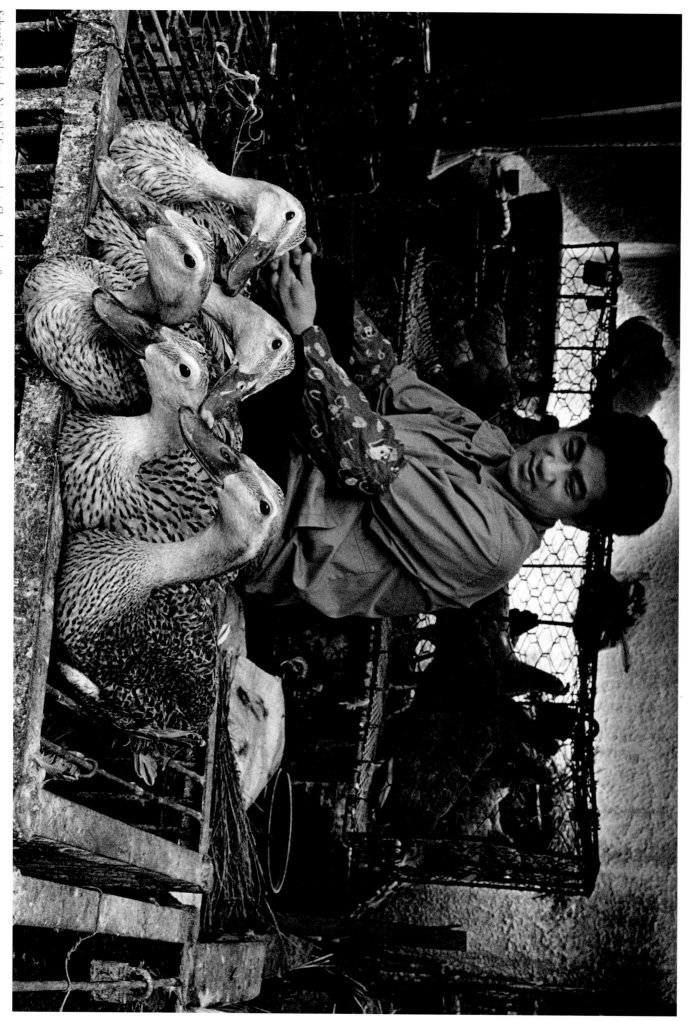

Sebastião Salgado, Nan Shi Street market, Shanghai, 1998

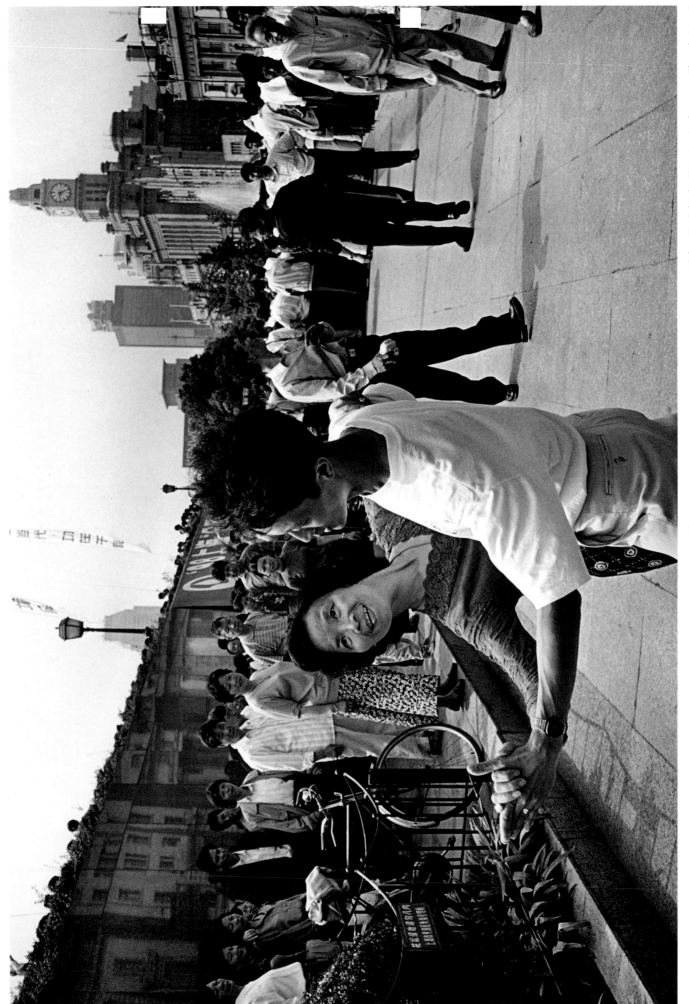

Sebastião Salgado, Dancing in the street, Shanghai, 1998

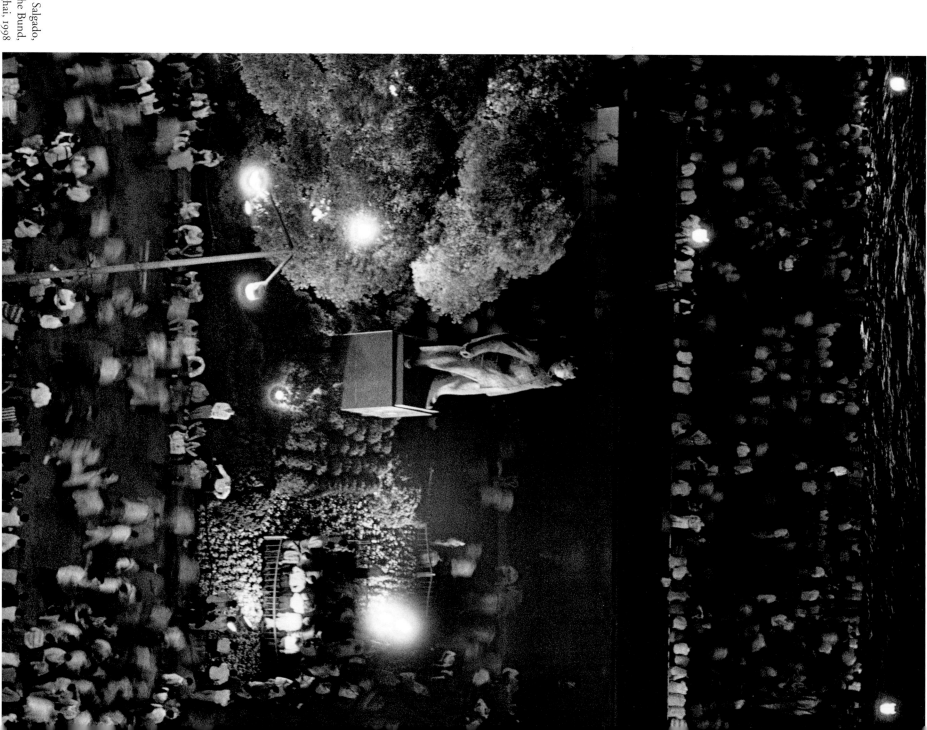

Sebastião Salgado,
Nightlife on the Bund,
Shanghai, 1998

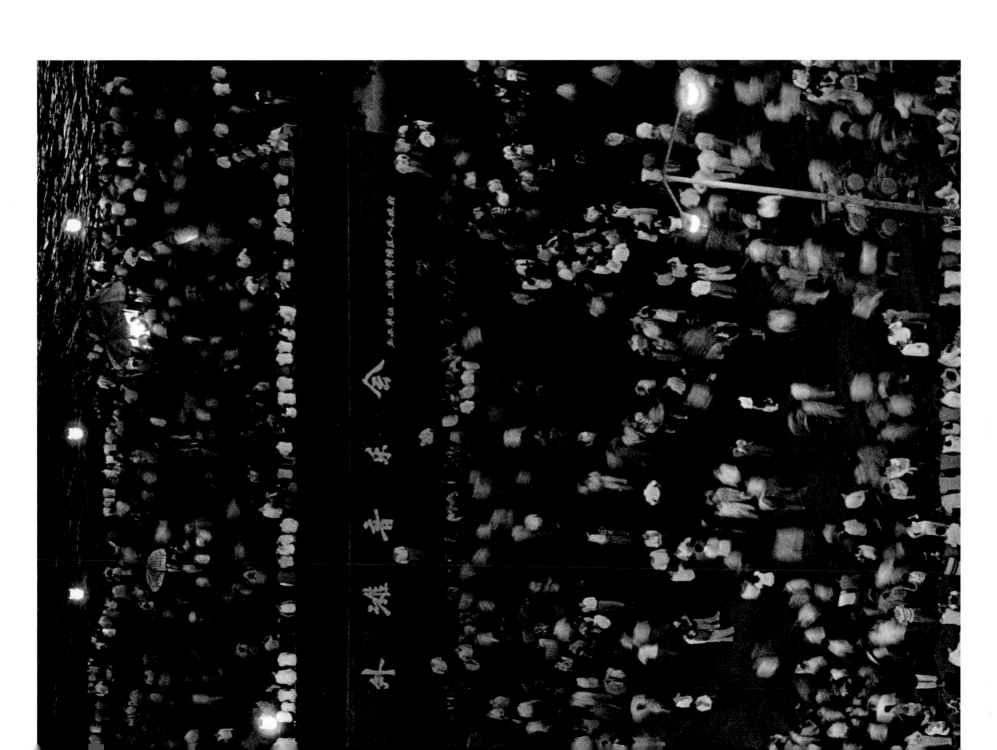

CHRONOLOGY OF MODERN CHINA

QING DYNASTY (1644–1912)

1644 Manchu invaders establish China's last imperial dynasty. The long reigns of emperors Kangshi (1662–1722) and Qianlong (1736–1795) re-establish Chinese political and cultural dominance of East Asia.

1760 The Canton system is created: all legal trade with Western maritime nations is to be conducted only at Canton, according to rigid rules.

1796–1804 The massive Buddhist-inspired White Lotus rebellion is suppressed but weakens the Qing order.

1800–1830s Increasing amounts of illegally traded opium are used by Western merchants to balance trade with China.

1839–1842 Opium war. Britain forces China to open five treaty ports and relinquish Hong Kong. The Treaty of Nanjing (1842) is the first of several unequal treaties between China and Western nations.

1850–1864 The Taiping Rebellion, a movement of the poor motivated by aspects of Christianity and by egalitarian social and economic ideals, nearly topples Qing regime.

1860 Britain and France occupy Beijing and obtain additional concessions that diminish China's sovereignty.

1861–1895 The Self-Strengthening movement is launched: the selective adoption of Western technologies and education to save the Confucian state.

1885–1895 With a military defeat by France and Japan, China loses influence in Vietnam and Korea; Japan colonizes Taiwan.

1898 The One Hundred Day Reform, an attempt by the Guangxu Emperor to modernize the Qing regime, fails; conservative officials react, the emperor is put under house arrest, and the empress Dowager Cixi takes over the government.

1900 The Boxer Uprising. Japan and several Western nations invade Northern China and occupy Beijing.

1901–1908 Late-Qing reforms are led by the Empress Dowager Cixi, including the end of the Confucian examination system to select officials in 1905.

1911 October 10. Rebellion in Wuchang by followers of the Nationalist leader Sun Yat-sen (1866–1925) leads to collapse of the Qing.

1912 February 12. The Qing throne is formally abdicated.

REPUBLIC (1912–1949)

1912–1916 Power falls to President Yuan Shikai, a Qing general-turned-dictator; his warlords will dominate China until 1928.

1914 Japan occupies German-controlled Shandong Province.

1915 Japan makes Twenty-one Demands for further Chinese concessions.

1919 May 4. Chinese hopes for post–World War I restoration of territorial integrity are dashed by the Treaty of Versailles; the May Fourth movement seeks to resist foreign imperialism by revolutionizing Chinese culture; this leads to the reorganization of Sun's Nationalist Party, the Guomindang (GMD).

1921 The Chinese Communist Party (CCP) is established; Mao Zedong (1893–1976) is one of a handful of Party organizers.

1923 CCP members join GMD as individuals, forming the First United Front.

1924 Soviet aid and advisors to GMD's Whampoa Military Academy train GMD/CCP leadership for national unification, headed by Chiang Kai-shek (1886–1975).

1926 GMD/CCP's Northern Expedition is launched against warlords.

1927 In the White Terror, Chiang Kai-shek virtually wipes out the urban-based CCP. CCP remnants flee to the countryside.

1927–1937 Nanjing Era. GMD is in power for a decade.

1931 The Mukden Incident initiates Japan's occupation of Manchuria.

1932 Japan attacks Shanghai.

1934–1935 The CCP is expelled from Jiangxi Soviet on Long March; Mao becomes primary leader of the CCP. With Zhou Enlai (1898–1976), Zhu De (1886–1976), Peng Dehuai (1898–1974), Lin Biao (1907–1971) and others, Mao creates the foundations for revolution at Yanan (1935–1947), in northwestern China.

1937–1945 World War II in China. Japan invades; The Rape of Nanjing in 1937 forces Chiang's government to Chongqing. Uneasy Second United Front is formed against Japan.

1942 China's Rectification campaign uses thought reform, not purges, to promote party policies.

1946 The CCP creates the People's Liberation Army (PLA).

1946–1949 Civil War. The CCP is victorious; Chiang and remaining GMD forces flee to Taiwan.

PEOPLE'S REPUBLIC OF CHINA (1949–PRESENT)

1949 October 1. The People's Republic (PRC) is formally established in Beijing as a democratic dictatorship based on the coexistence of four democratic classes.

December. Mao visits the Soviet Union in his first journey outside China. There is major alignment with the Soviets despite limited advantage to China.

1950 Territorial consolidation (except Taiwan). Troops enter Tibet (by 1951).

The economy is rehabilitated.

New laws are put into effect, including the Agrarian Reform law (often-violent redistribution of landlords' holdings, completed by 1953), and the New Marriage law (promising new rights to women).

The Three Selfs movement requires Chinese-Christians to cut ties with foreigners.

The Resist America and Aid Korea campaign is waged against Western, especially American, influences.

October. Chinese "volunteer" troops secretly enter the Korean War; counteroffensive is launched in November.

1951 Two new campaigns are launched: the Suppression of Counterrevolutionaries campaign, and the Three Antis campaign (against corruption, waste, bureaucratic abuses).

1952 The Five Antis campaign is effected: a mass movement against the bourgeoisie.

1953 Drive begins for collectivization in agriculture (completed by 1957, with nearly 800,000 collective farms).

July. Truce in Korea.

The First Five-Year Plan is proposed, using the Soviet model for heavy industrial development; with advisers and loans, the Soviet influence is strong.

December. In the first major purge of CCP, regional leaders Gao Gang and Rao Shushi are ousted.

First modern-style census: population approximately 582.6 million.

1954 Constitution is implemented; Mao becomes Chairman of the PRC. Business enterprises become "public-private." Zhou Enlai plays prominent role in Geneva during talks to settle the Franco-Vietnam War.

1955 Anti–Hu Feng movement: famous writer who questioned CCP control over culture is jailed as counterrevolutionary (until 1979).

All private enterprises are socialized.

Zhou Enlai represents China's enhanced position in the international world at Bandung Conference of Afro-Asian States.

1956 China's industrial output increases enormously. Higher education is revamped, with an emphasis on technical education and a downgrading of the liberal arts.

May. Mao delivers One Hundred Flowers speech, calling for more openness in cultural and scientific inquiry. Anti-Rightist campaign promptly follows criticism of the CCP; China's intellectuals are harshly suppressed.

1957 The Soviet Union agrees to assist China's nuclear development.

The Socialist Education movement emphasizes "redness"—loyal adherence to Communist ideology—over expertise.

August–November. Socialized agriculture is effected in the creation of People's Communes, incorporating 98 percent of the farming population; claims of production increases are wildly exaggerated.

November. Mao makes a second trip to the Soviet Union; the Sputnik satellite is seen as evidence that the Socialist system is destined to overthrow the capitalist system.

1958 The Second Five-Year Plan sets goal of a 75 percent increase in industrial and agricultural production.

February. The Great Leap Forward movement's unrealistic aim is to achieve huge increases in production by 1960; frenzied attempts are made to increase steel production with backyard furnaces.

1959 Indications of hunger in the countryside are followed by an outbreak of major famine (20–30,000,000 deaths from starvation by 1962).

Khrushchev begins withdrawal of Soviet experts, frustrating China's atomic development.

March. Tibetan uprising is brutally suppressed. Dalai Lama flees to India.

August. The CCP is split when Defense Minister Peng Dehuai is dismissed for criticizing Mao's Great Leap Forward and the People's Communes; Lin Biao becomes Defense Minister. Mao gives up chairmanship of state, but remains party chairman.

1960 China is critical of Soviet revisionism and idea of peaceful coexistence; a major rift occurs between China and the Soviet Union. Remaining Soviet advisors are recalled from China.

1961 February. A production of Wu Han's play *Dismissal of Hai Rui from Office* is staged, a thinly disguised critique of Mao's purge of Peng Dehuai and a cry against tyranny.

1962 With an economic retrenchment and stress on practical policies, Liu Shaoqi (1898–1969) and Deng Xiaoping (1904–1997) downplay Maoist policies.

Lin Biao uses *Quotations from Chairman Mao* (the "little red book") to inculcate correct behavior in the PLA, giving rise to cult of Mao. The fictitious *Diary of Lei Feng*, a heroic tale of a soldier, is used in the campaign to promote Mao's ideas of revolutionary commitment.

September. Mao calls for a new Socialist Education movement to emphasize class struggle in cultural life.

November. There is a unilateral Chinese cease-fire on Indian border after years of clashes over delineation of borders.

1963 Mao's Rural Socialist Education movement is implemented.

Jiang Qing calls for a ban on traditional drama.

1964 China protests US bombing of North Vietnam, claiming that an attack on North Vietnam would be the same as an attack on China.

October. China enters the nuclear age with a successful test of the atomic bomb.

The East is Red, an extravagant operatic celebration of CCP history and Mao's role in it, is staged.

1964 census: population approximately 694.6 million.

1965 September. Mao calls for criticism of reactionary intellectuals, with little response.

November. Mao moves to Shanghai to organize hard-line radicals, including his third wife, Jiang Qing, a major critic of recent cultural tendencies. Shanghai journalist Yao Wenyuan attacks Wu Han's play as "anti-Party poisonous weed," for undermining Mao's view of the masses as the primary force in history.

1966 February. Lin Biao enlists Jiang Qing to develop cultural policies for the PLA.

May 9. China makes its first thermonuclear test.

May 16. Politburo decides that the Cultural Revolution group must attack bourgeois elements in the CCP, the government, the PLA, and cultural circles.

Mao's May Seventh directive: the PLA is to be a "great school."

Spring/Summer. Important figures in Ministry of Culture are purged; attacks are made against Wu Han and other writers; radical protests on campuses. First appearance of Red Guards, who proclaim Mao as their "great teacher, great leader, great supreme commander, and great helmsman." Mao, fearing the bureaucratization that befell the Soviet Union economy and society, encourages urban youth to criticize and reform the CCP from below. Mao at first restrains the party, police, and army from interfering. As the youth began to splinter and fall into factions, Mao calls on the military to repress them, only to have it collapse along factional lines as well.

September. *Quotations from Chairman Mao* is published for the general public.

1967 January. Radical struggles continue in Chinese cities. The PLA is instructed to side with the "left-wing masses."

February. The Shanghai People's Commune is established. Mao allows PLA crackdown on militant radicals.

Fall/Winter. Schools are closed amid huge struggles. China's youth are urged to destroy old customs, old habits, old culture, and old thinking; to attack teachers, leaders, and parents. There is an outpouring of violence, with widespread mass criticisms, imprisonment, sadistic torture, and killing. Liu Shaoqi and Deng Xiaoping, major party leaders, are purged.

Population: approximately 750 million.

June. China explodes its first hydrogen bomb.

Summer. China's cities are in chaos.

1968 Widespread campaigns are waged against "bad elements."

July. Mao signals an end to the extreme radical phase of the Cultural Revolution.

December. Mao announces a directive to send educated urban youth to the countryside for re-education by poor and lower-middle-class peasants.

1969 Border clashes with the Soviet Union over Zhenbao Island in the Ussuri River and in Xinjiang Province.

Lin Biao is chosen as Mao's successor.

December. US trade embargo against China is partially removed.

Population: approximately 806 million.

1970 January. At Warsaw talks, China indicates a willingness to discuss substantive issues at a higher level with US.

April. The first Chinese satellite orbits successfully.

August. Mao issues new instructions for the CCP: downplay ideology and reduce the PLA's role. Mao doubts Lin Biao's loyalty.

October 1. American journalist Edgar Snow is invited to the twenty-first anniversary of the PRC. This is seen as a signal to President Richard Nixon.

1971 Screenings of model dramas The Red Lantern and The Red Detachment of Women, models of leftist patriotic cultural works.

April. US table-tennis team is invited to China ("ping pong diplomacy").

July. Henry Kissinger meets with Zhou Enlai in private talks.

September. Lin Biao is killed in a plane crash in Outer Mongolia, allegedly after an attempted coup against Mao.

October. Taiwan's seat in the UN is given to the PRC.

November. Publication of the first book of classical literature since the start of the Cultural Revolution: on the Tang poets Li Bo and Du Fu.

Population: approximately 852 million.

1972 February. President Nixon visits China, with the Shanghai Communiqué signifying a basic realignment of foreign policy for the US and China; US recognizes the principle that Taiwan is part of China.

Population: approximately 870 million.

1973 January. Struggles between radical and moderate factions in the Party leadership. Radicals, led by Mao's wife, Jiang Qing, gain the upper hand and begin a campaign to criticize Lin Biao and Confucius as a way of attacking the moderates, led by Zhou Enlai.

April. Deng Xiaoping, protégé of Zhou, reappears as vice-premier, and addresses UN General Assembly.

The Vienna Philharmonic Orchestra and the Philadelphia Orchestra visit China.

Population: approximately 892 million.

1975 April. Chiang Kai-shek dies in Taiwan.

May. In a Politburo meeting, Mao warns Jiang Qing and her associates against maneuvering as a "gang of four." However by fall, radicals convince Mao that moderates want to repudiate him and his work.

December. President Gerald Ford visits China and meets with Mao.

1976 January 8. Premier Zhou Enlai dies.

February. Hua Guofeng (b. 1921) succeeds Zhou as acting premier. A campaign is waged against "capitalist roader" Deng Xiaoping.

April 5. The Tiananmen Incident: violent clashes break out in Beijing and elsewhere between authorities and demonstrators mourning Zhou Enlai.

April 7. Hua is appointed premier; Deng is dismissed from all posts.

July 6. Zhu De dies.

July 28. In one of history's worst earthquakes at Tangshan, 300,000–600,000 people are killed.

September 8. Chairman Mao dies. A coalition of political, police, and military leaders forms to oppose radicals.

October 6. The Gang of Four is arrested.

Population: approximately 925 million.

1977 May 24. Building of Chairman Mao Memorial Hall in Tiananmen Square is completed.

July 21. Hua Guofeng is confirmed in leading posts; Deng Xiaoping is restored to secondary positions.

1978 November. Posters on Beijing's Democracy Wall accuse Mao of having supported the Gang of Four.

December 18–22. The Third Plenum of the 11th Party Congress focuses on economic modernization—the Four Modernizations (industry, agriculture, defence, science/technology); this begins Deng's Revolution, a fundamental reorganization of Chinese economy, society, and culture.

1979 January 1. US-China diplomatic relations resume.

January 7. China denounces December 1978 Vietnamese invasion of Cambodia.

January 28–February 5. Deng Xiaoping visits the US.

February–March. Chinese invade Vietnam.

March. Democracy advocate Wei Jingshange is arrested; in October he is sentenced to fifteen years in prison for counterrevolutionary activities.

April. US Congress passes Taiwan Relations Act. US commits to resisting force against Taiwan.

July. The Party plans to establish four Special Economic Zones (SEZs) for export.

December. Political posters are banned; the 1978–79 pro-democracy movement ends.

Students and scholars travel abroad, particularly to the US.

Responsibility system in agriculture is implemented, reverting responsibility for land to individual farmers. Communes are phased out in the ensuing years.

1980 February. Liu Shaoqi is posthumously rehabilitated.

February 29. Hu Yaobang is elected Party secretary-general.

March–April. China is admitted to International Monetary Fund and World Bank.

September 10. Zhao Ziyang replaces Hua Guofeng as premier; Deng Xiaoping and others resign vice-premierships due to old age.

Revised Marriage Law is put in effect to reduce population growth with later marriages: earliest age for marriage is now twenty-two for men, twenty for women.

October 20–December 29. The Gang of Four and several others are tried and convicted for their role in the Cultural Revolution.

1981 June 29. A Party communiqué cites the Cultural Revolution as a disaster, and criticizes Mao's role and the policies of his last years.

1982 July. Third national census: China's population is over one billion.

September. British Prime Minister Margaret Thatcher visits China to discuss the future of Hong Kong. Deng Xiaoping and associates occupy most positions of Party and state power.

1983 May. Arthur Miller's *Death of a Salesman*, directed by the playwright, opens in Beijing.

July 1. Deng's *Selected Works* are published.

Plans are made for a large-scale Pearl River economic zone.

A report is issued stating that economic crimes are at a record high.

September. Regulations are made governing joint ventures in China.

October. China is approved as a member of the International Atomic Energy Agency.

A campaign is launched against "spiritual pollution" from the effects of Western influence.

1984 January. Premier Zhao Ziyang makes an official visit to US.

April. President Ronald Reagan visits China.

June. Deng promises that Hong Kong's socio-economic system will remain the same after its return to China: "One country, two systems."

December 19. Prime Minister Thatcher and Premier Zhao sign Sino-British Joint Declaration on Hong Kong; Hong Kong will return to Chinese jurisdiction on July 1, 1997.

1985 March. Deng proposes "socialism with Chinese characteristics." Zhao Ziyang cites changes in wage and price systems essential to economic reform.

May. The Party orders modernization in education.

June. Deng reports the intention to reduce the PLA size by one million within two years.

July. The Party issues a report on large-scale smuggling and other economic crimes in Hainan.

September. In a major shift, the Party's power is transferred from elder leaders to younger, better-educated ones; sixty-four resign.

October. The Bolshoi Ballet performs in Beijing.

December. China's first public demonstrations against nuclear testing take place.

1986 March. China becomes a member of the Asian Development Bank.

April. US agrees to supply high-technology aviation equipment to China for military modernization.

April 21. A new law, to be implemented by 1990, requires nine years of compulsory education for all.

July 12. Military clash on Sino-Soviet border.

July 28. Mikhail Gorbachev calls for resumption of friendship between China and Soviet Union.

September 26. Shanghai Stock Market reopens after nearly forty years.

September 28. Party attacks "bourgeois liberalization" that undermines Socialist system and promotes capitalism.

October. Government encourages foreign investment in China.

November–December. Thousands of students demonstrate for democracy in Beijing and many other cities. In Hefei, Anhui Province, they rally in response to a speech by astrophysicist Fang Lizhi who says that democracy is "not granted but won."

December 2. Bankruptcy law is approved.

December 26. In Beijing, demonstrations that lack prior approval are banned.

1987 January. *The People's Daily* attacks bourgeois liberalization, saying that the success of the reform depends on Four Cardinal Principles; leadership of the CCP, Marx-Lenin-Mao Thought, people's democratic dictatorship, and the "socialist road."

Hu Yaobang resigns as CCP general secretary; he is replaced by Zhao Ziyang. The CCP expels Fang Lizhi and *People's Daily* reporter Liu Binyan for opposing the Four Cardinal Principles.

March 26. China-Portugal agreement is signed for return of Macao (under Portuguese administration since 1557) on December 20, 1999.

July. The CCP reports widespread corruption in the Party.

September–October. Demonstrations are held in Lhasa for Tibetan independence; clashes with authorities lead to arrests and deaths.

October 6. The US Senate condemns Chinese actions in Tibet. China protests US interference in internal affairs.

November. Zhao Ziyang names Li Peng acting premier.

1988 January 14. The CCP sends condolences to GMD in Taiwan on death of Jiang Jingguo (son of Chiang Kai-shek).

July 3. Li Peng encourages Taiwan to invest in mainland China.

August. Politburo decides to allow most commodity prices to be regulated by market.

September 17. Li Peng indicates his willingness to normalize relations with Soviet Union.

1989 February 1–4. Soviet Foreign Minister Eduard Shevardnadze visits (the first Soviet state visit since 1959).

February 25–26. President George Bush visits.

March. Anti-Chinese demonstrations in Lhasa erupt in violence; martial law is declared. Li Peng acknowledges that inflation and price hikes threaten China's modernization program.

April 15. Death of Hu Yaobang is followed by student demonstrations for Hu's rehabilitation and for democracy. Official mourning on April 22 sparks large student demonstration in Tiananmen Square.

April 27. Demonstration is held in Tiananmen Square for democratic freedoms, calls for government accountability and cleanup of Party corruption.

May 4. Massive demonstrations are held in Beijing and other major cities to commemorate the seventieth anniversary of the May Fourth movement. Calls are made for freedom of the press and democracy.

May 13. Beijing demonstrators vow to occupy the square until demands are met; they begin a hunger strike.

May 15–18. Gorbachev visits (the first visit of a Soviet leader since 1959). Deng and Gorbachev announce normalization in Sino-Soviet relations.

May 19. Zhao Ziyang meets with demonstrators on Tiananmen Square.

May 20. Martial law is declared for parts of Beijing. The PLA refuses to move against demonstrators. Li Peng's overthrow is called for.

May 30. Tiananmen Square demonstrators construct *Goddess of Democracy*, statue inspired by the Statue of Liberty.

1993 Wei Jingshang is released early from prison as part of Beijing's unsuccessful bid for the Olympic Games in the year 2000. (Wei is re-arrested and sentenced in 1995 to fourteen more years in prison.)

GDP grows by 14 percent.

1994 February. Deng's last public appearance.

May. President Bill Clinton ends link between China's human-rights record and Most Favored Nation trade status.

GDP growth rate is 12 percent, inflation 24 percent.

Zhu Rongji's austerity plan is designed to slow down China's economy.

1996 Democratic elections are held in Taiwan; PRC rockets landing nearby bring US naval response.

Reduction of inflation to 6 percent; GDP grows by 10 percent.

1997 February 19. Death of Deng Xiaoping at age ninety-three.

July 1. Hong Kong is returned to Chinese jurisdiction.

October. Jiang Zemin visits the US to discuss human-rights issues, a nuclear accord, and a promise of Chinese tariff cut to address trade imbalance.

November. Wei Jingshang arrives in US after his release from prison.

1998 March. Li Peng is replaced as premier by economic reformer Zhu Rongji.

April. Prominent dissident student leader Wang Dan is released from prison, and arrives in the US

China's economic growth drops sharply to below 8 percent per annum.

June. President Clinton visits China.

August. Major flooding occurs on the Yangtze and other rivers.

China wins world respect for economic role in Asian crisis.

Population: approximately 1.21 billion.

1999 Population: approximately 1.243 billion.

June 3–4. Beijing massacre: widespread violence throughout the city.

June 5. US provides sanctuary in Beijing for Fang Lizhi; the Bush administration suspends US-China military contacts and sales.

June 9. Deng praises China's military for suppressing counterrevolutionaries, and pledges to continue post-1978 open-door policy and reforms.

June 10. Arrests of leaders and participants of demonstrations begin.

June 24. Zhao Ziyang is dismissed from all high Party positions; he is replaced by Jiang Zemin as general-secretary.

August 24. *The People's Daily* promises punishment according to the law for demonstrations' leaders only, not ordinary participants.

November 9. Deng announces his intention to resign as chairman of Party Military Affairs Commission; Jiang Zemin is to replace him.

1990 January. Martial law is lifted in Beijing. Nearly six hundred arrested student-movement participants, having confessed, are released.

April 4. Basic Law of the Hong Kong Special Administrative Region of the PRC is adopted. The law, designed to ensure a fifty-year continuance of Hong Kong's economic system, will be effective July 1, 1997.

April 7. Asia's first regional communications satellite is launched.

April 23–26. Li Peng visits the Soviet Union.

May 1. Martial law ends in Lhasa, Tibet.

1991 GDP grows at a role of 7.5 percent. In the most rapid growth of any major world economy, China's GDP will average 11 percent per annum through 1997.

Population: approximately 1.152 billion.

1992 January. Deng makes "southern tour" to Shenzhen and Zhuhai SEZs, and to other cities to defend open-door economic strategies against hard-liners.

Major Yangtze River and border cities open to foreign investment.

Zhu Rongji becomes one of the chief leaders in China's economic growth; GDP grows by 12 percent.

Population: approximately 1.167 billion.

THE PHOTOGRAPHERS

For members of the press corps, Jack Birns, James Burke, and Enrico Sarsini, whose images are presented here courtesy Time Life Syndicate, biographical information was not available.

Born in Philadelphia to Russian immigrant parents, EVE ARNOLD began her career managing a photo-finishing plant. In 1948, she studied photography with Alexy Brodovich at the New School for Social Research in New York. She has won international recognition for her many photo essays on Asia, Africa, and the former Soviet Union, as well as for her portraits of personalities in the arts, politics, and cinema, including Mikhail Baryshnikov and Marilyn Monroe. Arnold became a member of Magnum Photos in 1951.

Swiss-born photographer and filmmaker RENÉ BURRI's work from China has been published and exhibited widely since his first solo exhibition, *China*, at Zurich's Galerie Form in 1965. He has published several books, including *The Gaucho* (with text by Jorge Luis Borges), and *In Search of the Holy Land*. Burri's work is represented in the collections of the Museum of Modern Art, the Art Institute of Chicago, and the Bibliothèque Nationale in Paris, among others. Burri has been a member of Magnum Photos since 1959.

DAVID BUTOW began his career in photography working for newspapers in the Los Angeles area, and turned freelance in 1992; his photographs have appeared on the covers of *Newsweek*, *Harper's*, *U.S. News and World Report*, and *People*. Butow, a member of the SABA photo agency, is presently a contract photographer with *U.S. News and World Report*.

ROBERT CAPA, born in 1913 in Budapest, Hungary, is revered as one of the great photojournalists of all time. First recognized for photographing the Spanish Civil War, Capa covered some of the most momentous events of the twentieth century, including the Japanese invasion of China in 1938, the liberation of Paris, the Battle of the Bulge, London during World War II, the founding of the new nation of Israel in 1948, and finally, in 1954, on assignment for *Life* magazine, the war in Vietnam, where he was killed by a land mine.

CHEN CHANGFEN was born in 1941 in Hunan. His work has been exhibited at the China Art Gallery in Beijing among other venues and published in China and Japan. Chen has photographed, lectured, and traveled in the United States, Japan, the former Soviet Union, Thailand, Turkey, and throughout Europe. He has been the recipient of awards from the Swiss Graphic Photo Exhibit (1987), the First China Photographic Art Exhibit, and the Chinese government. In 1989, Chen was chosen by *Time* magazine as one of ten eminent photographers of the past 150 years.

LOIS CONNER received a MFA in photography from Yale University in 1981. A National Endowment for the Arts grant recipient in 1979, she began photographing in China with a Guggenheim fellowship in 1984, which led to a limited-edition gravure book, *The River Flows Into the Heavens* (1988). Her work has been exhibited internationally and is represented in such public collections as the Museum of Modern Art and the Metropolitan Museum of Art in New York, the Smithsonian Museum of American Art in Washington, and the Victoria and Albert Museum in London. She is represented by the Laurence Miller Gallery in New York and since 1991 has been an Assistant Professor of Photography at Yale.

MACDUFF EVERTON was born in 1947 in Pearl River, New York and currently resides in Santa Barbara, California. His work is represented in such public collections as the Bibliothèque Nationale in Paris, the British Museum, the Huntington Library in San Marino, California, the Museum of Modern Art, and the White House. He has published several books, including *People of the Serpent: Cultural Change in the Yucatan*.

STUART FRANKLIN took up the camera at the age of seventeen, studied photography at West Surrey College of Art and Design, and began working as a photojournalist in 1980. Franklin traveled extensively as a freelance photographer for the Sygma agency and joined Magnum Photos in 1985. He has been honored with the Christian Aid Award for Humanitarian Photography (1981) and the Tom Hopkinson Prize for Photojournalism (1989). Franklin's book, *The Time of Trees*, will be published by Leonardo Arte in the year 2000.

ROLF GILLHAUSEN was born in 1922 in Cologne. Trained originally as an engine fitter, he began his career as a photographer with the Associated Press, and soon after started doing freelance work for *Stern* magazine. By the time he left *Stern* in 1984, he had been responsible for the photographic contents of over 1,000 issues. He founded GEO magazine in 1976, and was made an honorary member of the German Art Directors Club in 1986.

A renowned nature photographer and environmental activist, ROBERT GLENN KETCHUM is Curator of Photography for the National Park Foundation and on the Board of Councilors of the American Land Conservancy. He has received the United Nations Outstanding Environmental Achievement Award as well as the Sierra Club's Ansel Adams Award for Conservation Photography; Ketchum's Aperture publications include *The Legacy of Wildness* (1993), *The Tongass: Alaska's Vanishing Rainforest* (1994), and *Northwest Passage* (1996).

ANTONIN KRATOCHVIL was born in 1947 in Lovisice, Czechoslovakia. His book *Broken Dream* (1997) presents twenty years of work documenting Eastern Europe during the Cold War. He has earned numerous awards including the Infinity Award from the International Center of Photography (1991), the Leica Medal of Excellence (1994), and the Alfred Eisenstadt Award (1998). His forthcoming book entitled *Merry* will be published by The Monacelli Press in 2000.

Born and educated in Japan, HIROJI KUBOTA began his photographic career in the United States, working with Magnum Photos to cover Asia beginning in 1971. His photographs of China and Asia in particular have been exhibited and published internationally, most recently in *Out of the East* (1998).

OWEN LATTIMORE (1900–1989), noted Sinologist and author of many books on China, spent nearly half of his life there, working as a journalist, editor, anthropologist, and special advisor to Chiang Kai-shek. On returning to the United States in 1938, he became a lecturer at Johns Hopkins University and later directed its Walter Hines Page School of International Relations. During the 1950s, Lattimore was accused by Senator Joseph R. McCarthy of being an agent of the Soviet Union, a charge later dismissed by the federal government for lack of evidence. In 1962, he established the Department of Chinese Studies at the University of Leeds, England, where he remained until 1970.

MARK LEONG was born in Sunnyvale, California in 1966. He first visited China in 1989 on a graduate fellowship from Harvard University. Since then, he has worked on a long-term project entitled "China Obscura," which documents China's life during a time of momentous change. He has received grants from the National Endowment for the Arts, the Lila Wallace/Reader's Digest Foundation, and the Ford Foundation. He is represented by the New York photo agency Matrix.

Renowned journalist and teacher LI ZHENG SHENG was born in Dalian, China in 1940, and studied photography at the Changchun Film Academy before starting his career at the *Heilongjiang Daily* in 1963. He has been a professor at the Beijing International Political Academy and a visiting scholar at Harvard and Princeton Universities. Selections from the more than 100,000 photographs he took during the Cultural Revo-

lution were compiled in the acclaimed 1988 exhibition *Let History Tell the Future*, and subsequently appeared in a special 1996 issue of *Time* magazine. His work has also been featured in *L'Observateur* (France), *Stern* (Germany), *Asia Week* (Hong Kong), and the *New York Times*.

Born in Hong Kong, raised in Fuzhou, Fujian, China, and educated at Hunter College in New York, LIU HEUNG SHING has worked in China and throughout the world for major news organizations including Associated Press and Time, Inc. Currently Director of Development, Time Inc./Asia, Liu's recent honors include a shared Pulitzer prize (1991) and an Overseas Press Club award (1992).

REAGAN LOUIE returned to China, the land of his ancestors, during the 1980s and traveled and photographed extensively through every province and region. His work, published in the 1991 Aperture book *Toward a Truer Life*, is at once a study of a nation in the midst of sweeping historical change and a personal chronicle of a young Chinese-American's growing awareness of his heritage. Louie is currently Associate Professor of Photography at the San Francisco Art Institute. His work has been widely exhibited and is in the permanent collections of major museums.

MENG ZHAO RUI, senior journalist and Research Fellow, Pictorial Press of the Chinese People's Liberation Army, kindly provided his photograph of events on October 1, 1949.

CARL MYDANS joined *Life* magazine in 1936 before its first issue appeared, and remained on its staff for more than thirty-five years. He had previously been a photographer with the U.S. Farm Security Administration, under whose auspices he chronicled the cotton industry during the Depression; his work from that period is archived in the Library of Congress. His later books include *China: A Visual Adventure*, the autobiography *More Than Meets the Eye*, and *A Photojournalist's Journey Through War and Peace*.

BRIAN PALMER graduated from Brown University in 1986 with a degree in East Asian Studies. After traveling and photographing extensively in Asia, Palmer returned to New York where he earned a M.F.A. in Photography from the School of Visual Arts, and worked as a staff photographer for the *Village Voice* and *U.S. News and World Report*. He moved to Beijing in 1996, and served as Bureau Chief there for *U.S. News and World Report*.

SEBASTIÃO SALGADO has been awarded virtually every major photographic prize in France, Germany, Holland, Spain, Sweden, and the United States. A former member of Magnum Photos, he has twice been named Photographer of the Year by the International Center of Photography. Salgado was originally trained as an economist, and worked in developing nations for Brazil's Ministry of Finance and for the International Coffee Organization. In 1973 he turned to photography to convey the plight of the world's poor; his harrowing photographs of the Sahel famine in Africa during the early 1980s stirred an international call for aid to the region. Aperture published Salgado's acclaimed books *An Uncertain Grace* (1990) and *Workers* (1996), and will publish his *Migrations* in 2000. He lives in Paris.

Born in Shanghai in 1911, SAM TATA has been a photographer since 1936. After a fortunate meeting with Henri Cartier-Bresson in 1948 in Bombay, Tata returned to Shanghai in 1949 and recorded events before and after the establishment of Mao Zedong's government in China. Tata emigrated to Canada in 1956, and has since had his work exhibited and published widely, notably in the book *Shanghai 1949: The End of an Era* (1990). His photographs are included in many major collections, such as that of the National Portrait Gallery in London.

WANG JINSONG was born in Heilongjiang Province, China, in 1963. He graduated from what is now the Chinese Academy of Fine Art in 1987 with a degree in Chinese Painting. As a core member of the Cenozoic School, his works have been widely exhibited in China, Japan, Australia, Europe, and the United States. He currently teaches in the Fine Arts Department at Beijing Education University.

WU JIALIN was born in 1942. A self-taught photographer, he took up the camera in 1969. Wu's images of the Yunnan mountain people have been published and exhibited internationally. He received the Mother Jones International Fund for Documentary Photography Award in 1997 and is presently Deputy Director and Chief Reporter of the News Photo Agency of Yunnan Province.

WU YINXIAN, born in Jiangsu Province in 1900, has been called the doyen of Chinese photography. Wu developed his art in positions ranging from Film Team Leader for the Eighth Route Army (1938–1946) to leadership and teaching appointments at many of China's most important photography and film institutions. His photographs are included in numerous public collections including the Archives of China and the Museum of the Chinese Revolution, both in Beijing, and the Revolutionary Exhibition Hall, Yanan. His work was also exhibited at New York's International Center of Photography in 1985,

XIAO-MING LI started photographing while working as a darkroom technician at *National Pictorial* in Beijing, Li began his series on the unofficial Catholic Church in China in 1992 after completing his study of patients in mental institutions in China, selections of which were published in *Aperture 130: Explorations*. He joined Magnum Photos in 1994.

XU JINYAN has been a photographer with the News Photo Agency of Yunnan for over twenty years. His work is included in such collections as *The Southern Silk Road* and *The Ancient Tea and Horse Road*. Known by his subjects and colleagues alike as a great talker and listener, Xu has focused on documenting ordinary life along these two ancient roads in Yunnan. His photojournalism is marked by a keen understanding of the customs, history, and culture of the region.

RICHARD YEE was born in Guangzhou, China, and began photographing there as a young man. He came to the United States in 1992 and currently resides in Massachusetts. His work has been exhibited both in China and in the United States and is included in several permanent collections including the Seattle Museum of Fine Arts and the Addison Gallery of American Art.

ZHANG HAI-ER was born in Guangzhou, China in 1957. First trained as a stage designer at the Shanghai Drama Institute, Zhang worked as an art director and set designer for the Guangdong Television Network before continuing his education in photography at the Guangzhou College of Fine Arts. He has had numerous one-person exhibitions, both in China and in Europe and is represented by Agence Vu, Paris.

ZHENG NONG was born in 1968 in Dalian, Liaong Province. He studied book design at the Central Academy of Arts and Design in Beijing, then turned his attention to photography following his graduation. In 1997, Zheng published a collection of photographs he made during travels through China entitled *Walking Bystander*.

THE WRITER

RAE YANG was born in 1950 to a respected family in Beijing and became a member of the Red Guards during the Great Proletarian Cultural Revolution (1966–1976). Her recent book *Spider Eaters* (1998) is a spellbinding account of her privileged childhood, her life as a revolutionary farm laborer, and of her later transition into China's post-Mao society. Yang, who received a PhD in East Asian Studies from the University of Massachusetts, is presently Chair of the East Asian Studies program at Dickinson College in Pennsylvania.

ACKNOWLEDGMENTS

Among the many who have shared their insights and expertise on China and beyond, we especially thank Mathieu Borysevicz, Cornell Capa, Fred W. Drake, Joseph Fung, Nancy Hearst, Cindy Ho, Reagan Louie, Liu Heung Shing, Brian Palmer, Mary L. Pei, Shuang Shen, Boriana Song, Wu Jialin, and Zhang Kai Yuan. For their support of the exhibition we thank Mabel Brandon Cabot of Ford Motor Company; Ambassador Frank A. Wisner of AIG, and T. C. Hsu of The Starr Foundation; Stanley Harsha of the American Embassy, Beijing; Lu Jun and Lou Bai-Qian of the China International Cultural Exchange Center, Beijing; the Asia Society, especially Vishakha N. Desai, Colin C. Mackenzie, and Chaos Yang Chen; and Gus Kayafas of Palm Press, Inc. For their assistance in editorial and exhibition production matters, we thank Eric Lewandowski, Anna McPherson, Françoise Piffard, Jodi Saunders, Mary Steele, Diana Stoll, and David Strettell. We are grateful to the photographers whose work we were not able to include in these pages; viewing their images contributed much to our understanding of contemporary life, and of photography, in China.

CREDITS: TEXT

The publisher gratefully acknowledges permission to reprint the following: excerpts on page 7, Lu Xun, from "The True Story of Ah Q," page 152, Lu Xun, from "My Old Home," both from *Lu Xun: Selected Stories*, W.W. Norton © 1960; excerpt on page 11, Mao Zedong, from "Changsha," from *Literature of the People's Republic of China*, edited by Kai-you Hsu, Indiana University Press © 1980; excerpt on page 12, Lu Xun, from "Man and Time," from *Lu Hsun: Complete Poems*, edited by David Y. Ch'en, Arizona State University Center for Asian Studies © 1988; excerpts on page 15, Wen Yiduo, from "One Sentence," page 76, Lu Xun, from "Call to Arms," both from *The Columbia Anthology of Modern Chinese Literature*, edited by Joseph Lau and Howard Goldblatt, Columbia University Press © 1995; excerpt on page 51, Jiang He, from "Musical Variations on the Stars," from *After Mao: Chinese Literature and Society*, edited by Jeffrey C. Kinkley, Harvard University Press © 1978; excerpt on page 61, Dai Wangshu, from "I Think," from *Anthology of Modern Chinese Poetry*, edited by Michelle Yeh, Yale University Press © 1992; excerpts on page 54, Bei Do, from "The Morning's Story," page 66, Anonymous, from *Lyrics of Chu: Calling Back the Soul*, page 68, Li Bai, from *The Old Airs*, IX, page 70, Tao Quian, from "Drinking Wine, V," page 82, Wang Wei, page 91, Wang Wei, from "Sight-Seeing in the Moors Outside of Liang-zhou," page 167, Liu Xie, from "The Literary Mind Carves Dragons," page 174, Wang Han, all from *An Anthology of Chinese Literature*, edited by Stephen Owen, W.W. Norton © 1996; excerpt on page 73, Zhuang Zi, from "The Northern Travels of Knowledge," Lin Yutang, *Moment in Peking*, John Day © 1939; excerpt on page 103, Anonymous, from *The Book of Songs*, edited by Arthur Waley, Grove Press © 1937; excerpts on page 38, Jiang He, "Brief Lyric," from *Unfinished Poem*, page 49, Ruan Ji, from *Poems of My Heart*, page 106, Gu Cheng from "Capital I," all from *A Splintered Mirror*, edited by Donald Finkel, North Point Press © 1991; excerpt on page 116, Bao Zhao, from *Tedious Ways*, from *An Anthology of Chinese Literature*, edited by Cyril Birch, Grove Press © 1967; excerpt on page 153, Li-Young Lee, from "The Gift," from *The Open Boat*, edited by Garrett Hongo, Double Day © 1993; excerpt on page 177, Kyoko Hayashi from "The Wangpoo River," *Shanghai: Electric and Lurid City, An Anthology*, edited by Barbara Baker, Oxford University Press © 1998.

CREDITS: PHOTOGRAPHS

Unless otherwise noted, all photographs are courtesy of and copyright © 1999 by the photographers. Frontispiece, Chen Changfen, courtesy John Shuck © Chen Changfen; page 7, Owen Lattimore, courtesy Peabody Museum of Archaeology and Ethnology, Harvard University © Lattimore Foundation; pages 8–11, Robert Capa, courtesy Cornell Capa © Robert Capa/Magnum Photos; page 12, Photographer unknown, courtesy and © AP Wideworld; page 13, Wu Yinxian, courtesy and © Xinhua News Agency; pages 14–15, pages 16, 19, Jack Birns, courtesy Time Life Syndication © Jack Birns/Life Magazine, Time Inc.; pages 17–18, Sam Tata, courtesy Karl Brown © Sam Tata; page 20, James Burke, courtesy Time Life Syndication © James Burke/Life Magazine, Time Inc.; page 21, Carl Mydans, courtesy Time Life Syndication © Carl Mydans/Life Magazine, Time Inc.; page 27, Photographer unknown, courtesy and © Xinhua News Agency; page 28, Rolf Gillhausen, courtesy Black Star © Stern/Black Star; page 29, Photographer unknown, courtesy Black Star © Stern/Black Star; pages 31–33, René Buri, courtesy Magnum Photos © René Buri/Magnum Photos; page 34, Photographer unknown, courtesy and © Eastfoto; page 35, Enrico Sarsini, courtesy Time Life Syndication © Enrico Sarsini/Life Magazine, Time Inc.; pages 55–59, Eve Arnold, courtesy Magnum Photos © Eve Arnold/Magnum Photos; pages 61–69, Hiroji Kubota, courtesy Magnum Photos © Hiroji Kubota/Magnum Photos; pages 70–75, Xiao-Ming Li, courtesy Magnum Photos © Xiao-Ming Li; pages 152–157, Mark Leong, courtesy Matrix Photos © Mark Leong; pages 164–169, Stuart Franklin, courtesy Magnum Photos © Stuart Franklin; pages 170–178, David Butow, courtesy Saba © David Butow.

Library of Congress Catalog Card Number: 99-61680
Hardcover ISBN: 0-89381-862-3
Paperback ISBN: 0-89381-884-4

Printed and bound by L.E.G.O., Vicenza, Italy

Jacket photo: Hiroji Kubota, Shanghai, n.d.
Back jacket photo: Reagan Louie, Beijing, 1987
Halftitle photo: Chen Changfen, *Great Wall*, 1977

First edition

10 9 8 7 6 5 4 3 2 1

The Staff at Aperture for *China: Fifty Years Inside the People's Republic* is:

Michael E. Hoffman, *Executive Director*
Peggy Roalf, *Project Editor*
Wendy Byrne, *Designer*
Stevan A. Baron, *Production Director*
Helen Marra, *Production Manager*
Eileen Max, *Associate Production Director*
Lesley A. Martin, *Managing Editor*
Matthew Howard, *Editor*
Laurel Ptak, *Assistant Editor*
Rebecca Kandel, *Editorial Assistant*
Caroline Lee, *Art Wrangler*
Sara Federlein, *Development Manager*
Kathie von Ankum, *Foreign Rights Manager*
Jane Goldberg, *Editorial Work-Scholar*
Elaine Schnoor, *Production Work-Scholar*

The Staff at Aperture for the traveling exhibition *China: Fifty Years Inside the People's Republic* is:

Launa Beuhler, *Traveling Exhibitions Coordinator*
Huiwai Chu, *Associate Traveling Exhibitions Coordinator*
Rebecca Welch, *Gallery Manager*
Anthony Montoya, *Archive Director*
Annie Hollingsworth, *Gallery Work-Scholar*
Erin Tohill, *Gallery Work-Scholar*

Aperture Foundation publishes a periodical, books, and portfolios of fine photography and produces world-class exhibitions to communicate with serious photographers and creative people everywhere. Catalogs are available upon request.

Aperture Book Center and Customer Service, Millerton. PO Box M, Millerton, NY 12546. Phone: (518) 789-9003. Fax: (518) 789-3394. Toll-free: (800) 929-2323. E-mail:customerservice@aperture.org.

Aperture Book Center, Burden Gallery, and Aperture Foundation, New York.
20 East 23rd Street, New York, New York 10010.
Phone: (212) 505-5555. Fax: (212) 979-7759.
E-mail: info@aperture.org
Visit Aperture's website: http://www.aperture.org.

Aperture Foundation books are distributed internationally through:

CANADA: General/Irwin Publishing Co., Ltd., 325 Humber College Blvd., Etobicoke, Ontario, M9W 7C3, Fax: (416) 213-1917.

UNITED KINGDOM, SCANDINAVIA, AND CONTINENTAL EUROPE: Robert Hale, Ltd., Clerkenwell House, 45-47 Clerkenwell Green, London, United Kingdom, EC1R OHT, Fax: (44) 171-490-4958.

NETHERLANDS, BELGIUM, LUXEMBURG: Nilsson & Lamm, BV, Pampuslaan 212-214, P.O. Box 195, 1382 JS Weesp, Fax: (31) 29-441-5054.

AUSTRALIA: Tower Books Pty. Ltd., Unit 9/19 Rodborough Road, Frenchs Forest, Sydney, New South Wales, Australia, Fax: (61) 2-9975-5599.

NEW ZEALAND: Southern Publishers Group, 22 Burleigh Street, Grafton, Auckland, New Zealand, Fax: (64) 9-309-6170.

INDIA: TBI Publishers, 46, Housing Project, South Extension Parr-I, New Delhi 110049, India, Fax: (91) 11-461-0576.

For international magazine subscription orders to the periodical *Aperture*, contact Aperture International Subscription Service, P.O. Box 14, Harold Hill, Romford, RM3 8EQ, United Kingdom. One year: $50.00. Price subject to change.

To subscribe to the periodical *Aperture* in the U.S.A. contact Aperture, P.O. Box 3000, Denville, New Jersey 07834. Toll-free: (800) 783-4903. One year: $40.00. Two years: $66.00. Price subject to change.

My joy is the joy of sunlight,
In a moment of creation
I will leave shining words
In the pupils of children's eyes
Igniting golden flames.
Whenever seedlings sprout
I shall sing a song of green.
I'm so simple I'm profound!

My grief is the grief of birds.
The Spring will understand:
Flying from hardship and failure
To a future of warmth and light.
There my blood-stained pinions
Will scratch hieroglyphics
On every human heart
For every year to come.

Because all that I am
Has been a gift from earth.

—Shu Ting (b. 1952),
from "Gifts"

"China: Fifty Years Inside the People's Republic"
Exhibition Schedule
(as of May 26, 1999):

Asia Society
New York
October 7, 1999–January 2, 2000

Royal Ontario Museum
Ontario, Canada
January 15–March 26, 2000

University of California Berkeley Art Museum
and Graduate School of Journalism
Berkeley, California
April 12–June 18, 2000

The Minneapolis Institute of Arts
Minneapolis, Minnesota
Winter 2001

Lowe Art Museum
University of Miami
Coral Gables, Florida
September 18–November 17, 2002

Arthur M. Sackler Gallery
Smithsonian Institution
Washington, D. C.
February 22–May 16, 2004